She Who Wins

Renée
Bau

Renée Bauer

SHE WHO WINS

DITCH YOUR INNER "GOOD GIRL," OVERCOME UNCERTAINTY, AND WIN AT YOUR LIFE.

Urano
publishing

Argentina - Chile - Colombia - Spain
USA - Mexico - Peru - Uruguay

© 2023 by Renée Bauer

© 2023 by Urano Publishing, an imprint of Urano World USA, Inc

8871 SW 129th Terrace Miami FL 33176 USA

Urano
publishing

Cover art and design by Sandra de Waard

Cover copyright © Urano Publishing, an imprint of Urano World USA, Inc

The first edition of this book was published in september 2023

ISBN: 978-1-953027-09-2

E-ISBN: 978-1-953027-13-9

Printed in Spain

Library of Cataloging-in-Publication Data

Bauer, Renée

1. Feminism 2. Self-Help

She Who Wins

Dedicated to my mom, the fierce female who raised me.

Table of Contents

Part Four:
She Who *Wins* at Life

Introduction

I'm a recovering "good girl."

I've always colored in the lines, followed the rules, held my strong opinions, and smiled every step of the way. I've never been suspended or arrested. I've never even failed a class. I did all the right things that were expected of any "good girl." Up until my early thirties, my idea of being a rebel was sneaking candy into the movie theater in my oversized bag, breaking dress code in high school, or driving my car until my tank was empty. I hardly think these things would raise me to troublemaker or dissident status.

So, the early half of my life was well planned and executed according to my color-tabbed binder. I skipped down the good girl path set out for me. And all was good... that is, until it wasn't.

College. Check.

Law school. Check.

Marriage three months later. Check.

Law firm job. Check.

White colonial in the suburbs with a child on the way. Check. Check. Check.

Fired.

Wait. What went wrong? Good girls don't get fired; the spunky ones do. Should I have just put my head down and zipped my lips to preserve my security and sanity? But at what cost?

Divorced.

Hold on. How did that happen? How did I end up divorced with a two-year-old? What was wrong with me for not just being happy with all that I had?

Messy entrepreneurship.

Oh no. Being a business owner was supposed to be about getting my time back and having financial freedom, so how was I working more than I ever had before? And how did I still have an empty bank account?

Divorced again.

Now just hold up because this can't be my life. The online dating app said we were a 94 percent match. It should have told me the 6 percent that was misaligned would lead to next-level glitches.

Where did I go wrong? It wasn't supposed to be this way. I didn't have a tab in my binder for "turn your life upside down and dump its contents all over the floor." But somewhere along the way, I fell off the train destined for suburban bliss. I was out of touch with who I was at my core, and I was lost and alone. I was empty and unfulfilled. I was disconnected, and I knew that if something didn't change, I would wake up in twenty years wondering what happened to me. I needed to shift, but I had no idea how. I thought I could hustle and grind my way out of my funk, but all that did was quick fix my feelings. And a bandage is never the solution for a gouge in the soul. That inferno of not knowing who I was, where I was going, or what I wanted, was the darkest time in my life.

In the moment, I thought divorce was the worst thing that could ever happen to me. Now, I know it happened *for* me. In fact, everything I ran up against played tug-of-war with my good-girl ways. It's impossible to set up a successful business without ruffling some feathers, being a boss, and making hard decisions. It's equally impossible to have a healthy relationship when you are compromising who you are because you think that is what the other person wants. When you shrink your light to make your partner more comfortable, eventually your sparkle dulls.

Yet, as the years ticked by, I realized something. The only way to live an aligned life was to drop the good-girl act and trade her in for something more authentic, something more unruly. And if I was being honest with myself, every time I had an uncomfortable conversation, made a radical decision, or stopped paying attention to other people's opinions, I friggin' loved it.

The more I flexed my bravery muscle, the stronger it became. The stronger it became, the more I chased my bold dreams to speak on stages, build a multimillion-dollar business, invest in other female-owned start-ups, and be able to say *no* when something didn't feel right. And the more I chased my bold dreams, the more free, fulfilled, and fierce I became. I kept moving the needle every time I stopped making choices from a place of pleasing and started living from a place of truth.

Today, it's easy for me to make decisions. I trust myself. I know within seconds if something feels like a *hell yes* or a *hell no*. I don't second-guess my instincts. The woman I am at my core knows better than anyone what is right for me because she makes my stomach churn and heave if something is off, and she delights me with excited anticipation when something is in harmony. She constantly reminds me that I am fierce and capable

because I let her warrior voice vibrate through me while I silence the critic and pessimist that tries to disrupt my growth. I don't think about other people's judgments or opinions because they don't offer any value. I surround myself with those who motivate me because inspiration comes from genuine connections and from being around people who are following their own unique purpose. Equally as important, I give my time sparingly to those who vibrate at a low energy because that can be contagious too.

Being a "good girl" got me good grades, honor society, a good-enough marriage, and a steady life. Being a good girl also would have kept me stuck at the status quo had I lingered there too long. And that was a life sentence I refused to accept. I wanted more. I know you want more too.

This book is for every woman who was told to smile, to quiet down, and to shrink themselves into the smallest version of themselves. It's for every woman who is struggling to make a life-altering decision or is wondering, "What's next?" It's for every woman who thinks this is as good as it gets. It's for every woman who has felt like there has to be more. It's for every woman who feels like she doesn't have a reason to complain or who feels selfish for even questioning her happiness.

Consider this book your permission to get loud in your beliefs, passionate about your convictions, and to sashay confidently into your life on your terms. It's never too late for anything. There isn't an expiration date on ideas. You can find love, write a book, start a business, travel the world, or do whatever you dare to dream at any age. So, let's get something straight, right now.

You don't need to be the good girl anymore.

You don't need to follow the path someone else laid.

You don't need to fit into a mold.

You don't need to make anyone else happy.
You don't need to show less emotion.
You don't need to be humble.
You don't need to pretend to be someone else.
There is a fierce woman inside you fighting to get out.
She is daring.
She is heroic.
She is opinionated.
She takes up space.
She is uncompromising in her dreams.
She is YOU.
It's time to get reacquainted with,
SHE WHO WINS.

She Who Wins

Stops and Assesses

CHAPTER 1

Stop and Disrupt

Well-behaved women seldom make history.
—LAUREL THATCHER ULRICH

I once had turquoise hair extensions.

I'm also a lawyer. Lawyers aren't supposed to have turquoise hair. Someone, somewhere, set the rules for how lawyers are "supposed" to act, how they are "supposed" to look, and how they "should" behave. The first time I saw a good friend after I had the teal strands of delight freshly attached to my head, she said, "What are you going to do when you have court?" As if I couldn't be a good, competent lawyer with hair the color of taffy. The decision to have turquoise hair created a disruption. It disrupted my friend's perception of how one who works in the legal field is "supposed" to show up to her job. Going to court with hair the color of rock candy didn't impact the job I did for my clients or the outcome of my cases. My story of disruption doesn't stop here.

Not long after that conversation about my hair, I was picking out carpet for my law office renovation and the nice woman helping me in the store had pulled out all kinds of commercial carpet.

They all had one thing in common. They were bland, boring, and just made me feel *ew*. I flipped through the carpet squares looking for something that might appeal to my creative side.

Beige with off-white specks. Nope.

Gray with navy specks. Nope.

Beige with beige specks. Or was that a swirl. I couldn't tell. Nope. Nope. Nope.

I wanted my workspace to fuel my creativity. I wanted to sit at my desk and feel inspired, not contained and stifled by beige carpets and fluorescent lighting. I knew just what I needed. "Do you have any animal prints?"

She laughed, adding yet another beige carpet square to the stack. "This one is taupe," she said.

"Animal prints?" I asked again.

"Oh," she said. "You were being serious. Well, let's see what I can find." She pulled out some subtle designs that one might call an animal print if you squeezed your eyes shut and imagined a cheetah. Then I spotted the one in a stack that she hadn't even thought to show me.

"That one," I told her, pointing to the wildcat-patterned square across the room.

"You said this was for an office?" She narrowed her eyes and said, very slowly, "A. Law. Office?"

"Yep." I flipped my turquoise hair over my shoulder.

As she wrote up the purchase order, she said without looking up from her computer, "Are you sure that's proper?" She paused. "For a law office?"

And there it was.

You see, these stories really have nothing to do with living a fierce, bold life. In fact, the color of my hair is irrelevant to whether I can do my job as a lawyer or whether I'm happy. The

carpet pattern in my office doesn't have any direct correlation to the success of my firm or my level of joy. But the stories are a microcosm of something much larger at play. The saleswoman had a lens from which she viewed the world, as we all do. It's the same lens my friend was looking out from when she asked me how I would lawyer with unsuitable strands of blue hair protruding from my head (she didn't actually say that, but I imagine she was thinking it). Our view of what is acceptable and doable is the very reason we are kept small. And it's why we must start this book here.

Getting comfortable with disrupting the current state of things is where our work begins. You must disrupt the thoughts that are shaped by societal norms, generational influences, and your own self-limiting beliefs so that you can start to step into an authentic, soulful, joyful, amazing existence. Until you become intentional about changing the story that is stuck on repeat, you will continue to do things the way they are "supposed" to be done.

I hope this book stirs something in you not because it reminds you of how small you've allowed yourself to be, but rather, because it showcases how large you can dream. So long as you remain paused in stagnation, you will not leave behind whatever is holding you back from becoming the protagonist of your life. I hope this book rouses you to take radical action so that you can never return to your former way of being. Once you decide that passivity is no longer for you, you can choose to move forward, no matter how hard, how terrifying, how uncomfortable, or how uncertain it is. Once you've decided to leave the good girl in the dust, you can become the fierce female you were born to be.

You have everything it takes to be a visionary, an innovator, and a changemaker. You don't need fancy degrees or a posh

wardrobe to impact lives. You don't need a guru's guidance or fancy retreats to tap into your power. You are unique, and you have something to say to the world. No one can articulate it like you. The lens from which you view the world is utterly and totally your own, and it cannot be replicated. If you wait for "perfect timing" to make a change, you are procrastinating on your potential.

It's your time, right now, right here.

Are you ready to let the good girl go?

Are you ready to be a disruptor?

Good.

Now, leap.

Stop, Drop and Roll into Your Life

Fire occurs when substances combine chemically with oxygen to produce bright light and heat. While the instinct is to extinguish any fire you see, when the fire is within us, we should fan the flames and encourage the intensity to escalate. The fire within you can change your life, as well as the lives of others. Let's not snuff it out. Let's nurture it and feed it so it can run wild and free.

In 1973, the National Commission on Fire Prevention and Control published an educational tool introducing us to the "Stop, Drop, and Roll" method of fire protection. It stemmed from a study of flammable clothing and was taught to children as a simple and effective method of extinguishing flames. Today, we still know what this formula means as it applies to fire. In this book, however, we are applying it to your life.

We don't want to douse the fire within you, but rather, to keep the flames glowing bright. Stop, drop, and roll is the key to finding your fierceness and acting upon it.

The Stop, Drop, and Roll formula is a simple, memorable application that you can apply to every situation you come against. We will apply it over and over again so by the end of this book, it will be embedded in your consciousness. You will be able to use the formula every time you are contemplating a pivot or a shift for the rest of your life. When you feel stuck, you will be able to come back to stop, drop, and roll, working through each phase to move past inertia.

It's easy.

It doesn't require so much as a pen.

You can run through it while sipping your morning coffee, or driving, or listening to your boss drone on.

The Stop, Drop, and Roll formula will guide you *not* to the answer you think you want, but rather, to the answer you need.

Let's start with an overview. There are three stages to the formula and the sections of this book will break apart each phase in greater detail.

STOP + **DROP** + **ROLL** = **WIN**
(and assess) (your excuses) (into action) (at life)

1. **Stop (and Assess)** → Stop and assess what you really want. The battle between your head and heart rages when you have a complicated, risky decision to make. Every major

and minor decision I've ever made, from divorce, to quitting a job, to starting a business, to saying *no*, to saying *hell yes*, is a conversation that has occurred between my head and heart. Understanding the dichotomy between the two is essential to everything else. When I've let my head win, I've regretted not feeling all in. When I trusted my heart, opportunities in my life expanded. Our head holds us back and our heart propels us forward. Our head keeps us safe, and our heart dares us to act on our dreams. You will learn how to distinguish the difference.

2. **Drop (your Excuses)** → Drop your excuses that are holding you back. Everyone has their unique brand of bullshit that they tell themselves over and over. I was a people pleaser and conflict avoider. Because of this, I sacrificed things that mattered to me just to avoid disappointing others. This was a recipe for resentment and burn out, and I was essentially allowing myself to take the passenger seat in my life. Your brand of bullshit may look different, but the impact is the same. It holds you back. We will examine the biggest offenders so that you can recognize them and leave them in the dust.

3. **Roll (into Action)** → Roll forward into action. Everything will unfold exactly the way it's supposed to, but you must act. We need to give the Universe a hand and start the forward momentum. We don't always need to take massive leaps. Sometimes, just a little push to get rolling will start things moving. Whenever I've felt stuck, I try and find the smallest thing I can do. A walk. A phone call. Writing for just half an hour. Sending the email that needs to go out. The small steps add up and help move us past inertia.

4. **Win (at life)** → Winning at life is what happens when you stop, drop, and roll into every decision you come up against. You cannot lose when you are listening to your heart, dropping your excuses, and taking action. The outcome, regardless of what that looks like, is the least important part of this journey. It is not the two-dimensional goal that matters, but the growth that happens along the way to achieving that end. That is the good stuff. That is where living manifests. That is winning.

The Stop, Drop, and Roll formula will help you weigh your decisions, crush what is holding you back, and spring into action. By the end of this book, you are going to be equipped to make positive changes that will empower you to step beyond what is comfortable and do things that equally terrify and excite you. Because that is why you picked up this book. You want to change something in your life that just isn't working anymore. Maybe you want to leave a joyless marriage. Maybe you want to leave a job you hate. Maybe you want to start a business. Maybe you've allowed your dreams to fade over the years and now, you are saying *there has to be more*. I'm here to tell you, there abso-fucking-lutely is more to your life. And I'll be cheering you along every step of the way.

Victory is not something that just happens to you, but rather, something you chase down, tackle, and snatch into your possession because you are its rightful owner. Accepting mediocrity is giving up on yourself. It's settling for average, and you are not average, fierce friend.

You are meant to be seen and be heard.

Make Her Proud

Who do you want to be when you grow up?

How many times are we asked that question as a child? Ever notice how different our answers are received depending on our age? The ballerina we wanted to be as an eight-year-old is cute and sweet, but in college that dream is "irresponsible" and "unrealistic."

What will you do for money? How will you support yourself?

The adults around us unintentionally snuff out our dreams with one practical question after another. Their intentions aren't wrong. They want us to be secure and to have a nice life. But why do we stop getting asked what we want to do and who we want to be once we have a job and are settled into a "suitable" life? The answer to what we wanted seems not to matter as we get older, become married, have kids, buy a house, and get accustomed to a week or two of vacation time for the entire year. When was the last time you actually thought about who you want to be?

Why is it so much harder to answer now? As an adult, we aren't as quick to respond as our eight-year-old selves were. It's as if being an adult is contradictory to our ability to dream without restraints, inhibitions, and judgments. Up to this point, you have shown up in the world by following the rules that were set out in the "How to be an Adult" manual you were given. Oh, you didn't get one of those instruction guides? Me neither, yet for years I lived by those unwritten principles—that is, until I decided to make my own.

The decisions I made along the messy, bumpy, potholed road to rewriting my own rulebook were hard. I went through two

divorces, quit my secure job to start my own business, faced my fear of public speaking, threw caution to the wind to get married a third time, and then exited the secure business I painstakingly grew so that I could host events and masterminds, write books, and become a paid speaker. And I did it all without knowing whether anyone would show up to my events, hire me for speaking engagements, or want to read what I wrote. These were all disruptor decisions. But not every decision needs to be major. You can rumble small first to get some practice. You can test out disrupting the status quo. You can try on being a rule-breaker to see how it feels. It's an acquired taste that is also quite addictive.

That adult manual that no one seems to actually possess, but that we all know about and have read, studied, and embodied every single day, is antiquated and steeped in patriarchy. Nothing ticks me off more than someone telling me I must do something a certain way because that's "just the way it is." That phrase makes my toes curl and my fists clench. There is more than one way to live. We don't need to follow these unwritten rules. We don't need to listen to this anonymous author who has been allowed too much space in our minds.

Living a life "by the book" is a slow, steady walk to the grave. Listen, we are all heading there anyway. So, why not get there by joyfully and unapologetically stepping into the life that your eight-year-old self would be excited about? She remembers the dreams you had. She remembers when the possibilities knew no bounds. She remembers the excitement you felt when you thought about carving out your place in the world. She believes in you. She knows you are capable.

So, let's make her proud.

"Just Fine" is Purgatory

I spent almost two decades working as a divorce attorney before I left it all behind. During that time, there wasn't a week that went by when I didn't talk to someone about walking away from something that no longer served them. They wanted out. They were miserable with their partner. They couldn't imagine spending the rest of their life living with that person. Yet, do you know what held almost every single person back from taking the first step?

Uncertainty.

Overwhelm.

Fear of the unknown.

Worry about what people would say.

Concern about how their family would react.

Apprehension about money and whether they would survive with less.

They didn't want to do what they weren't supposed to do.

They didn't want to disrupt.

Instead, they stayed put and each day they lost a little more of themselves in the name of doing that which was expected. They stayed to be the good girl, the good daughter, the good employee, and the good wife. They became a person who put up with, dealt with, and adapted to what was allotted to them.

Here's the truth bomb. You don't truly live by following the rules someone else wrote. Sure, you can muddle along and get to the end being just fine. But who wants to be "just fine?" When I cross the finish line, I want to know I did, tried, failed, believed, risked, and loved my way to the end. But, that level of living comes with one caveat; you can't win at *your* life if you're running the race in someone else's ugly, brown loafers.

I'm not saying you should abdicate responsibility, sell your house, move to Bali, and light things on fire (unless what you want to burn is this aforementioned rulebook—let's light that bitch up.) But I am saying you need to show up with purpose every day of your life. Every day, ask yourself who you want to be. Today. Tomorrow. Next year. You get to change that future person: change her job, change her role, change her hair color, change her spouse, change whatever the hell you want to in her life. You should do so without apology, without regard for the naysayers and well-intentioned cynics. We are not unmovable, unchangeable, and unpliable. We can rewrite, reimagine, and re-invent our lives on our terms.

The idea of being disrupted should feel familiar to you already because our lives are filled with disruptions. But usually, we only deal with the ones that have been thrust upon us, rather than us making the decision to disrupt.

A disruption happened to me about eight months out of law school. I despised my first job. Every day I would go off to work singing a little melody:

Heigh-ho, Heigh-ho
It's off to hell I go.

I was newly married to husband number one, and we were planning to buy a house. I couldn't possibly quit my job because it would be irresponsible. I had to stick it out because anything else would disrupt the plan. It didn't matter that the behavior exhibited by superiors teetered on harassment or that the work-life culture was soul sucking. It didn't matter because I stayed. I sucked it up. That's what good employees do. That's what good girls do.

Fortunately, I was fired for being a bit too fiery in the mouth, but you know what incredible thing happened after I was fired? I got another job. One I loved. And that job ultimately gave me the confidence and training to start my own law practice. My point is, I figured it out because I had no other choice. Disruption was thrown at me when I was thrust into unemployment and had to scramble to figure out what I was going to do next.

Two days after I was fired, I bought a house. Shit gets real when you have a mortgage payment and no income. But I figured it out. I had to. Had I not been fired, I wonder how long I would have stayed before I had enough. I wonder if I would have wasted years singing that little melody. I think that's probable, because at that point in my life, I was following the rules and doing the expected thing even if it meant my soul was slowly dripping down the drain. I would not have chosen that disruption myself, but the Universe had other plans and imposed its will.

That is the funny thing about being forced into a disruption; we always figure it out. Things always fall into place. So, why do we lose faith when ultimately, we have the power to make the decision? Why do we stay stuck when we should know that it, whatever *it* is, will work itself out? I'll give you a hint: Because we think it's reckless and irresponsible to walk away or take the leap.

Think back to when you were a child. You did all kinds of things that were new and uncomfortable. You rode your bike for the first time. You went on your first rollercoaster. You tried new food. As a teenager, you had your first day at your first-ever job. You went off to college and were forced to meet new friends. You grew by doing new things. And then you stopped. It was as if a large cement wall came down in front of you and another behind you like Indiana Jones trying to get out of the Temple of Doom,

and you stayed stuck in between two cement barriers, preventing you from taking even one more step forward.

What is the thing that is sitting on your soul right now, weighing you down, and keeping you from living a victorious life? Are you letting the external influences in your life dictate your decisions? To be a disruptor, you must first be clear about what is trying to stifle your growth. You are surrounded by so much external chatter. Friends who might mean well and family who have your best interest at heart will tell you how ridiculous your idea is. Their advice is being squeezed out of their own fears, their own insecurities, and their own regrets.

Commercials and magazine ads tell us what our age and weight say about how attractive we are. Everything in the media tells us how unfashionable we are. Our income level tells us what we are worth. Our social media feeds tell us other people have perfectly curated, color-coordinated existences. We live in a state of comparison. When are we not comparing ourselves to others?

How much money we have.

What car we drive.

Whether we have the latest, greatest phone or handbag.

Our marital status tells us how loveable we are. Ever notice the platitudes someone spews when you tell them you are still single. "You'll find someone," they might say. "Plenty of fish in the sea." Or maybe you tell them you're divorced. Maybe you tell them you are divorced twice. They take a step back as if being divorced is contagious. They mumble, "You'll be OK... Lots of divorcées out there... Dating is so different now. Good luck." They look down because they can't make eye contact. These are all judgments that are not necessarily meant to make us feel a certain way, but they always do. In these moments, you

are living on the fringes of being a disruptor and that makes people uncomfortable.

We also let our generational history dictate our values, our belief systems, and even our behaviors. Our parents held onto the story told to them and have now passed their stories to their children. These tales will continue to be told, like folklore shaping future generations until something changes.

Until someone says, "Not me. No longer. Not my story."

Are these factors guiding the decisions you make? Is there a voice that creeps into your mind at night when you should be sleeping that says, "Who do you think you are?" It whispers into your ear, "Stay in your lane."

It's the reason why making a bold, fierce decision is so difficult.

Think about the last time you made a difficult decision. I'm almost willing to bet you a pair of Jimmy Choo's (although I've heard they are quite uncomfortable) that you let your head weigh heavier in your decision-making than your internal voice. Do you dislike your job but feel stuck? What is holding you back from doing something else? Likely, the chatter is holding you back. Your rational head tells you that leaving your job is irresponsible. Your people-pleaser brain tells you that divorce is selfish. You think moving cross country is too scary and too irrational. You think you should quit complaining because others have it worse. You think you know how to *shoulda, coulda, woulda* live your life.

But being "just fine" is not the goal. Being "just fine" is for those who choose to play it safe and ignore their most authentic truth. Being "just fine" is for those who don't believe in themselves.

That's not you.

Stuck is a Choice

Newton's First Law of Motion tells us that an object will not change its state of motion—whether it's moving or not—unless acted upon by force. Usually, fear and uncertainty cause you to stay in one place, unmoving and stuck. And the conversation you have with yourself is on repeat.

"How do I know if leaving my job is the best decision?"

"How do I know if I should move?"

"How do I know if I should go back to school?"

"How do I know I'll get the raise if I ask?"

"How do I know that ending my marriage or this relationship is the right decision?"

"How do I know?"

We don't move unless by force. For me, I was forced out of a job. For others, they are forced into a divorce they didn't want. You have so much power to control your trajectory. You shouldn't be waiting for someone to force it upon you. You should be the one revving up your own life.

Now, I'm a realist so I'm not going to pretend that once you make the decision to disrupt your life, the rest is easy. Quite the opposite. Your decision might put you on a shoestring budget. It might cause heartache. It might be the longest and most difficult thing you've ever done. But it will also be 100 percent worth it because you'll know you made the disruptor decision for the right reason. It is the decision that will fill you up so your cup can runneth over. The right decision is not always the easy decision. Sometimes, it's much easier to stay in the secure job, in the bad relationship, or in the city you hate. It's easier to stay still than to disrupt your life. If you wait for the right time, years might pass you by. If you wait for support from family and friends, you

might wait a lifetime. Your life is too important to wait for permission to start living it.

It took me until my forties to realize that I've spent a lot of my life trying to live by the "supposed to" model of adulthood. When I did make the disruptor decisions, I let guilt, fear, and shame dwell in my brain. For years, I questioned the decisions I'd made that were outside the model. Fortunately, I have the rest of my life to decondition that training. It's why I do the work I do now, and it's why this book is so important to me. I hope it resonates with you, too.

Every time you're faced with a decision, you're at a proverbial crossroads. Your head will try to protect you; she is a pesky and rational conformist, and she will tell you all the things that might go wrong. But our heart is the rebel; she has the direct line to what's happening inside of you, at your core. She is your intuition, your inner knowing, and your gut instinct. Call her what you want, but she is omniscient. She knows. We'll challenge this dichotomy deeper in the next chapter.

For now, let's kick off our time together by committing to being disruptors. Let's flick the archaic, annoying, good-girl, small-world, "supposed to" models to the curb where they belong. And for good measure, let's run it over a few times so it doesn't pop up like Wile E. Coyote from the Roadrunner (you know, back in the day, when cartoons were good). Now remember, the moment you stick to doing what you are "supposed" to do, you are doing the small thing. You are doing the thing that shrinks your spirit, your soul, and your ability to dream big, bold, and fiercely.

This book meets you exactly where you are right now: where the nagging feeling of discontent meets the unspoken thought that something greater is steeping beneath your surface, excited

to get out and be seen and heard. Throughout the book, I share my stories, but your unique path is yours alone. I can't feign to know what is going on inside of you. I can't imagine what your unique suffering feels like. But the decisions each of us make have similarities.

They are hard.

They require us to tune into ourselves.

They require action.

While your challenges may look different, adversity and pain are a human experience. It's not my place to tell you whether you should leave your marriage or relationship. I don't know whether you should quit your job or move across the country. I don't know exactly what is nagging at you. I'm not going to say whether your relationship is bad or good, or your job is fulfilling or unfulfilling. No one can tell you that. Not a guru out in the social media space. Not your friends. Not your caring relatives. I am not going to propose that the decisions I made in my life are the right decisions for you, because everyone's circumstances are so different.

Only *you* can make the decisions that need to be made. Stop asking everyone else. Who cares what they think? It's irrelevant to your decision-making process. No matter what decision you make, it's always the right one. Even something that starts as *yes* and later turns into *no*, is the right decision for that moment and that part of your growth journey. Doesn't it feel like a lot less pressure once you know every decision is the correct one? Isn't it time to decide that being stuck isn't for you anymore? The choice is all yours.

Choose wisely, my fierce friend.

But let's get something clear right now. You have all the sparkle and shine you need already. You don't need to change. We

just need to get that polishing cloth out and return you to your natural brilliance.

Are you ready to figure out who you want to be? How about who you can be?

Stop and declare, *I am ready to get a little disruptive.*

Chapter Sound Bites

- The Stop, Drop, and Roll formula will guide you *not* to the answer you think you want, but rather, to the answer you need.
 - o Stop (and Assess)
 - o Drop (your Excuses)
 - o Roll (into Action)
 - o Win (at Life)
- If you would like a free pdf of the Stop, Drop, and Roll formula to keep handy, go to https://msreneebauer.com/ and enter your email address to immediately download it.
- When you cross the finish line, you want to know that you did, tried, failed, believed, risked, and loved your way to the end.
- You already have everything it takes to be a visionary, an innovator, and a changemaker.
- So, let's flick the archaic, annoying, good-girl, small-world, "supposed to" model to the curb where it belongs.
- **STOP and declare,** *I am ready to get a little disruptive.*

CHAPTER 2

Stop and Amour Propre

True abundance isn't based on our net worth.
It's based on our self-worth.
—GABRIELLE BERNSTEIN

It takes a lot to make me cry. Movies can do it. Books definitely can too. But real-life situations often don't because I'm good at evaluating and coming up with a strategic plan on how to move through whatever it is that is plaguing me. Still, there was a morning about a year ago when I couldn't keep my eyes dry. I was on the brink of complete and total defeat.

Why? Because I stepped on the scale.

For months, I'd been walking two-to-three miles every day without fail. Plus, I was weight training three or four days a week. I hadn't weighed myself in a while because I knew the power the number might have over my mood. But that morning, I decided I wanted to see the progress I had made after months of dedication and consistency.

I rolled out of bed, stripped off all my clothes (including my hair scrunchie—you never know where hidden pounds can live), and stepped on the dusty scale. I closed my eyes while the number

calculated, and when I opened them, I was shocked. The scale had not gone down at all. Not even one measly pound. Instead, it was five pounds higher than when I'd started. How was that even possible? I was doing everything right (80 percent of the time). Hey, don't judge. I like a good key lime pie. Instead, I sat across from Jay, my current husband, with tears swelling and said, "What in the actual fuck."

I was ready to throw in the towel. If I'm working this hard and not seeing results, I might as well stop straining my body, stop moving, and take up permanent residence on my couch. My dog would not complain with that decision.

I've come so far on my worthiness journey, yet something such as a number threw me off and made me feel like a failure. Then I realized how much influence I was giving to something that didn't matter at all.

I was once in a toxic relationship, and when I walked into the house after returning from the gym one night my partner said, "I don't know why you even bother. Your ass will always be big." In that moment, I didn't feel big, but I did feel very, very small. My self-worth had hit rock bottom. I didn't believe I was worthy of the body I wanted, so how could I deserve the relationship I hoped for or the business I dreamed of? The feelings of unworthiness oozed into so much more than cellulite. I couldn't slap some cream on and wish it away. Inadequacy seeped into every facet of my life.

A number on a scale.

A spoken sentence.

I gave so much power to both. The conditioning ran deep and wide, and it started a long time ago when I was still trying to figure out who I was in this world. I'll never forget the comment my father's professional acquaintance made to him one day about

me, as if he had any business commenting on my appearance. I was in my early twenties.

"If she lost weight, she'd be pretty," he said (as though he was the epitome of health).

So much damage was unknowingly done so early, and it was veiled in an attempt to be what? Helpful? Inspiring? *Maybe, if we tell her this, she will do something about it and become worthy of a compliment.* It was unspoken, but that's what I heard. What my body looked like at that time, whether I was active or not, fit or not, happy or not, was irrelevant. The fact was, someone who barely knew me thought it was OK to judge me. Words matter, and regardless of the intent behind them, they had lasting impact. It becomes even harder to stay grounded when everywhere you look, there is commentary reiterating that a woman's value is based on what she looks like.

Not long ago, I was visiting my mother, and she had two women's magazines sitting on her coffee table. They were two separate publications, and yet their headlines were so similar.

How to Lose 14 Pounds in 10 Days.

How to Look 10 Years Younger.

How to Dress to Look Slimmer

Bake the Perfect 4th of July Dessert.

Irritated by the titles and hopeful their similarities were just a coincidence, I decided to look the magazines up on social media. As I scrolled, my jaw dropped. It felt like I stepped into a day in the life of a 1960's housewife, when it was a thing to measure one's ankles to be sure they were narrower than the calves.

Stay trim.

Smile so you appear agreeable and (gulp) likeable.

Bake everything from scratch.

Look good and bake better.

Every month, the topics featured weight loss, baking, and chasing youth.

I pulled out my phone, snapped some photos of the magazines covers, and rage posted on social media. Of course, neither magazine responded to my angry rant, but I spent the rest of the day incensed. How have we made so much progress, yet stayed exactly in the same place?

Our daughters see this. They are being conditioned too, and it will continue until we change the conversation with ourselves. Because while we can tell them they are powerful, if we are modeling something different, what are we really teaching them? Society continues to sexualize girls and police what they wear, while shaming them for "flaunting" their bodies. How about we focus on teaching our boys that women can be bosses, leaders, and thought leaders? Is that too much to ask? Apparently so.

Because when I started paying attention, I realized it is everywhere. I was sitting in Starbucks one day while writing this book and I overheard a grandmother talking to her granddaughter. I was barely listening to their conversation until I heard this:

"She is very slim. A size 4. She's very pretty," the grandmother said.

I didn't know who she was talking about, but it didn't matter. I looked at the granddaughter who had a soccer championship T-shirt on. I imagined her pummeling the ball into the net. The girl's eyes flickered from side-to-side as her grandmother talked. She just listened and absorbed. I wondered what was going through the child's mind. How did she process what she'd heard from her grandmother's mouth? The grandmother didn't mean any harm, but so much can be instilled in a short exchange with an impressionable mind.

Slim is worthy.

Size 4 is worthy.

Pretty is worthy.

Everything else is less than.

It brought me back to that morning when I had stepped on the scale and told myself that thin was ideal.

"Why are you being so hard on yourself?" Jay asked as he watched me on the brink of tears. "Look at everything you do. Look at what you've built. Is this really that important?"

I wasn't ready to hear it. I stood up, opened my slider, stepped outside, and put my bare feet in the grass, being careful not to step in dog poop because that definitely would have exacerbated my self-pity festivities. I took some deep breaths and centered myself. Opening my eyes and witnessing a number on a scale had transported me back to all those previous times in my life when my weight was the center of someone else's opinion. How could I stand on a soap box and spout ideals of women as fierce creatures that can change the world if I was hyper-focused on getting smaller? The wounds ran deep though. The conditioning had been there for so long. Get smaller, take up less space, and then you'll be worthy. I thought of the time I hired a nutrition "coach" and how he had humiliated me by squeezing my arm and telling me I could control my fat with faith and by eating exactly what was on the diet he gave me and nothing more. I cried every time I left those appointments.

I needed to be done with that old story. I needed to call myself out. I found myself attaching my weight to my worth. I made it significant to my identity, and in the moment, I felt less-than because my scale was more-than. That realization hit me hard.

I still have work to do too.

Love Yourself Fiercely

Mimi, my maternal grandmother, was French Canadian. Her first name was Florida (I'm not kidding,) but everyone called her "Tiny" even though she was Dolly-Parton vibing, if you know what I mean. She smelled of Virginia Slims and drugstore perfume. Her pants were polyester. Her sass was ubiquitous. Her opinions were as salty as her party mix. I adored my time with her.

I took French in middle school because of Mimi, and when she visited for a long weekend, I was excited to share my French lingo with her. That was, until she got a good look at my textbook.

"It's all wrong," she said with piss and vigor. "Your book is wrong, and you should tell your teacher."

My French teacher was also my best friend's mother, which complicated things.

"I don't think it's wrong, Mimi. It's real French, not Canadian." Open mouth, insert foot.

"No." She flipped through the text and settled on a page. "This is wrong." She turned the page. "And this is wrong. It's all wrong. It's a shame you are learning the wrong French."

Mimi was passionate and stubborn when she was certain she was right.

She made major, disruptor decisions in her life. She got divorced when no one did. She lived independently for as far back as I can remember. She volunteered in politics and vehemently defended her candidates. She was the OG of running bingo nights. You don't know competition until you play bingo against a gaggle of old ladies. They mean business, and they would rather give up their secret Italian sauce recipe than give up a win,

even against a child. I always admired her spunk. She knew who she was and what she stood for. She mastered her *amour propre*—her self-love. (It's the same in both Canadian and Parisian French, Mimi.)

Isn't that a beautiful way of looking at your worth? Your own love matters, and it needs your time and attention. Your own love is important. Your own love deserves the absolute best life you can give her. Your own love. How is your amour propre?

When was the last time you placed a condition on something you wanted? You'll write the book after you attend the writer's retreat. You'll wear the bikini after you lose weight. You'll ask for the promotion when you feel more comfortable in your job. You'll start the business when you take the course on entrepreneurship. We often think that we'll be better prepared to go for something when we get more education or achieve some endpoint. When you do this, you are essentially telling yourself that you aren't good enough right now. This is the opposite of amour propre.

Growth is the goal; perfection is not. Challenging yourself to get uncomfortable so you can see what you are made of is the aim. Achieving some ideal that someone else predetermined is not. You are worthy exactly the way you are today. You don't need to shrink smaller. You don't need to earn more money. You don't need to dress better or drive the better car. You don't need the Botox or the lip injections. You don't need any more than you have right now, right here. But you do need to know that you are capable of whatever it is you've ever dreamed of. Going after something because you know it's meant for you is an inside job. You don't have anything to prove to anyone else, but it is your duty to show yourself what you are made of.

It's not your job to fit by shrinking into a role or size. Your worthiness is not attached to the ideals someone else assigns to you. Your value as a woman, a human, and a soul, is immense. Your value exists just the way you are, right now. You don't need to lose weight, or earn more money, or get a more fashionable closet, or whatever else you think you need to do outwardly to earn your worth. Those are fallacies that have been perpetuated by media, society, carefully crafted product-marketing plans, and sometimes even people close to our lives. Think about what you are consuming on social media and choose wisely, because when you are constantly bombarded with unattainable standards, your self-confidence inevitably takes a plunge.

For me, body weight was a narrative I thought I had undone after years of personal development, but old lessons die hard. That morning, with some redirected effort, I decided to look at what I had gained over the past few months, instead of what I didn't lose. My energy levels were high. I was bonding with my son over gym PRs, and we even signed up to compete in a powerlifting meet together. Jay and I were connecting every day over our walks, having great conversations wherein we even mapped out the premise of this book. So, why was I letting something so insignificant influence me so greatly?

What external influences have you attached your worth to?

Your body?

Your wrinkles?

Your hair?

Your income?

Your worthiness has nothing to do with how you look on the outside; it has everything to do with your light on the inside. Your energy is a feeling. It's not a look. How do others feel when you interact with them? How are your serving others based on

your experiences? That's what matters. Not your thigh size, laugh lines, hair texture, nor the little tag on the inside of your jeans.

It was my responsibility to change the script. I wasn't willing to give power to an ex-husband, a family friend, or a number. I wasn't willing to allow something so insignificant to control my life, because the minute I stopped feeling worthy was also the minute I stopped living fiercely. It's a sacrifice I wasn't willing to make.

And it's your responsibility to stop and assess who and what you are allowing to dictate *your* worth. You need to call yourself out on whatever old story haunts you, then stick it where it belongs. What stories from your past have you allowed to control your life? Imagine if you are in a simple, white room. This place doesn't contain any furniture, but it does hold all the self-limiting beliefs you've held onto through the years. Imagine taking a sledgehammer to the wall and, one whack at a time, destroying all the notions that have held you back up to this point. Every time you bring the sledgehammer down, you demolish another old story. When one wall is crumbled at your feet, you move onto the next until all four walls are debris, and the things that have controlled your self-worth are destroyed. You are unhindered by walls. You are free.

Let's make a pact right now. When a friend disparages herself based on her outward appearance, lets redirect her and remind her of all that is right with her. Instead of jumping in with our own woes of ineptitude, lets change the conversation. It starts with you and me. We can create a ripple effect in our circles. Now, that is positive power.

Life is messy. Love can be messy. Owning a business can be messy. Writing a book is very messy. Don't wait for perfection

before you move forward on your dreams. You are worthy of the life you want. You are worthy of the love you deserve. You are worthy of seeing all your dreams come to life.

Your worthiness is not to be given away or bargained for. It is yours to fiercely defend. It is yours to command and ply to your will.

Now, it's up to you to act.

Remember, a good girl tries to shrink and keep the peace. You are not a good girl.

You are a fierce female, so take up space, and lead the way.

It's time for you to **STOP** and commit to loving yourself unconditionally.

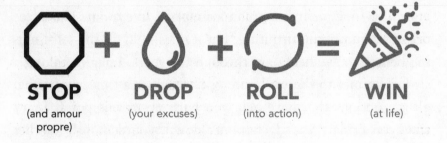

STOP
(and amour propre)

DROP
(your excuses)

ROLL
(into action)

WIN
(at life)

You Are Who You Spend Time With

Would you want your daughter to have your relationship?

I've asked this question of clients for years as they waver on what to do next in their marriages. I've not heard one person answer in the affirmative. I'm a divorce attorney, remember? People don't come to me when they're content.

"Of course not," they say. "I want her to be happy."

There it is. They believe that they are not worthy of being in a happy marriage or relationship. It's not good enough for their child, but it's good enough for them.

Good enough is quicksand. You will eventually sink further into the hole until there is nothing left of your spirit. You will be swallowed up in negativity, unfulfillment, and disconnection. Yet so many stay because the discomfort of what you know is better than the uncertainty of what you don't know. I wish I could make every woman who feels this way truly believe that they will be OK on their own. I wish I could help them see how capable they are.

No matter how scary it is, no matter how fearful you are of starting over, no matter how terrifying it is to tell your partner that it isn't working anymore, you can prosper and bloom on the other side. I can share my story or share the stories of the thousands of women I've helped during my time as a divorce attorney, but unless you believe in your own worth, you will be stuck saying it's good enough.

Good enough is never enough.

Conflict without resolution. Existence without connection. Those are the equations that result in relationship discontent, and if your relationship is not healthy, everything else in your life will be off-kilter. Your job, your friendships, your business, your health, and even your relationships with your children will suffer when your relationship is toxic, unhealthy, or just good enough. In other words, when you are in a relationship that weighs you down, you cannot shine, and you cannot win at life because you become who you spend your time with. Who you sleep next to each night can dictate your mental health, your physical health, and your future. Your partner's energy becomes yours, and no matter how much work you do on your own healing, if they don't grow with you, your light will be dimmed.

My light went out completely at one point in my life. For two decades, I've watched couples uncouple, but it just hits

differently when it's your own. Rock bottom happened in the most romantic city in the world. I had always wanted to go to Paris, and I finally made it there, but everything was wrong. When I had to escape to a confessional in Notre Dame to get away from him, I knew the end had arrived. But I stayed in that marriage a little longer because I desperately wanted to believe it could be fixed.

A few months later, it was a beautiful day, and I was at my son's baseball game. On the outside, all looked well. On the inside, I was the most broken I'd ever been, and the shame was like a black mold on my soul. My second marriage was a failure. The marriage that was supposed to work was done. On that gorgeous spring day, desperate for guidance, I sat down next to my first husband's new wife, a clinical psychologist. I really didn't need her answer though. I had already reached the end of the internet researching, and I didn't need anyone with a degree to tell me what I already knew. My second marriage was a failure, and I would have to tell people soon.

The shame was heavy and deep. My marriage was so short that we didn't even have a chance to use the gift card we'd received for family photos. In that moment, I asked her for some sign of hope that maybe our marriage could be saved, counseled into compliance, or medicated. I knew the answer, but I asked anyway. I was desperate to cling to something because I was also thinking:

What would people say?
What would people think?
I was going to be alone.
I wasn't worthy of being loved.

I was a business owner. I was a strong woman. I was independent. Yet, over the course of eighteen months, I was somebody else. I was short-tempered at work and snapping at those around me. I withdrew from friends and family. I was a stranger in the mirror. My spirit was shattered.

In that second marriage, there were so many red flags. I ignored them all. I made excuses, and told myself that no one was perfect. But the night when words that were previously so foreign to me came out of my mouth, I knew if I didn't leave, I would hate the person I'd become. The night when I picked up a fork and threw it so hard at the floor that it left a hole in the hardwood was the moment I realized I didn't recognize myself.

I eventually walked away because alone-and-at-peace was better than together-and-at-war. My first husband and I had worked so hard to coparent as a united front to insulate our son from conflict, so I'd be damned if someone else was going to expose him to chaos. It wasn't going to happen on my watch.

It doesn't matter how successful you are or how much money you have. It doesn't matter how many initials you have after your name or how many diplomas hang on your wall. It doesn't matter, because when you are in a bad relationship, it will destroy you from the inside and out. There are no exceptions.

Your sense of worth, your soul, and your happiness cannot stay intact if your relationship is flailing. You must love yourself more than you hate being alone.

Follow the Relationship Flags

There are always red flags. We often ignore them because the truth is hard. After two decades of helping couples break up, I can

say the cause of breakups is always the same. They happen re-gardless of income level or whether a couple lives in the suburbs or city. I've seen breakups in short marriages and long-term rela-tionships. I've seen so many women say that they waited for the kids to get older, only to find themselves twenty years into a mar-riage that fell apart at year five. It breaks my heart to think about how much joyful living they lost because they waited so long. You can't change the past, but you get to change your future.

Recognize the signs early. Pay attention to the red flags. They are not in your imagination, and you are not going crazy. If your relationship has any of these signs, it's a tell that something needs to be fixed. And if it can't be, then it's time to move on so you can move up.

- Broken Trust – Building trust after it has been broken is hard work. It can be done, but it takes time and effort. If there isn't trust, there isn't anything else worth fighting for.
- Lack of Vulnerability and Intimacy – This is both physical and emotional. A lack of either can create a wall between the couple. This is when you hear someone say they are living like roommates. The detachment is on a soul level. The hard conversations are where connection is made, so don't sweep it under the rug just because it's easier than the conflict.
- Lack of Respect – You can't receive and give love when there isn't respect. It's as simple as that. Respect should be there on good days and tough days. It shouldn't ebb and flow.
- Physical abuse – A slap, a push, a shove, or anything worse is a red flag of the largest magnitude. Seek out help now and create a safety plan. You didn't deserve it. You didn't provoke him. You don't need to stay.

- Financial Transparency – Money causes major conflict between couples, and if left unresolved, it could be the demise of the relationship. Make sure you both know what's coming in, where it's going, and how you agree to spend discretionary income.
- Substance Abuse – From substance abuse stems financial issues, resentment, denial, and anger. If undealt with, substance abuse will be the undoing of your relationship. Professional help must be sought.
- Just fine – A "just fine" relationship is never just fine. There is always something missing. Don't fool yourself into believing a relationship that is "just fine" is healthy. It often means you are living in a numb state of being.

You shouldn't have to walk on eggshells. You shouldn't have to make excuses for your spouse to your friends and family. You shouldn't have to change your own behavior so as not to upset them. You shouldn't have to beg for their attention.

I've gone through two divorces. Each marriage was very different from the other, but the common denominator was the feeling that tugged at my heart and told me something needed to change. I knew deep down that the relationship I wanted and the ones my soon-to-be exes deserved, were different from what we were living.

Making the decision to end a relationship, especially one in which you have a shared history, is so damn hard. Letting go is hard. It's messy. There is so much untangling. Like a bunch of necklaces thrown together in a drawer, it's chaotic, complicated, twisted, and knotted.

But living your whole life in a relationship that has run its course is a tragedy.

Chapter Sound Bites

- You don't need to lose weight, earn more money, get a more fashionable closet, or outwardly do whatever else you think you need to in order to earn your worth.
- Who you sleep next to each night can dictate your mental health, your physical health, and your future, so choose wisely, and be willing to release them (and yourself) when it's time to let go.
- You must love yourself more than you hate being alone.
- You are worthy exactly the way you are today.
- **STOP and assess** your *amour propre* (your self-love).

Stop and Listen

Your heart knows things that your mind can't explain.
—ANONYMOUS

The woman in my conference room fidgets with her ring, twisting it as she looks around. Her gaze lingers on a picture on the wall that says, *Today, you are exactly where you are supposed to be. What happens tomorrow is up to you.* She brings her palm to the corner of one eye but there isn't anything there to wipe, not now anyway. Finally, she draws her breath in and exhales the question that has been on her mind for months. "How do you know?"

You see, the person sitting across from me might always be different, but the look in their eyes when they ask this question is always the same. Their face is split between hope and fear. I've answered this question at least once a week for the past two decades.

I am a divorce lawyer, but their inquiry doesn't have anything to do with the law. I would argue that their question doesn't actually have anything to do with divorce. Rather, they want someone to tell them what to do. They want someone to clear up their

confusion. They want someone to slide a piece of paper containing an answer across the mahogany table so that they can sleep again at night. They want someone to make the tough decisions for them.

I didn't go to law school to answer this question, and you didn't pick up this book to read about divorce, but at the root of every inquiry of what's next, whether it's in your relationship, your career, or your life, there is a moment when you ask yourself, *what do I do now*? You've reached a breaking point. You find yourself at a crossroad. You need to decide to go right or left, forward or back.

The one thing you learn in law school is that the answer to every question is, *it depends*. It applies here, too. It depends on who you ask. It depends on what you want. It depends on whether you've resigned yourself to accept the status quo. (Although, if you are reading this book, I know that's not the case.) It depends on whether you're ready to get really uncomfortable.

It depends.

Your truth, for example, is very different than your friend's truth. One way isn't right and the other wrong. You can't take a quiz or flip to the back of the book for the answer key. Your paths are different. Your truth is unique. It's supposed to be that way. But getting to your truth is where the challenge lies. It's why so many women get stuck. They are suspended between two realities—one, in which they know they want something different; and the other, in which they can't take the first step towards change. The paradox is unshakeable because we've spent so many years conditioned to be people pleasers, peacekeepers, and pacifists.

This is the place where the Hs collide; your Head and your Heart suit up for war. Like in any war, the opposition digs into

their position. Each side is determined to win and resolute in its conviction that its adversary is wrong.

So, when someone is sitting across the waxed, wooden table, and they are looking to me for their truth, my answer is always the same.

"It depends," I pause, "on who you listen to."

Meet Helen and Harley

I'd like to introduce you to a couple of dames, Helen and Harley. They are inside you. You know them both well, even if you've never officially been introduced. So, let's get reintroduced.

Helen is a crossing guard in a neon yellow vest which has the word *guard* written across it. She holds a stop sign out in front of her, and in the other hand she has a circular sign that screams "Slow." A whistle hangs from her lips so she can blow it fast and forcefully whenever she senses danger. Helen loves to remain in control. She wants to protect you at all costs. Helen is a watch-dog, a rule follower, and a color-inside-the-lines type of lady. If she can't outright prevent you from skydiving, she will evaluate all the risks that could come from it. Helen is your head.

On the other hand, Harley adorns a bohemian-chic dress in a soft, neutral hue that is lavishly embellished with crystals and pearly beadwork. A crown of flowers sits on her head and her wrists are stacked with beaded bracelets. In one hand, she holds a quill ready to write your future. Her other hand is outstretched, inviting you to join her in a field of wildflowers. Harley wants you to soar. Harley trusts that your journey, no matter how hard, uneven, or tumultuous, will lead you to a life of authenticity and happiness. Harley is your heart.

Most times you are confronted with a choice, Helen and Harley clash. They are rarely a united front. They won't join forces to pave your path because they are so vastly different. Their dichotomy is part of their resolve.

Helen is commanding in her reflector vest. Her voice bellows and booms and her whistle screeches. She waves her arms with the signs in her hands and demands that you listen to her and heed her warning. She tells you she is protecting you. She tells you she will keep you safe. She tells you to step behind her where nothing bad can happen.

Then there is Harley. She sends subtle signals. The "red flag" is not just some innocuous thought, but a guiding light. The churning in your stomach is not an upset stomach, but a reminder to pay attention to what doesn't feel right. The flutter in your belly is a spark telling you that "someday" should be now. But Harley won't compete with Helen. She knows you'll make the right choice if you are paying attention. The problem is, most of us are not. Most of us let Helen lead the way to shelter even if we really want to stand in the rain with our arms raised to the sky with Harley.

The woman sitting across from me in the conference room raises an eyebrow and squints at me, as if she didn't quite hear me correctly. She nervously laughs. "I don't know those women," she says and her lip curls up into a partial grimace. "Are they lawyers in your firm, too?"

Most of us make decisions logically, rationally, and responsibly. It's the adult thing to do. It's as adult as buying a mattress. The small voice buried deep inside that started you on a path of speculation and contemplation gets trampled on and tossed aside. It gets disregarded and deemed irrelevant, irrational, and reckless because Helen's voice is loud and piercing. She is a stubborn

old hag, but all her chatter is just a distraction from the real thing going on inside you. What would happen if you followed Harley's gentle guidance instead? What if you stepped out from being shielded by Helen into the wide-open space where Harley resides?

"I'm just so confused," the woman in my office says. "I'm trying to figure out what to do. I came to *you* for advice."

And therein lies the problem. She wants me to give her an answer, and I'm about to lose her.

When you are faced with a pivot, decision, or "what's next" moment, you shut Harley down because she's barely perceptible if you're not tuning in. Instead, you ask friends. You ask Google. Maybe you go to a tarot card reader. You crowdsource all the information you think you need to make a well informed, thought-out, practical decision. You let Helen control the narrative. It's the adult thing to do. And when you accept Helen's protection, you shut Harley out, and with her, you shut down what lives in your heart—your intuition, your gut instinct, your inner knowing, your sixth sense, or your second sight. (Call it what feels right to you.) For our purpose today, I'll call it your heart because therein lies the source of everything you need. In other words, you have all the information you need to make a decision, but you won't hear the answer until you tune into the right channel.

The distance from your head to your heart is a mere eighteen inches. Yet, they are a galaxy away from each other. Your head's purpose is to keep you safe, and your heart's purpose is to watch you fly.

You can't do both.

You can't soar with a weighted vest holding you down. There are whole institutions, such as Heartmath, studying whether the

heart knows better than the head what is best for a person. They've been at it for thirty years, and they've shown that when we slow our minds and tune into our deeper, heart feelings, we can connect to our intuition and that our intuition is our guide to decision-making. When we make decisions from our intuition, we make more intelligent decisions from a deeper source of wisdom. When we allow our heart or intuition to lead, we are more creative, synchronicities in our life multiply, and we can flow through life rather than fight against it.

When we do finally allow our heart to guide us, the voice in our head might get quieter for a moment. Helen might eventually stand there in all her bewilderment and proclaim, "Well, I'll be damned. That was the right thing to do." Stay alert though, because tomorrow, she may speak up again, and it will be up to you to say, "Take a seat dear head, our heart is speaking."

It's tempting to allow your head to steer the ship because we've been so conditioned to do the responsible, reasonable things. If Whitney Wolfe Herd, founder of Bumble, stayed quiet instead of suing her previous company for sexual harassment, she may not have been inspired to combat online hate by creating a female-friendly dating app. And yet, when she took her company public, that app resulted in her becoming the world's youngest, self-made, female billionaire. Trading in a surfboard for some skis might have been the responsible thing to do when Bethany Hamilton suffered a shark attack as a teenager, but instead, she went on to become one of the leading professional surfers of all time. Malala Yousafzai could have been silenced after being gunned down by the Taliban for speaking out about girls' education, but instead she went on to write books, become the youngest recipient of a Nobel Peace Prize, graduate from

university, and continue her work on behalf of girls. If Jamie Kern Lima had given up when a potential investor body-shamed her for not looking the part of someone in the beauty industry, she would not have gone on to build a beauty empire focused on helping women with the same skin struggles she coped with. When life knocked these women down, the sensible thing for them to do would have been to back down, bow out, and throw in the towel.

Instead, they rose through adversity and challenges. They refused to accept their fate as something that happened to them, choosing instead to mold their futures according to their own visions. They are all extraordinary women, and yet they are also ordinary. Their success did not come from luck. At some point, each of them decided to ply their unique challenges to their will. You have that same power.

Women are capable of changing the world. We can lead, create, innovate, overcome, and conquer. Those that do have rejected the notion that it is impossible. They've refused to accept regular as their lot in life. At one point, they all had to turn the volume way down on their head, which told them the reasons why they shouldn't go for it. They all had to make the decision to follow their heart. They had to be open to receiving the messages that were meant for them.

You are capable of changing lives around you, but that doesn't happen when you play it safe and small. It happens when you decide you are done following the path laid out by somebody else. It's easy to blame others for keeping you from your potential, but the biggest enemy is within you. The limitations you place on yourself are a far-worse foe than anyone you'll encounter on the outside. The words you speak to yourself are far more potent than anything someone else speaks to you.

When I was in high school, I was in an honors English class. I will forever remember the gut punch I felt when my teacher asked me to see him after school. I was nervous the entire day. I didn't have a reason to be anxious about it, but I felt his energy when he requested the meeting. It felt judgmental and condescending. My instinct was right. When I walked into his classroom, he was scowling, and what he said next broke my heart.

"You don't have any business being in this class. Your writing is not at an honors level." He handed me an essay I'd written. It had a C minus splashed across the top. "I was being generous with this grade."

Writing was what I'd been doing for as long as I could read. Past teachers had praised my writing, but none of that mattered because his insult landed hard. I almost quit, but instead I dug in to prove him wrong. I conformed my style to what he deemed acceptable, even though my own flair died. He called me back a few weeks later.

"This is better." He handed me a paper with a B marked across the top. Then he said, "Did you actually write this, or did you plagiarize it?" Gut punch again.

I lost my joy for writing that year. My writing became clinical and mechanical and I despised his class. He dimmed the bliss I once felt when I put pen to paper. Worse than his words, though, was what I did internally. I almost convinced myself that I should stop writing. I almost persuaded myself that my dreams of writing a book should be set on fire because I wasn't any good. It took some time away from that class to realize that he could not dictate what it meant to be a "good writer." It took more time to reignite the dream of being an author. Eventually, my heart won out, and while this book still may not meet his standards, I hope it resonates with you because that's all that matters. His opinion

could have stopped me cold. And my internalization of his opinions could have changed my trajectory, had I let them.

Your tomorrow starts right now. It's time to stop and listen. It's time to put Helen in her rightful place. It's time to put Harley in charge of your future. If you don't get clear on the internal conflict within you, you'll have a difficult time tuning into the voice that matters most. Instead, you will feel chaotic and confused, and you will stay stuck. You will listen to other people, as I almost did with my teacher. If you stop and assess what it is you really want rather than what is the logical, adult thing to do, you will always find the right answer. You won't need to ask anyone for their opinion. You won't need to scour the internet for a solution. You won't need to take a poll. You won't need the A on the paper. You will mute all the chatter in your head and tune in to your heart.

You don't need a fancy degree to start your business. You don't need a marriage that is horrible to want something more than "just fine." You don't need a friend to travel with you to plan that bucket-list trip. You don't need anything other than what is already inside you. You don't need Helen to protect you.

You've got Harley—a whole, internal hype squad—cheering you on.

STOP and assess who you are listening to.

STOP **DROP** **ROLL** **WIN**
(and listen) (your excuses) (into action) (at life)

Turn Your Decision-Maker Dial to High

When I toyed with the idea of opening my own law firm, I was working in a stable job and making steady income at a firm where my coworkers were like extended family. I had no reason to leave, yet there was something nagging me every morning as I commuted forty-five minutes to work. My son was the first kid to be dropped off at daycare and the last one to be picked up. I was tired and unfulfilled, and I felt like I was half-assing every role I had.

"How do I know leaving my job and starting my own firm is the right decision?"

I wanted someone to slide a piece of paper across the table and tell me what to do. I wanted someone to tell me everything would be OK if I quit my job. I wanted someone to look into a crystal ball and let me know it was all good. Instead, my mind was on overdrive, and I asked everyone I knew what they thought I should do, as if their opinion could pay my bills, generate clients, or run my business.

My head told me every reason why I should take a detour around the danger. She sounded like this:

It's too expensive to start a business.
Clients won't hire you.
You won't have health insurance.
You won't have steady income.
You don't even have an office location.
There are just so many things to do to set up a business.
You hate math.
What if you fail?

My head told me that I had legitimate, rational reasons not to quit my job. Helen was thorough in her duties to remind me of all the things that could go wrong. But on the other side was my heart. Harley knew I wouldn't be happy until I was doing it my own way. Harley knew that being an entrepreneur was in my blood and would be just as much a part of me as being a lawyer was (that is, until being a lawyer wasn't anymore). Remember, just because you wanted to do something years ago doesn't mean you have to want to do it for the rest of your life. Harley knew I was capable. I wasn't really aware of the inharmonious push and pull that was happening internally, but I did know something needed to change. So, I opened my doors from a folding table (because the fancy presidential desk I splurged on didn't fit through the door), and I jumped heart-first into a journey with an uncertain, undefined outcome.

Was it scary? Damn straight.

Was it what I needed to do? Hell, yes.

Have I ever regretted it? What about in the early days when I could barely make payroll or when I didn't pay myself for a month? Or when COVID had me evaluating whether I would have to terminate some of my employees, people who were like family to me? Or when thoughts of the business kept me up at night? No. Even through all that, I knew I was being true to my heart. I have never regretted walking away from what I knew into the foggy waters of business ownership. I would do it all over again. It was all worth it because it was on my terms. I was making the rules which also allowed me to break them anytime I wanted.

A year after I opened my law practice, I was faced with another dilemma. I wanted someone to tell me whether I should leave a perfectly acceptable, "fine" first marriage. I even went to

a psychic for some guidance hoping her tea leaves would offer a solution. I was a little green grasshopper on this personal development journey, and while I could hear my heart, I didn't know what to do with it. I didn't know that I didn't need anything else. My decision-maker dial was bouncing back and forth like a seismograph in the midst of an earthquake. I floundered in my decision because my head told me (as did some friends and family) that I was ridiculous for wanting more from a relationship. When I finally made the choice, I struggled every step of the way because I didn't entirely trust my heart. My head kept interrupting with her unwelcome rationalities. *Why can't you just be happy* played on repeat.

A few years later, I almost stayed in a toxic second marriage because I was concerned about what people would say and think about me. I knew it wouldn't get better, and the toxicity would seep into every part of my life as it had already begun to do. But I still paused because I imagined what people would say. *Something must be wrong with her if she's twice divorced.*

Maybe they were right. Maybe my office landlord, who was also a lawyer, was right when I overheard him one day…

"You don't marry a woman like that. She has her own agenda. She is a mother, and she thinks she can run a law firm too?" I can still hear him laughing.

I questioned whether I was the problem and what my future looked like.

Maybe he's right and I should suck this bad marriage up, I considered. I almost let Helen win. I might still be with the wrong person if I had ignored the voice inside me that was waving a whole row of red flags. Fortunately, Harley was there to set me straight.

"Damn straight, you have an agenda," she said. "Don't apologize for it."

"Damn straight, you'll create a business that helps people move through one of the most difficult times in their lives," she reminded me, "while also being a mother."

"Damn straight, when you make money, you can pour back into the community," she whispered.

"And damn straight, you deserve a relationship that is mutually respectful and loving."

And so, I walked away from the second marriage with my head held high, knowing it was right. By doing so, I honored Harley's wisdom because she sees me better than anyone else.

Was it hard? Definitely.

Was it the right thing to do? Absolutely. Helen eventually patted Harley on the back and said, "Phew. That was a close call. I probably should listen more and ruminate less."

Money, other people's opinions, logistics… none of that matters. Those things can be figured out. What you need to pay attention to is what makes your stomach flutter or heart rate speed up. You need to tune into what excites you even while it also terrifies you. That is your answer. That is your decision-maker.

That is the only thing you need to know to take a step forward.

To quit the job.

To start the business.

To move or not move.

To walk away from a relationship.

That is all you need to know to make the decision, to choose the path, to do the scary, bold, terrifying, fierce thing. This is the answer to, *how do you know?*

"Maybe if you work really hard, one day you can buy a building, too," the landlord lawyer said to me one day. "Maybe, you'll

have all this, too." He gestured to the office around him. I bought two buildings down the street and moved my business there.

Damn straight I have an agenda.

As should you.

Chapter Sound Bites

- The chatter in your head is just a distraction to keep you safe and small, and it derails you from the real thing going on inside you.
- Pay attention to what makes your stomach flutter or your heart rate speed up—those are your internal guides, and you need to follow them.
- You have all the information you need to make a decision, but you won't hear the answer until you tune into the right channel.
- You can't soar with a weighted vest holding you down.
- **STOP and assess** who you are listening to.

CHAPTER 4

Stop and Reflect

It's very exciting to feel like a new woman
with a new identity.
—TRINNY WOODALL

"What are you doing?" Jay asked me one day as I wandered from the kitchen to the family room and back again without a task or aim. I had no idea. I didn't know what to do with myself.

Laundry was done.

Dishwasher was emptied.

The house was clean.

I literally didn't have a thing to do.

My son had just turned sixteen years old. Leading up to his momentous birthday, we had spent a lot of time together. I'd driven him a half hour to school and home again every day since he'd been in preschool. I drove him to sports. We watched movies together. We went to the gym together at 5 a.m. We had a lot of time being Mother and Son. That is, until he got his license and a car; all of a sudden, his freedom was a portal into my identity debacle.

My role as a mother had been shaken, and I was not handling it well.

He didn't need me. Sure, he still needed me to prepare his eggs in the morning, but even that was waning when I found dirty sauté pans caked with yolk in the sink. He could drive himself to school and sports, and we didn't get that time to talk in the car. He started going to the gym with his friends. I felt like I had lost him. My job as a parent got really murky, but it wasn't the first time.

The first Labor Day after my divorce, my son, then two years old, was with his dad. They went camping for the weekend, and his dad sent me photos of our son eating marshmallows over a campfire, splashing in a lake, and fishing. My ex did everything right in sharing those moments when I wasn't there. However, when those pictures came through, I crumbled to my knees. Quite literally. I was in the kitchen of the condo I was living in, and my phone alerted me to a message. When I opened the pictures, I smiled at my son's chubby face and chocolate covered cheeks, and then collapsed.

I was missing out. I wasn't there to rinse the sand from his bottom or to wipe his sticky marshmallow-coated fingers. I sobbed for hours. I doubted every decision I'd ever made. I felt selfish because I was the one who had asked for the divorce. I felt like an awful mother. I was ashamed. My grief consumed me that entire weekend, and I didn't leave the condo. I felt bad for me. I felt sorry for what my life had become. I didn't know what to do so, I turned to the only thing that brought me comfort over the years (no, not martinis) and I flipped open my laptop.

Writing has always been an outlet for me. I've been putting words on paper for as long as I could read. One of my earliest childhood memories is annoyingly asking my parents to read every street sign or billboard we passed in the car. I desperately wanted to read, and with that came my obsession with words.

Whether I was journaling or writing poetry or short stories, I was always expressing myself through my pen. It was part of my identity. Creativity energized me. It was an escape, and a way to be so beautifully and genuinely vulnerable.

What I couldn't speak, I could write.

Something happened after I walked down the aisle at twenty-seven years old. I stopped writing. I don't really know why. I just did. There were other things to do once I was a married woman. We entertained friends. We spent weekends at a country club where I never quite felt that I fit in. We vacationed. I sound ungrateful for my idyllic life, right? That's how I felt too; feelings of unfulfillment and detachment churned within me. But I lost my words in that marriage. I don't blame anyone except myself. I could have made the time, but I didn't, so my pen dried up. It was almost as though writing was the place where I could expose my real self, but in that period of my life, I couldn't stomach vulnerability because I didn't want to face what it was showing me.

So, on that weekend so very long ago, when I was desperately missing my child, my identity as a mother shifted from all-consuming to every other weekend. I stared at an empty document on my laptop, and I let the words fall out of me. I didn't know who I was or whether I had anything worthy to say. I didn't know whether I was deserving of love or even of being a mother. It was too hard to face those questions. It was too hard to lean into the pain. I wanted to disassociate from it entirely. If I didn't think about it and I pretended it didn't exist, I would be OK. So, after I smashed the keys for hours, I hit delete and erased every word. It was easier that way. There wouldn't be any evidence left behind to remind me of all that had gone wrong since my magnificent, ballroom wedding in Boston five years prior.

Instead, I began writing a book about starting a law firm. It was safer. It was all I could muster. But it was still significant because it was the day I started writing again. My first book was written during one identity fiasco, and this book was written during another, fourteen years later.

Our lives go through phases. We embrace different roles at different times. Like anything else, some of those roles will end. When they do, watch out. An identity crisis could be lurking just around a completed "to-do" list.

When you cut through the façade of your routine and sit with yourself, it can be an emotional experience. Who are you if you're not that role you've identified with for so long? What is your purpose if not to take care of someone else? What were you put on this earth to do?

Your Soul Connection

Who are you?

A mother? A wife? An ex-wife? A lawyer? A doctor? A hair stylist? A coach? A sister? A daughter? A teacher?

You've acquired titles along the way, and with them comes a predetermined notion of what it looks like to fulfill those duties. But what happens when the role changes? What happens when your children turn eighteen, go to college, get married, move across the country, and have their own kids? Who are you then? What happens if you are fired from your job or you retire? Who are you? Your identity is so much more than any of these titles, no matter how hard you worked for those degrees or how many behinds you wiped. Yes, you are even more than a mother.

Being a mother is a role. It's part of your existence. It's important. It's life changing. Yet, it still isn't your identity because while you will always be a mother, the all-consuming season of that role will come to an end. I promise you that your child does not want you following them to college. Yet, I regularly see women making motherhood their identity. The women going through divorces who have disregarded their identity for years feel lost when they no longer have their children to cater to every minute. So, they cling to the conflict in the divorce that prevents them from moving forward and creating their future self. They hang onto the blame game, and they never find themselves.

They have an identity dilemma.

You don't need to be divorced to have this identity disconnect. I have married friends who won't take time to refill their cup because they don't want to miss even one soccer game, or they don't believe their spouse can handle getting the kids to all the activities, or they don't want to ask for help from family. For whatever reason, they believe they are the only one who can do it properly. So their resentment towards their spouse grows, ultimately taking a toll on their marriage. They tell their friends they cannot plan anything during soccer season, basketball season, and baseball season, but they are happy to meet up for brunch the one day they are available eighteen months from now when they have exactly two hours and fifteen minutes of free time. They are burnt out. Their mental health is trashed. But they'll be able to say they attended every single game, as if there was an award for the weariest mom.

They have an identity dilemma. (And if you're one of my friends who feels called out by this description, I said what I said. Now let's plan a girl's weekend. I love you.)

Maybe you don't have children, and your job is where you bury yourself. Workaholism is not just reserved for men. Women get lost in their careers all the time. You want to prove that you are capable. You want to prove that you are successful. You want to prove that you don't need anyone's help. I've seen this happen with lawyers and doctors whose entire existence stems from the initials after their name. My husband, a retired police lieutenant, said it was prevalent with officers as well. Maybe what you do is who you are. It's tangled up and twisted together. Your career is your baby, and so you also have an identity dilemma.

For a while, I did too.

Who you are is so much more than what you do, and it's more than a role you've assumed through marriage, childbirth, or an employment contract. Who you are runs deep. When you've rediscovered it, it will fulfill you, drive you, and give you purpose through all the seasons of change. It will be the center you come back to through every transitional time.

Who you are is your compass, and she will always lead you home to yourself.

A human experience without soul work is a squandered opportunity. Your soul work comes from a place other than to-do lists, carting kids around, or revenue projections. Soul work is what happens when you let go of the external stuff that needs to get done in favor of what brings you utter and undeniable internal joy.

Nature is where some people feel most at peace. If you've been to the Grand Canyon, you know the experience of looking over the edge into something so glorious it renders you speechless. That's soul work. It inspires people. Others feel most connected to their soul through movement. Musicians will say they get lost in the notes or beat, and when they are playing, it's like

nothing else exists. That's soul work. An artist fills their soul through painting. An actor charges their soul when they step on stage. Many writers will share the same almost out-of-body experience where the words flow without effort. And when they go back and read what they've written, they don't remember typing the sentences, and yet they are astounded by the wisdom within the phrases.

Soul work is not a title or a role.

It's not a chore.

It's not something to be checked off the list.

It's a purpose.

It's a purpose that materializes outwardly only after you turn inward. It's a compass that points you in the direction of where you should be going. That is your soul identity. We all have it. But so many of us get caught up in the day-to-day that we lose what it was that once lit us up.

Have you ever been so enraptured in a moment that you forget about your phone and the dirty laundry because you were completely and utterly present? What were you doing? Where were you? What did you smell? What did you feel? What did you see? If I think about those moments, I am usually in nature, in the flow of writing, or on stage speaking. All time stops. I'm exactly where I'm supposed to be, doing what I'm supposed to be doing. It's as if something else takes over in those moments. I'm enjoying the most human experience. I know I'm living my purpose.

Last year, I tagged along with my husband to Vegas. While he attended a conference, I kayaked at the base of the Hoover Dam and spent the entire day racking up miles, sore muscles, and some incredible views. During that day, I was completely present. There was nowhere else to be except in the moment. I didn't have cell

phone service. I didn't have anyone to talk to. I didn't have any-where else to be. I paddled and allowed my thoughts to wander. It was like a meditation in motion. I let thoughts come and go. I had so many epiphanies during that time. There wasn't any external chatter from life outside. It was just me, the river, and a paddle, and the current lead the way. It was blissful, and the clarity that came from that time alone with my thoughts was existential.

Contrarily, think about doing something that sucks your soul dry. Think about how you feel when you walk into that job you absolutely despise or meet with someone who is a psychic vam-pire. The thought creates a physical reaction. You might get a knot in your stomach, or your shoulders tense up, or you feel anxiety. It changes your mood and how you show up in the world. You can't always avoid unpleasant situations or people, but you can make a conscious effort to minimize those adverse effects by doing soul-fueling things just as frequently as the soul-sucking ones.

Think about the people you most admire. I bet they are living their soul work. I have a friend, Erin Hatzikostas, who left the corporate world to coach and inspire others to be their most au-thentic selves in their workplaces. In her former c-suite executive job, whenever she was asked to give a presentation, she would bring her personality to the stage. She would not conform to what was typical of corporate talks. She would literally dance on stage at stuffy conferences despite her superior's respectful re-quest that she rethink her approach. Authenticity is her soul work. Now, she speaks to thousands of people every year, and she continues to do it her way—with humor, awkward dance moves, and major authenticity. Audiences love her.

I previously interviewed Kara Goldin, CEO of Hint Water, on my podcast. Her dream to start a beverage company wasn't because

she wanted to run a super-successful company. It stemmed from her desire to create a product that she felt good about giving to her family. What followed was a relentless drive to help people get healthier by offering them something different than soda. It was her soul work.

Lara Knight is a fashion designer who has designed gowns for A-list celebrities, as well as for everyday women. She pours her soul into her creations, and you can feel the passion behind every gorgeous masterpiece that flows from her fingertips. Her soul work is bringing something beautiful into this world and making every woman who wears her work feel like a queen.

For these women, their passion became their work, but it doesn't always have to be this way. You can find soul work in a personal goal too. The litmus test is simple. If you get excited thinking about it, talking about it, and doing it, it's your purpose. What do you find so much pleasure in that you lose track of time when you're doing it? What have you always said you were going to do one day? Think about what you love so much that you'd tattoo it on your body. (Your kid's faces are not allowed for this exercise.) I have multiple book tattoos. It's been a constant in my life. What would you be willing to etch into your skin? Find what lights you up, proclaim it, and watch your soul soar.

STOP and reflect on who you are.

STOP
(and reflect)

\+

DROP
(your excuses)

\+

ROLL
(into action)

=

WIN
(at life)

You Complete You

"You complete me."

I absolutely despise this movie quote:

No, Jerry, what we have here is an identity dilemma and some major codependency issues to boot. It is not your job to complete anyone, and it certainly should not be your goal to find someone to complete you. Staying, committing, or marrying because you are looking for someone to complete your life is setting you and your partner up for disappointment. No one can be everything to someone. If you are not clear on who you are and what you want, you will allow someone else to define you. And to those who are married to their work and don't know who they are outside of it, I'm talking to you too.

I once had a boyfriend tell me I was "too independent." I took it as a compliment; although I'm confident that isn't how he intended it. Here's the scoop: unless you are healed, healthy, and secure in who you are, you are not showing up as your best self to any relationship. By the time I met my current husband, I knew exactly what I would and would not put up with. I knew my values, and I knew what dealbreakers I would not accept. We were on our second date, and before we went any further, I needed to be sure we were aligned. I went through my mental checklist, and my clarity around who I was and what I was looking for was a gift to us both. We were both navigating parenting as divorcées while working full time, and neither of us had time for dead ends. I wasn't looking for a lifetime mate, but I wanted to be certain that anyone I put time and energy into was an aligned match. I didn't need it to work out. I didn't have any expectations. I was so comfortable and sure about my identity that being alone was not a threat; it was just a state of being.

Have you ever brought yourself to a fancy restaurant, got-
ten a table (not a bar seat where you can talk to someone), put
your phone away, and dined alone? Why do some people find
it so difficult to be alone? To travel alone? To eat alone? Hell,
to even go the bathroom alone? What are we are trying to
avoid when we drag a friend along to the bathroom with us?
If it's for safety, that's one thing—circle the wagons to keep
each other safe. But when it's just because we need to have
someone there so we don't feel alone, that's something else.
Why is being quiet with our thoughts a thing to be avoided at
all costs?

By the time you finish this book, I want you to challenge your-
self to go out by yourself to eat at the nice place. Fight the urge to
invite your friend or partner. Make a date with yourself. This
small, simple act is so empowering. If you can overcome the ini-
tial awkwardness you may feel when you first sit down and don't
have anywhere to look, by the time dessert rolls around (yes, or-
der dessert too), you'll feel like you can do anything. Snap a pic-
ture of your glass of bubbly or crème brûlée, and tag me in the
photo on Instagram or Facebook (@msreneebauer #shewhowins)
so I can celebrate your win with you.

Use this time to figure out who you are all on your own
without someone else's influence guiding your decisions. Pay
attention to what you order, what you think about, and how
you feel. Do you select a different restaurant than you normally
do when someone else is with you? Do you order different types
of food? Do you interact with the servers in a different manner?
How do you show up as a party of one? Because you complete
you.

Now, celebrate that.

An Unbecoming

Your identity is not a one-and-done deal. It grows, changes, and develops. It shifts, morphs, and sometimes even disappears. For me, grief and loss of missing my son opened the valve to my journey of finding my new identity. For you, it may be something else. It could be pain or joy. It could be time spent in meditation. It could be time spent alone. I can't tell you how to find your identity, but I know what it looks like when it's lost.

If I asked you what lessons you learned last year or five years ago, could you answer the question? The person you were five years ago should not be the same person you are today. We are meant to grow and learn along the way.

The journey to my identity was not linear. I was lost. I found myself. I went off course again and dragged myself back to center. It's still an evolving process. It's been a long time since that Labor Day when my son was little, and I felt like a failure. Through this book, I dare say that I now have the courage to share what I couldn't when I hit "delete" all those years ago. My identity shifted with time. It's meant to.

So how do you find your identity? It's easy to tell someone to do the things that bring them joy or that they should tap into their inner child. Those are clichés that fail to recognize that when you find yourself, you also lose a different part of yourself. Finding your identity is also an unbecoming. It means you unbecome who you thought you were supposed to be. You let go of judgment. You let go of other people's expectations.

Unbecoming is hard work, and it means you will let go of who you were in order to become who you are meant to be. Unbecoming means you reject the conditioning from your childhood. You reject perfectionism. You reject the anxiety of failure.

You reject what society tells you to be. You reject the fairytale you've told yourself life is supposed to look like. Once all disillusionments are at your feet, set a match to them and watch the flames burn.

When you have your past conditioning smoldering at your feet, stomp out the embers, because now it's time to get to work on your reawakening.

Who Are You?

I was never a fan of books that had homework assignments and exercises baked into each chapter. I never did any of them. I'm sure you don't need another thing on your to-do list either. However, as I toyed with how to conclude this chapter with some transformational insight, I kept going back to what worked for me.

Creating quiet space to let your mind wander can reap great rewards. Some people can get there through meditation, but I like to have something tangible to read over and over again. I find that when I put pen to paper, doors open to more thoughts which lead to even deeper insights. Sometimes, just letting the pen guide you helps you reach a conclusion that would otherwise never surface. It's amazing to watch feelings come up when you start examining some deep questions.

One of the prompts I share below is to create a "No" list. In other words, what no longer lights you up that you are going to say *no* to from here out? When one of my mentors asked me to create such a list, I was shocked by what came out. The thing that was draining me, exhausting me, and causing me major burnout, was going to court. At one time, this very thing lit me up, but that

wasn't the case anymore. Yet, somewhere along the way, I started trying to convince myself that I still loved it even though my nervous system was telling me differently. I remember laughing when I told her I was putting "going to court" on my "no" list. I told her every reason why I would never be able to follow through on this list even though the prospect of it intrigued me. I had so many excuses for why this exercise shouldn't apply to me.

She just didn't get it. (She actually knew better than me.)

If I didn't go to court, my business wouldn't succeed. (We had our best year once I got out of the way.)

If I stopped taking cases, no one would come to the firm. (Hello, Ego. Nice to meet you.)

If I wasn't doing the work that generated income, we wouldn't meet our overhead and I couldn't make payroll. (Actually, when I had time to focus on scaling the business, we grew faster.)

What I did know was this: If I didn't change something, exhaustion would lead to making poor business decisions and would trickle down to my whole team.

So, after I told her all the reasons why my deepest "no" desire could not come to be, she challenged me to give it a try and see what happened. She also reminded me that if I could say "no" to what wasn't lighting me up anymore, I could make space for what would light me up. And if I was right and it didn't work, I could go back to what I was doing.

She was 100 percent right. I love when someone calls me out on my own bullshit and sets me straight. When I started honoring my "No" List, I had time to put effort into doing things that filled me up, which opened doors to other opportunities. And all my ridiculous excuses never materialized. Shocking, right? Not really.

So, pick up a pen, grab a journal, and let's drop some words on paper. Write whatever comes to mind without judgment. If

you feel inspired to write a lot about one prompt, allow the words to flow. Sometimes we have to say everything that isn't before we land on what is. The few minutes of your time is worth it. You are worth it. Then tuck away what you wrote so you can reflect on it when you need a reminder of what you really want.

This is all about uncovering who you are, what you stand for, and how you want to live your life. Allow your words to fall out of you unhindered by judgment, reasonableness, or rationalizations. This is just for you and your soul. Because what you let out can help you decide what is and isn't for you. It can help you weed through who is and isn't for you. It can help you figure out your next move. Are you ready? Let's get to know you.

- If nothing changed in your life exactly as it is right now, how would that make you feel? What would you change?
- What breaks your heart?
- What brings you joy?
- If you had your dream job, what would you be doing?
- How do you want to be remembered?
- What is your Superpower?
- Create a "No" List. What will you say "no" to from now on because it does not light you up?
- What decisions would you make if you had unlimited resources?
- What does winning at life mean to you?

When you complete this reflection, you will have some insight into what changes you need to make so that you can live a life that feels complete and fulfilling. You will know what bold decision you must pursue. You will know where you should be spending your time. You may even realize who you need to distance

yourself from because they drain your energy and joy. You will know that you can do whatever it is that you dare to dream because you have a superpower that is yours alone. You will start to win because you will have defined winning.

And, you will start to remember who you are: she is fierce. I hope you spend some time getting to know her again.

Chapter Sound Bites

- No matter how hard you worked for your degrees, your identity is so much more than a title.
- Soul work is what happens when you let go of the external stuff that needs to get done in favor of the internal things that bring you utter and undeniable joy.
- Unbecoming means you will let go of who you were, to become who you are meant to be.
- If you get excited thinking about it, talking about it, and doing it, it's your purpose.
- **STOP and reflect** on who you are.

Part Two:

She Who Wins

Drops the Excuses

Drop Your Bullshit

*Once your excuses are gone, you will simply have
to settle for being awesome.*
—LORII MYERS

Children are master excuse-makers.

They grab a toy from a classmate in kindergarten and when
scolded, they point across the room and say, "He wasn't shar-
ing." In elementary school, if they do poorly on a quiz they say,
"The teacher never told us this would be tested." In high school,
if they're caught drinking, they say, "So-and-so pressured me."

They fling excuses to avoid consequences. It's easier to de-
flect, dodge, and divert, as if adults will believe their mistruths.
Their developing brains think excuses will be better received
than owning up to bad behaviors. In adulthood, we like to think
we understand the value of owning our actions. But do we really?
Just like kids, we like to blame others for our misfortunes.

It's not our fault that our lives aren't living up to all the hype.
It's not our fault that we didn't get the promotion. It's not our
fault that our marriage is less than blissful. It's not our fault that
we feel dissatisfied and unfulfilled.

It's not our fault.

Sometimes things happen to us that are outside of our control. When we use that information to further embed the idea that the world is out to get us, make our lives miserable, and keep us small, we are confirming our current bias. We will do everything in our power to sanction that which we already believe is true.

Here's the part you don't want to hear but I'm going to spill the tea on anyway. This is the moment we get real (because fake is not an option). Are you ready?

Your excuses are the reason why you are stuck. Full stop.

To move forward fiercely, you need to assassinate your excuses. If I wanted to do this nice and easy, I would have encouraged you to coddle your excuses. I would have said maybe you can massage or knead them into compliance. I would have disposed of them in a gentler, friendlier way. Excuses are like pesky little mosquitos that like to hang around in large numbers. They never bring anything to the party, but they leave behind unpleasant welts and worse, disease. And they will bite you in the ass if they can get to it.

It's time to swat those annoying pests (ahem, excuses) out of your life. And if that doesn't work, we will point the insect spray right at that swarm hovering around your head and blast them away, because there is no gentle method of removal. You must aggressively and relentlessly exterminate those buggers. No matter the method. No matter the casualties.

You are a fiercer than your excuses.

Gucci vs. Happy

You are not responsible for some of the things that happen in your life—that is true—but how you respond to those things *is*

your responsibility. And when you don't intentionally take control of the narrative, you are allowing those annoying excuses to take up residence in your home and feast upon your dreams.

I've worked with thousands of people and have watched how they handled having their worlds turned upside down and shaken all over the floor. Over the years, I've witnessed some people who have stayed stuck in anger, hurt, and conflict. I've watched others leave their marriages filled with optimism and confidence. It didn't matter who initiated the divorce. It didn't matter if someone had an affair or if there was another cause to the breakdown of the marriage. The circumstances of each person's unique situation didn't play any kind of role in determining how they made it out the other side. I've seen the wronged party make peace with the path their marriage took, while others make war and leave carnage in their stead.

My analytical legal brain (the one law school starved of creativity until now) would have thought the difference would be in the details of their divorce agreements. It would make sense that someone who got more would come out better, right?

Wrong.

Not even close.

I've seen a woman who was going to receive more money in support than I could ever imagine spending in a year, never mind a month, crippled with anxiety because she couldn't fathom how she was going to survive. She brought her ex back to court many times over the years that followed because she believed her ex somehow bested her, and she was determined not to let him have the last word. The fallout from her grudge was devastating. She never dated. She was too busy comparing her lifestyle to her ex-husband's, to enjoy any of what was accessible to her. Her resentment and anger bled her dry of joy. She couldn't shake it. Or maybe she didn't want to change it. Blaming her ex for her

misery was comfortable. It was familiar territory, and she wasn't ready to let go. So, she remained the victim.

On the other hand, I've watched another woman walk away hopeful when she had little more than enough to pay her bills. She never went back to court even though she could have. She sends a Christmas photo card to me every year telling me what has been happening in her life. Her reports are always positive and uplifting. In every photo, her smile reaches her eyes. While getting used to not having her son 100 percent of the time was hard at first, she learned to cherish the time she had him. And she started crossing things off her bucket list on the days he was with her ex. She didn't care that her ex got a big promotion and was able to take their son on a nice vacation that she could not afford. She was happy her son was happy. She didn't just give lip service to the word *happy*. She lived it.

So, what is the difference between these two women? Your rational mind would tell you that their stories should be flipped. The one who was getting oodles of money should feel secure and free, living her best life dripping in Louis Vuitton and Chanel. She had the means to travel the world, fly first class, and drink good champagne. The one with barely enough resources should be anxious and afraid of the future. She should be the one bringing her ex back to court through the years to squeeze him just a little more so her life can be a little easier.

Yet, how they came out the other end of their respective divorces had nothing to do with cash flow. It didn't matter what their visitation schedule with their children looked like. It didn't matter how much was in their bank account. It didn't even have anything to do with their exes. It didn't matter what happened in their divorce at all. Their next chapter was entirely based not on money or legalities, but on their own outlooks. Whether they

returned to court fueled by anger and resentment was determined by their perspective.

Which one would you rather be if you had the choice?

I'd take happy over Gucci any day of the week. I imagine the one stuck in resentment would probably give up her Valentinos for happy too.

Yet, just like in a divorce, when a disruptor event happens to us, it's human nature to get caught up in how everyone else can fix the problem that has been thrown at us.

Some divorcées look to their exes and think, *if only he gave me more, I wouldn't be so angry*, or, *if only my attorney got me more, I'd be OK*. What someone gets or must give has no impact on how they come out the other end of this disruptive event.

Look, for example, at the diet industry. You can walk into any supplement store and have a whole aisle dedicated to "blasting the fat" by taking a simple little pill. It's a billion-dollar industry founded on people not wanting to do the work. The industry spouts misconceptions that your body can be molded from a product rather than from the inside out with nutrition and movement. The industry is literally getting rich off our excuses.

It's the same any time we decide to pin the excuse on somebody other than ourselves. Does any of this sound familiar to you?

"If only my boss wasn't out to get me, I'd get promoted."

"If only I had more money, I'd be happier."

"If only my childhood wasn't messed up, I'd be a better person."

"If only I dropped ten pounds, I'd be content."

"If only (fill in the blank with your *if only* phrase)."

The problem with this thought process is that you are looking externally for solutions. You want your boss, your spouse, or your whoever-isn't-you to figure out the problem you believe you

have. Why give that person that power? Isn't happy a far better revenge?

Now imagine *if only* you blasted through the bullshit holding you back.

Look, assassinating excuses is hard work. It's comfortable and easy to shift the blame. It's easier to stay stuck and look for external reasons for why we can't get moving. When you turn the mirror around and look long and deep at how your excuses are holding you back, you're ready to bypass them. That's the tough part, but you can do this. You can be in control. You can provide your own solutions. It might take some grit and resilience, but it is possible.

You have your own unique brand of bullshit that you lean on when faced with something scary. The problem is, these bullshit excuses prevent you from moving from where you are, to where you want to go. They are the cause of you not changing. They are the cause of your dreams taking a backseat. They are the cause of inaction. Here are the most common:

- Fear – Protecting yourself from discomfort is a natural response to fear. Being afraid of rejection may prevent you from applying for a job or submitting your book to literary agents. Fear of embarrassment could prevent you from pursuing a speaking career. Being afraid of being alone could paralyze you from leaving a toxic relationship. Your fear could singlehandedly be keeping you from winning at your life because, let's face it, no one likes to be afraid. However, what happens on the other side of fear is extraordinary. You realize you survived it. And next time, you set your sights even higher.
- Uncertainty – Not knowing the outcome can hold you back when you don't like to take risks or leave things to chance.

However, uncertainty is part of your life for even the small stuff. You don't know how the day will unfold when you leave the house in the morning. There are all kinds of disruptions that could change the course of your day whether that's traffic, a cancelled appointment, or an angry client. However, when it comes to making big decisions, if you refuse to get cozy with the unknown, then uncertainty of what things look like on the other side might hold you back.

- External Influences – The people closest to you want to see you safe, and often they impose their own self-limiting beliefs onto you. When you let their opinions influence you, that can dictate your decisions to your detriment. Every time you ask someone what they think about a situation in your life, if you are not careful, you could be letting in another voice that does not really know what is best for your heart and soul. The only opinion that really matters in your decision-making process is your own.

- Distractions – You are faced with distractions every day and when you don't wrangle these pesky critters in, they can prevent you from focusing on what moves the needle in your life. Tasks and to-do lists can last days, weeks, and even years. An upcoming tropical vacation can distract you from the fact that your job is sucking your soul dry. A busy calendar can distract you from taking the time to train for the marathon, write the book, or create the business plan that would bring you true satisfaction. The distractions in your life can be quite bossy, and it's your job to put them in their proper place.

- Lack of Self-Confidence – Why do you tell your best friend what an amazing, beautiful human she is, but then not give yourself the same pep talk? Do you look in the mirror and see your flaws before anything else? Confidence is something

you choose. When you focus on what you perceive as deficits, you can't possibly show up in the world as the bright light that you are.

- Imposter Syndrome – Do you self-sabotage because you don't believe you are worthy of success, a healthy relationship, a dream job, or whatever else you want? Do you tell yourself that you are not educated enough, rich enough, or thin enough to go for it? You are the real deal. You are not an imposter. Now, act as if you knew that to be true.

- Perfectionism – The idea that if you cannot do it, complete it, or show up for it perfectly, then you should not do it all, will keep you small. No one has ever done anything perfectly the first time. Allow yourself to be a student of messy.

How many of these have played a role in your life? How many of these prevented you from going for it? How many stopped you in your tracks? Acknowledging your bullshit is half the battle. Often, our fight-or-flight mode kicks in and we don't take the time to evaluate what's happening inside of us. Instead, we just do whatever it takes to reverse that uncomfortable feeling. When you can identify what your favorite brand of bullshit is, you can be equipped with the tools to smash them to pieces. It might sound like this:

I'm afraid of starting my business because of the financial uncertainty. But the payoff of having my own company is financial and personal freedom, and that far outweighs my fear.

Or maybe it sounds like this:

I'm such an introvert that I can't travel to that conference by myself. But I will not allow a label to limit me because the opportunity to network and meet new people, even if its uncomfortable, will be worth it.

The limitations you place on yourself from the stories in your own head can dictate which risks you decide to take or which dreams you decide to squander.

When I got divorced the second time, I looked out at the weeds in my expansive yard and realized I needed to whack some of those dandelions down. But I had a problem. I had no idea how to use a weedwhacker. I was not going to let that stop me, so my Saturday project commenced. I spent at least an hour or two getting the thing started. I spent another hour figuring out how to change the strings. More time went to trying to keep it running. (Who knew it needed gas?) Once it was revved and ready to go, I whacked all those weeds (and excuses) into oblivion. Eight hours later, I had grass clippings up my nose, weed debris down my shirt, and my hay fever was seriously pissed at me, but I did it.

Then on Monday, I hired a landscaper and never looked back. I took control of a situation and decided to find my own solution. When I tried that solution on for size and didn't like it, I found another one.

If we look at situations, life decisions, and game changers on a grand scale, we will get overwhelmed. But once we break things down into actionable, bite-sized tasks, they become manageable.

Just zap one mosquito at a time.

Just whack one weed at a time.

Just pounce on one excuse at a time.

Excuses are meant to hold you back and I promise you that when you bypass your bullshit, nothing and no one can stop you.

You are meant to be and do so much.

You are meant to impact lives.

You are meant to teach and share your story.

You are meant to be expansive.

So, stop imposing limitations on your possibilities. Stop rationalizing those things (or people) that keep you small. Stop justifying inaction. What can you do today to change your tomorrow? What solution can you devise to fix a problem that's plaguing you? What roadblock can you bash through?

It's time to take inventory of your excuses. What excuses come up repeatedly for you? I bet they have been on repeat for a long time now. I want you to visualize cutting those excuses down to size, samurai style. Lift your sword, swipe strong and swift, and leave them on the floor to be swept away by the wind.

You need to bypass your own bullshit so the next phase of the Stop, Drop, and Roll formula is to DROP your excuses.

Once you get brutal with your excuses and DROP them once and for all, you will be unstoppable.

And if you need a little help, I have a weedwhacker I can sell you.

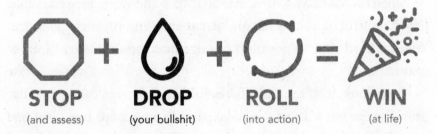

STOP
(and assess)

DROP
(your bullshit)

ROLL
(into action)

WIN
(at life)

You Are the Solution

When you stop expecting other people to fix things for you, you have the power to do anything you want and be anyone you want. Let me repeat that.

You have the power.

When you dropkick the excuses to the curb, you start taking control over your life. And when that happens, you start to win at life.

The attitude you bring to any situation is the key to vanquishing your excuses. The questions you ask yourself are the key to changing your attitude. Let me illustrate this further.

I had a client; let's call her Jillian. Jillian was in a twenty-six-year marriage that was "good enough." They lived in a nice house, drove nice cars, and went on vacations twice a year. Jillian and her husband weren't particularly happy, and there were plenty of things about her husband she didn't like, such as how embarrassing he got when he drank too much at family functions or how he'd disappeared for hours and not tell her where he was. He spent money frivolously while she liked to save. But Jillian would have stayed married forever because the prospect of leaving made her uncomfortable. There were too many variables and too many uncertainties. So married she stayed.

Until one day when that all changed.

Jillian's husband came clean that he was having an affair, and she found herself unwillingly thrust into the throes of divorce. Suddenly, she had to understand her finances when she had never paid the bills or invested money before. She had to contemplate where she would live and who would care for her house because in the past, her husband had taken care of those things. She had to figure out how to plan a vacation if she ever wanted to travel again (which she did). There were too many unknowns that she didn't have control over. She didn't like it one bit, and had her husband wavered, she would have stayed married forever even if she couldn't trust him again. She would live with "good enough" because it was all she had known for so long.

The divorce carried on, and eventually she found herself sign-
ing papers completely overwhelmed and unsure about what her
next chapter looked like. But she didn't have a choice because
this disruption was forced upon her, and she needed to figure it
out. Jillian could have stayed angry. She could have blamed her
ex for not earning enough to pay her more. She could have
blamed her attorney (me) for not getting her enough to maintain
the exact same lifestyle she was accustomed to. She could have
blamed the woman who her husband slept with for breaking up
her marriage. While all of those thoughts most certainly crept
into her mind at some point, she didn't allow them to linger for
too long. She booted them out and chose something different.

She assassinated her excuses. (Not her ex.)

Jillian made a transformation simply by changing the conver-
sation she was having in her head. She initially allowed herself to
have the attitude of, "I won't recover." She had all the "woe is
me" chats with herself (and with me). She hovered in victim
mode, and she asked the questions that required external
solutions.

"How will I take care of the house?"

"How will I save for retirement?"

"How will I date?"

"How will I recover from this?"

These questions pried the control from her white-knuckled fin-
gers because someone had to solve them for her. And if she needed
someone else to provide a solution, she had no power. Enter angst
and anxiety. Jillian could have stayed trapped in this attitude for
years or even her entire life. She could have continued to blame
everyone else for her grief, but she didn't. At some point, Jillian
reached her emotional threshold. You see, this emotional thresh-
old predicts what happens next. She decided she didn't want to

stay caught in excuses and blame (and she had plenty of people to blame) so she decided to reframe her story. She decided to grab the pen and start writing her own next chapter. She started asking different questions and that pivot point changed her life.

"What can *I* do to make sure the house is maintained?"

"What can *I* do to become comfortable with my finances?"

"What can *I* do to start trusting again?"

"What can *I* do to recover from this plot twist in my life?"

She stopped asking, "How will I exist in this situation?" and instead asked, "What can I do to change what no longer serves me?" The shift was ever so slight, yet momentous in impact. Once she flipped the questions around, she started procuring solutions to the things that kept her up at night. Once she started finding solutions, she took back control. That's freedom.

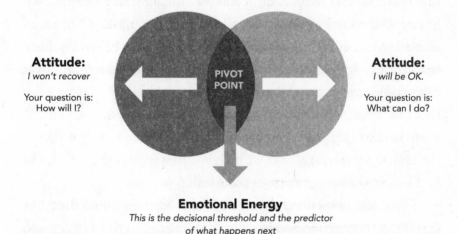

Attitude:
I won't recover

Your question is:
How will I?

PIVOT POINT

Attitude:
I will be OK.

Your question is:
What can I do?

Emotional Energy
This is the decisional threshold and the predictor
of what happens next

The future is where it's at, and the past is old news. There is no longer any room to regret and ruminate on days gone by because you realize you are stronger and more independent than you ever thought possible. This goes for everything in your life. You are smart enough to start the business and scale it to whatever you

want. You are brave enough to stand on stage and tell your story. You are tenacious enough to not let rejection stop you. You are enough—no matter your past, no matter your upbringing, no matter what.

You are ready to DROP your unique brand of bullshit because it's holding you back. Your pivot point comes when you decide that you want to be in control of your life. You reach an emotional threshold wherein you declare that you are done giving your power to others. That could be your boss (start the business), your spouse (go to counseling or walk away), your family (communicate your boundaries). You stop using someone else or a circumstance as a crutch.

Jillian emailed me a year after her divorce. She said she was happier than she had ever been. She said she didn't realize how unhappy she was before, until she was forced into a new reality. She said she loved having control over her own money. She started dating again and was shockingly enjoying it. Jillian changed her attitude and dropped the excuses. She stopped looking over her shoulder into the past and started providing her own solutions to whatever was coming up for her. When she got honest with herself, she even recognized that she was sleepwalking through her marriage, and while her husband had the affair, she had barely shown up for the relationship for years.

When she owned her own role in the breakup, something incredible happened. She forgave her ex. She didn't want him back. Hell, she wouldn't take him back for four vacations a year, but now she was able to understand that the things she'd been afraid of were just excuses. When she dropped the excuses, she dropped the struggle and picked up something much lighter—her joy again.

She was finally free.

Chapter Sound Bites

- Your excuses are the reason why you are stuck.
- When a disruptor event happens to us, it's human nature to get caught up in how everyone else can fix the problem that has been thrown at us.
- It's time to stop asking, "How will I exist in this situation?" and instead ask, "What can I do to change what no longer serves me?"
- Excuses are meant to hold you back, and I promise you that when you bypass your bullshit, nothing and no one can stop you.
- **DROP your excuses**, and become unstoppable.

Drop The Fear

She was powerful, not because she wasn't scared,
but because she went on so strongly, despite the fear.
—ATTICUS

I'd always been uncomfortable when I had to stand at the front of the classroom and give a presentation, or when I found all eyes on me. It wasn't just a school thing.

My baby shower was torture. I loathed all those people watching me unwrap gifts as I awkwardly thanked a second cousin for yet another onesie. I was a wallflower at school dances. I didn't answer questions unless a teacher called on me. I've always been wholly, unequivocally, and irreversibly the opposite of a steal-the-show kind of person. I was afraid I wouldn't say the right thing or would say something to make people laugh at me instead of with me. I was afraid I would look foolish. I am also *not* a risk taker. Sure, I went skydiving when I was nineteen, but I was attached to someone who could pull the cord if I hyperventilated on the way down. I'm a rule follower, people pleaser, steady-the-boat kind of gal... ya know, a "good girl." I've been that way my entire life. Taking risks is looking fear in the face

and saying, "F-off." That wasn't me. I didn't swear back then either. Yet, I seemed to always find myself in situations that had me sweating through my shirt despite my extra-strong, "promise to keep me dry" deodorant.

When I was in sixth grade, I played an owl in a summer theater program. I had to sit on an oversized papier-mâché rock, blow into a recorder, and spout a few well-rehearsed lines. On opening night, in brown and yellow felt feathers and an orange beak, I opened my mouth on cue, but nothing came out. The lights were blinding. The silence in a full auditorium was deafening. And the words were forgotten. So, I did the only thing I could. I brought the plastic instrument to my lips and squeaked out a few offkey notes. From that moment on, public speaking caused rings of sweat to form under my arms and a not-so-minor sensation that I might pass out or puke. I've since learned not to wear silk shirts, and a little food always helps the queasiness. Somewhere out there is a video of me teaching a mediation class, and I'm sure the sweaty sheen of my forehead reflected on the camera lens. I really hope that video got lost somewhere in the VHS graveyard.

Standing in front of people and talking terrifies me. It's the ultimate risk because there is a chance I'll forget my words. There is a danger that I will make a fool of myself. I've done both before. There is a possibility I will pass out, although I haven't managed to yet. Even today, before starting a trial or stepping up to the mic, I get nauseous. I don't hear anything else around me. I become blinded by the thought that I will forget how to speak, or I'll sound stupid, or I'll forget to put an "r" at the end of a word that is meant to have one. (My Boston accent is like a boomerang when I'm in heightened states of emotion.) I've always made the decision to do it anyway (except for the recorder, which I quit really fast).

Blinding fear can dictate your life because it is meant to keep you safe and protected. It protects you from the uncertainty of what happens on the other side of leaving a relationship. It protects you from financial insecurity that you could face if you start a business. It protects you from being alone on a Friday night by telling you not to move across the country where you don't know anyone.

While fear has good intentions, it also has unintended consequences. Fear stifles your dreams. Fear keeps you small and unmoving. It keeps you stagnant. Fear is the great minimizer of your life. Fear holds you hostage from doing the thing that is terrifying and bold. Fear also holds you back from seeing the bigger picture and from opportunities right in front of you. Politicians love to use your fear as their campaign strategy. Some religions do too. So, to get from where you are to where you want to be, you must fiercely conquer your fear. You can't shortcut your fear. You just have to move through it. Is it scary? Of course. Will you survive it? You will. And when you do it enough, you start to actually get comfortable in the uncomfortable.

Fear is the enemy, and you are the victor. A warrior doesn't retreat. She runs headfirst into battle.

What's the Worst that Can Happen?

Think about what it is that you are most afraid of. It could be large-scale fear like being alone, or experiencing financial insecurity. Or it can be small scale, like getting lost or facing a spider. I once picked up a massive, furry, brown spider with my bare hands because I thought it was my son's toy. The drama that followed once I realized it was moving was major. When I couldn't

find it after I flung the "not-a-toy" spider in the air, it was almost enough for me to put a for-sale sign on my house. So yeah, big, furry spiders in my hand are big fear for me. For others, fear is rational and justified, but I digress.

If you're currently a business owner, your fear probably sounds like this:

> *If I hire someone, they won't do it the way I do it, or I won't be able to make payroll.*

If you wanted to start a business, you may think:

> *I don't know the first thing about creating a legal business entity.*

If you're in a job you despise, the thought of quitting may sound like this:

> *If I quit, I may not find something else that pays as well.*

If you're contemplating leaving a relationship, this is likely to have crossed your mind:

> *If I walk away, I'll never find someone else, and how will I take care of the lawn?*

If you're a writer and you've dreamed of publishing a book, you've probably thought:

> *What if people don't like what I wrote?*

If you've always wanted to travel alone, you might wonder:

How can I possibly dine by myself every night?

Fear literally prevents you from doing what your heart wants you to do. What is the absolute worst that can happen? I promise you it's nothing you can't overcome.

Who cares if you fumble your way into business ownership?

You'll survive. And you'll learn with every misstep.

Who cares if you spend a Friday night alone?

You'll survive. And you'll learn how to be with yourself.

Who cares if someone doesn't like your book?

You'll survive. And someone else will love it and need it.

Who cares if you forget your words on stage?

You'll survive. And you'll learn how to adapt under pressure for the next time.

Your worst-case scenario is probably not even that bad in the grand scheme of life. It may even be something you can look back on with awe and wonder as to how you navigated those choppy waters. When I was standing on that stage, speechless and in feathers, I thought I would never recover from the humiliation. But I did. When I desperately searched my bedroom for

the tarantula (hey, it was big, OK?) I thought I would never stop shaking. But I did. When I found myself twice divorced, I thought I'd never overcome the loneliness. I did. When my business suffered massive losses during the height of COVID, I thought it would never recover. It did. You will conquer whatever challenge is thrown at you. You know what is far worse than the worst thing you can imagine? Not moving. The thought of being stuck is really scary stuff. Fortunately, it's within your control to make sure that never happens.

I have a magnet on my fridge that says, "Do one thing every day that scares you." When my son was younger, he was struggling with fear every time he stepped up to the plate because he'd been hit hard by a baseball in a previous game, so I gave the magnet to him. He eventually overcame his fear, and the magnet made it back to the fridge. Whenever I feel deeply uncomfortable or scared at the prospect of something, I know it is meant for me.

Fear is a litmus test. If it doesn't create flutters in your belly, it's probably not big enough. The scariest ideas will have the greatest impact on your life. Fear likes to throw its hat in the ring during game-changer, momentous decisions. Your decision to combat your fear will literally change your life.

Let me be perfectly clear, there is no such thing as fearless. That's a misnomer. No one is fearless. Those who claim to be are lying to you and themselves. They are just masking it better than others. Fearless means it's too small to make an impact. Those are the small decisions that vibrate at a much lower frequency. We make small decisions all the time. They don't keep you up at night or make you doubt yourself. Fear bumps into us when we are faced with big decisions—the ones that induce a fear coma, or shake up your life in the best way possible. Your goal is to

push through the fear and do it anyway. Don't wait to be fearless. It won't ever happen.

Fear is an excuse. It will hold you back if you let it. Listen, I get it. It's hard to overcome fear. It's impact rumbles both in your head and physically in your body. However, dropping your fear as an excuse is the only way to win at your life. You can't live always safe from fear and also find fulfillment. I can already imagine all the gloomy Guses who may disagree with me here. They may say, "but a life of comfort is a peaceful life, and isn't that the goal?"

Hell no. The goal isn't to play it so safe that you never experience the heights of victory born of risk. A life where you are not pushing yourself is a life where you will never experience the elation that comes from overcoming challenges. Playing small means you haven't pushed yourself hard enough to see what you are capable of. Growth comes from adversity. Strength comes from repeatedly flexing your bravery muscles.

Remember, fear keeps you small. Winning at your life means you are taking up space and playing all in, even when fear is making you break out in a sweat. You will survive, and at the same time, you will grow. You may even get everything you've always dreamed of. So rather than worry about what can go wrong, why don't you ask yourself *what can go right?* Are you ready to get cozy with your fear? On the other side, a whole kingdom awaits you, but in this fairytale, you are the hero.

The difference between the woman who does and the woman who does not is what she does with her fear.

I know that fear doesn't have anything on you.

STOP + **DROP** + **ROLL** = **WIN**
(and assess) (your fear) (into action) (at life)

Messy is the New Perfect

When I was in college, I became certified as a step-aerobics instructor. The summer before going back to school, with a job in place, I planned out my routines, created my favorite playlists, and updated my aerobics wardrobe. I loved strapping the belt pack around my waist and miking up. I thought I was cool as whip cream. The reality was I sucked as an instructor. I couldn't keep the beat when I had to lead, and under my instruction, my class looked like disorganized chaos because no one could follow me either. My career as a step instructor was short lived.

Let's face it: no one has mastery of something the first time they do it. Actually, everyone usually sucks at the beginning. Let's make sure our standards are in their proper place. That goes for cooking a new recipe, starting a business, stepping on stage, and everything in between. No one wakes up as an expert in anything. No one rises to the top on an easy, well-defined path. No one is automatically a good teacher, speaker, writer, business owner, or even lover. Being a beginner, and even sucking at something, is all part of the ride. Granted, some people suck less at things (like step-aerobics instruction) but messy action is a prerequisite to proficiency.

Perfectionism is a dream killer, and if you're like I used to be, you think that if you can't do it perfectly, you shouldn't do it all. That is so very misguided.

Messy is refreshing.

Messy is liberating.

Messy is the new perfect.

Thinking that you need to do it perfectly is just fear of being perceived as having imperfections. Do you know of even one person who is perfect? Seriously, do you know of anyone who has it all together all the time? (Not even J.Lo has it all together.) You don't know any perfect people, and if you say *yes*, you aren't really paying attention, because every single one of us is messy. So, why then do we place impossible standards of perfection on ourselves? I certainly don't require perfection in anyone, and I bet you don't either, yet we ask this of ourselves.

When I first decided to take a go at personally branding myself, I knew that much of it included putting myself out there to be heard and seen (gasp!). To be seen, I thought, I need to look put together, blow-dried, and articulate. At the beginning of my personal branding journey, I scheduled a day to record batches of videos, and I was all set up to be a social media queen. The lighting was good. The camera was charged. My outfit changes were nearby. My script was taped to the wall on over-sized Post-its. I thought I had the social media game under my control.

Eight hours later and a gazillion takes erased, I had not made even one usable video. Why? Because in each, I found something imperfect. So I deemed the videos unworthy. All that time and effort was wasted because I was trying to produce perfection. It took me a while to realize that no one wants perfection. I certainly don't connect with people who seem to have it all together. I want the real, the raw, the ugly, and the unfiltered. And that

includes tripping over words sometimes, or having messy hair, or no make-up.

I quit teaching aerobics before I really got started. I was so hung up on being a perfect teacher, that when I saw that I needed some practice, I quit. If I couldn't do it perfectly, I didn't want to do it at all. That self-limiting belief erased all the months of studying and practicing for the certification. I was too afraid of letting people see that I was human.

Perfection is the enemy of your journey. The fear of letting people know your faults could obliterate your dreams. I'll let you in on a little secret: others already know you are imperfect. So why self-reject your ideas and potential before they've been able to breathe, grow, and flourish? Why hold yourself back for fear of being imperfect? You are imperfectly perfect just as you are. Your imperfect humanity is what will set you free.

Now, go do all the things you want to, and don't be afraid to get a little messy.

What If It All Worked Out?

It was October 2021, and I was sitting on the couch in my favorite spot, the far end where I could put my feet up on the ottoman and pile my drinks, snacks, and books on the coffee table next to me. I was scrolling through social media. Jay was at the other end of the sofa scrolling through the news. It was our comfortable routine.

As my finger swiped up again and again, I was astounded by all the incredible women in my feed. They were living boldly and bravely, cheering other women on, while being real and positive about their journeys. It crossed my mind how lucky I was to be

personally connected to so many of these strong women, and then a thought entered my head. What if I could bring some of these women together in one space so we could all connect, learn from, and be motivated by each other? I closed my eyes, and I could see the energy. I didn't know where it would be or who would speak, but I knew what the day felt like.

My head snapped up.

"Babe," I said to Jay.

"Yes." He was still flipping from one news station to another.

"I have an idea." I was energized.

"Uh-oh," he replied. "I'm listening." His face was half scowl and half encouragement.

You must understand that whenever I tell my husband I have an idea, he somehow gets roped in. It tends to cause some chaos in his life, so he had every reason to be hesitant.

I was talking fast. "What if I held an in-person event? Women would come, and we would have speakers, food, workshops, music, and maybe even entertainment and..." I noticed Jay's face was frozen in a half-smile as he nodded at me. I blabbed on for a few more minutes about my vision. When I was done, I waited for his reaction. There was silence and then he said, "Oh, wow."

More silence.

"That sounds amazing." He lowered the remote control. "But don't you think that just maybe, perhaps... I don't know; maybe you have a lot going on right now and this would be better in a couple of years?" He nodded frantically at me probably trying to will me into seeing it his way.

I let his words sink in. He wasn't wrong. There was validity in his logic. I had every reason not to do this. There were so many other things eating up my time. Planning an event would

surely be an overwhelming endeavor, especially because I'd never hosted an event before and so had no idea what I was doing.

"Yeah, you're probably right," I finally said, and I went back to scrolling. He let out a huge sigh of relief and picked the remote up again.

Click. Swipe. Click. Swipe.

The venue for the first *She Who Wins* Summit was booked the next day.

Here's how it went down. I couldn't shake the idea. I was up all night envisioning this event: what it could be and who it could impact. The next morning, I found a perfect space that was large, yet inexpensive enough, to bring my vision to life.

Adrenaline propelled my plans into action and within a few additional days, I had booked speakers and hired a balloon company. (Because is it even a real event without a balloon arch?) The DJ was booked. The dancers were lined up. This event was going down.

Then something happened.

About two weeks later, I woke up having a panic attack in the middle of the night. I was gasping for air, and I shot up to a sitting position. My mouth was dry. I was sweating. Fear woke me out of a dead slumber.

Who are you to plan something like this?
Who are you to ask people to spend money on an event?
Who are you to ask people to give up a Saturday?
No one will come.
It will be an embarrassment.
Cancel it.
You are not an event host.
You don't know what you are doing.

I fell back to sleep with the realization that this event could not happen. I needed to abandon it ASAP. The next day, I sat in my office with my phone in my hand ready to call the venue and tell them I needed to cancel. I rolled my explanation around in my head. I would just tell them it was all a big mistake. I would ask them to send my deposit back and pretend the whole interaction never happened. I figured after I made that call, I would call my speaker friends who all gave me a *hell yes* when I asked them. They would understand.

I put the phone down. They wouldn't understand.

They would tell me I've got this and that they would support me. (Every single one of them had already said that when I told them about the event.)

I knew I was letting fear stop me. I was letting fear stifle my vision. I thought of the women who inspired me to dream up the idea to begin with. I couldn't cancel because then I would have let fear rule. I almost let fear snuff out a dream.

Here's the thing about moments like this: when you get called to do something, it is your responsibility and obligation to act on it. To do otherwise is disrespectful. The moments that inspire us so deeply are the ones we need to pay attention to. Those are messages from the universe, from your instinct, or from some higher source, and they tell you that you are being called to act.

Act swiftly.

Act without doubt.

Act without fear, because it will never be a mistake when you are being directed by your internal forces.

What if everything worked out? What if your dreams were actualized? What if you imagined your life a year, five years, or fifteen years from now, and you were living the most aligned, most beautiful version of your life that you had ever imagined?

Would you say that it was worth it? Would you go through the struggle again to get to that place? Would you tell someone else who is at the start of their journey to go for it? Would you push through your fear again? You already know the answer to that. You would because fear has nothing on you.

Six months later, the first *She Who Wins* Summit sold out. It was a packed room. We had attendees come from as far away as South Africa, and as I looked out into the audience that day, I was filled with emotion for the women who showed up for themselves and for every other woman there.

A few days after the event, Jay and I were in our respective places on the couch. He let out a huge sigh of relief.

"Now that the event is over, we can relax," he said. He spent the weeks leading up to the event driving from one corner of the state to another to pick up swag, set up a photo station, haul décor to the venue, and create name tags, signs, and QR codes. To say he was exhausted was an understatement.

I didn't respond to him. I just smiled.

"Oh shit, babe." He dropped the remote. "What did you do now?"

A few days later, I booked the venue for the next event.

Chapter Sound Bites

- To get from where you are to where you want to be, you must fiercely conquer your fear.
- A life where you are not pushing yourself is a life where you will never experience the elation that comes from overcoming a challenge.
- Your imperfect humanity is what will set you free.
- When you feel called to do something, it is your responsibility and obligation to act on it.
- **DROP your fear,** and get everything you've ever dreamed of.

CHAPTER 7

Drop the Guilt

Guilt is perhaps the most painful companion of death.
—COCO CHANEL

It was a regular weekday. I managed to get my dress on the right way—this is an accomplishment because I once went to court with my dress on backwards; I also once went to court with an orange baby-food stain on the crotch of my cream suit—put on some pumps, and dropped my son off at daycare. Traffic was light, which was a good thing because I was on the highway going a little too fast. I was a little late, and a client would be waiting for me in court. Then, my cell phone rang. I picked up the call on the first ring. When daycare calls soon after the drop-off, it's never good news.

"Hello."

"Hi Renée. Ethan is fine," the daycare provider said, "but he's running a fever and he needs to be picked up. Can you come get him?"

I was calculating how I was going to make this happen, and panic set in.

"Right now?" I asked, hoping that she would say she had dialed the wrong number. Mom guilt set in just for having had that thought.

"Yes, and he needs to be clear of a fever for twenty-four hours before he returns. He's fussy and clearly doesn't feel well." I heard the judgment in that statement. Maybe his nose was runny when I dropped him off, but he always had a runny nose. I had no reason to suspect he had a fever, did I? Was I bad mother for missing it? I didn't have family nearby who I could just ask to pop over and help out.

"OK," I said, but my heart was pounding. I pulled my car into the breakdown lane not sure of what I was going to do next. I took a deep breath. "OK, I can figure this out," I reassured myself, although I didn't quite believe it.

"Hello?"

"Umm...yes, I'll be there in an hour." I was already calculating how long it would take me to get to court, handle the client, and get back to daycare. It would definitely be more than an hour. Who could I call? No one would be able to drop everything immediately and get him before I could.

"Renée? You're on your way?"

"Yes, sorry. I'm here. Maybe, a little longer than an hour." I lied. I would need at least two, and maybe even closer to three hours.

"You really need to get him sooner."

"I'll do my best," I said, and hung up the phone before she could say anything more. Every second mattered, and I didn't have any to spare.

My car idled in the breakdown lane but the only breakdown that was about to occur was the one happening in the driver's seat. I sat there for a few minutes unable to move. I wasn't sure if I should turn around at the next exit or continue to my destination. I weighed my options. I could go to court and get to Ethan in a couple of hours, but daycare would be upset it took me so

long. Then there was the weight of leaving my sick child there when I imagined he was probably upset and needing his mother's snuggles. Or, I could call my client and tell her I wasn't coming, but I imagined her standing there on the verge of her own breakdown because of the turmoil happening in her life too. Plus, I'd have to explain to my boss why we have an upset client after I stood her up. Both choices were damning. No matter what, I'd be disappointing someone, but I could almost live with that. What was tormenting me were the simultaneous inadequacies I felt as a mother, lawyer, and employee. More guilt settled in.

I made a few calls because I couldn't stay parked in the breakdown lane all day. Every second wasted was a second later I would get to my son. Oh, the guilt was thick. As expected, no one could help in that moment, so I wiped my tears, decided on a gameplan, and prayed it would all work out. I pulled back onto the highway and drove even faster to make up for the time I lost during my personal crisis. I showed up at court and rushed through the morning, vaguely paying attention to my client because I was singularly focused on getting out of there and back in the car to collect my sick child. The client wasn't happy, and I felt like I failed her. By the time I got to the daycare, the provider wasn't happy because it took me so long to get there. When I saw my miserable baby with his running nose and piercing wail, I felt like I failed him too.

Guilt is a bitch.

Dropkick Guilt to the Gutter

When I was a kid, I had awful allergies, the kind where my eyes would swell shut during pollen season. To open them, I had to

soften them up by putting hot cotton balls over my lids. I could alleviate some of the symptoms with pills, but there was a major problem. I couldn't swallow those monstrosities. So, my mother would open the capsule and sprinkle it into applesauce or put a tablet into a brownie. The smooth sweetness of the applesauce or chocolate was meant to drown out the bitterness. But those tiny, powerful dots were too strong. (This is probably the reason I don't eat applesauce and find brownies to be my least-favorite treat today). One spoonful after another or one crunch after another, I swallowed the bitter medicine, desperate for relief. Eventually, I learned to swallow the pill.

Like the bitter pill disguised as something sweet, your guilt is disguised as being a dutiful mom, employee, spouse, daughter, or whatever else fits here for you. Pay attention to what decisions you make and how you justify your actions. When you make decisions based on guilt, you are allowing some phantasmic ideal to control your life and ultimately shortchange your happiness. Your child won't need therapy because you missed a few games. Your spouse won't starve if you aren't there to feed them. Your relatives won't disown you if you establish some boundaries. (And if they do, maybe that is what needed to happen.)

I've witnessed countless women stay in unhealthy marriages because of the guilt they attached to decisions that would impact their children. They didn't even realize the disservice they were doing to their children by allowing them to witness daily conflict. They didn't want to hear that an unloving relationship has greater long-term implications than a divorce.

I've seen friends run themselves into the ground and grow hostile and resentful toward their spouses because they didn't prioritize self-care, time alone, or time away with friends who would recharge their soul. I've seen women say yes to doing things they

don't want to do—even when it triggers childhood trauma—because they don't want to disappoint family members.

When you try to live this ideal of being everything to everyone, you put yourself last, and when you do that, you cannot win at your life. When was the last time you took care of your soul? I'm not talking about getting your nails done. That might be care on some level, but I've never met anyone who said getting their nails done rejuvenated their spirit. I'm talking about seeing friends who make you belly laugh. I'm talking about a day when you don't have anyone to take care of except yourself. I'm talking about a day when you are at peace and invigorated because you've done something that YOU love doing. In other words, when was the last time you had a day that was unapologetically, guiltlessly about you?

If the thought of doing something for you immediately sends you into a frenzy or isn't something you can schedule because your weekends are filled with transporting your kids to and for, then you are letting guilt dictate your mental health, and dare I say, even your joy.

If you can't take time to care for yourself now, later will be too late. It's a harsh truth, and if it triggers you and makes your skin prickle, then this message is exactly for you. Guilt over trying to be everything to everyone all the time will be the cause of turmoil in your body, mind, and soul. When you drop the guilt, you get confident in your yesses and nos. When you can confidently say something is a "hell yes" or an "absolute no," you start to make decisions based on your truth at a cellular level. When you say "no," you open up the time and space for a "yes" of the recharging variety. Don't you feel lighter already, just thinking about dropping that heavy burden of guilt?

Making the decision to drop the guilt takes practice. Vanquishing guilt isn't a switch that can be flicked. It's more of a dial. You need to turn the dial down when you find those guilty thoughts dripping into your consciousness. Even when you turn the dial as far down as it will go, there will always be a flicker hovering just below the surface. But now, you've made the decision not to let it be the predominate indicator of what you will or won't do. Guilt is useless, and becoming aware of that helps you get better at dropping it. The next time a guilty thought nags itself into your psyche, recognize it, and then turn the dial way down. You may even want to acknowledge the thought, and then release it out loud to really get clear on its lack of purpose in your life.

It would sound something like this:

I'm feeling guilty because I'm taking time away from being a parent to do something for me, but I know that I will be a better mother when I'm feeling happy and fulfilled.

I'm feeling guilty because I should be working right now, but I know a vacation will fuel my creativity and reinvigorate my passion, which will help my work.

I'm feeling guilty for wanting more in my relationship, but I know that by having the hard conversation, there will be clarity about what needs to happen in the future to change what isn't working now.

When you can put words to the guilt and the "why" on the other side of the guilt, it becomes easier to turn that dial down. Are you ready to let the guilt go so you can choose the action on the other side of that word? What do you feel guilty about? Can you

see that the guilt is likely coming from a place of wanting to be it all for everyone? Perhaps it's coming from a place of not wanting to disappoint anyone. Or perhaps, it's because you feel guilty for doing something outside of the "good-girl" paradigm.

Let's stick the guilt in the gutter with the rest of the excuses.

STOP + **DROP** + **ROLL** = **WIN**
(and assess) (the guilt) (into action) (at life)

Guilt is a Decision

Guilt creeps in everywhere. Ever lose sleep over forgetting to dress your child up for theme day? Or missing the school concert because it's held at 10:00 a.m. on a weekday? How about the guilt you feel when you get into a drive-through line to feed your child dinner? Know that feeling? Yes, me too. Ever order a decadent dessert and, after you lick the plate, you immediately feel guilty? How about the guilt from not returning a friend's call? Or guilt because you didn't have time to cook something for the potluck so ordered takeout and replated it? (Hey, don't judge. I didn't have time to make empanadas from scratch.)

I was away on vacation in Anguilla when the kennel called. My rescue pup was having seizures and was being rushed to the animal ER. The conversation with the ER nurse was awful; I had to give them permission to not resuscitate him if he should go into heart failure. Tig, my poor pup who had such a horrible beginning to his life (and the scars to prove it), would die alone. Oh god, the guilt was intense. I tried everything in my power

(short of hijacking a private jet) to get home. The wait for my flight the next day was brutal. I sobbed. The flight home was heart-wrenching as I imagined landing to news that he had passed. He did survive, and in fact, he is under my desk snoring as I type, though now he is on seizure meds for the rest of his life. Let me tell you, that guilt took me out at my knees.

When was the last time you had guilt? I bet it was recent. In fact, there are studies demonstrating that guilt can trickle in at the oddest of times. Perhaps you feel guilt because you didn't bake cookies from scratch for your child's class; your rational head tells you that the "baked-out-of-a-box" cookies are fine, but your guilty brain will tell you otherwise. Yes, guilt is a tricky bugger.

Women feel guilty about almost everything.

We feel guilty because of a failed or—I like to say—*completed* relationship.

We feel guilty for not working enough or for working too much.

We feel guilty for how we look when we compare ourselves to others, or even to our younger selves.

We feel guilty because we spoke up, or because we didn't when we should have.

We feel guilty for being too assertive, or for being too much of a doormat.

Women are not just guilty for one thing; we are also guilty for the opposite of that same thing. Can you feel the energy of my head exploding? How can we win when we are damned if we do and damned if we don't?

It's not our fault. We are surrounded by messages everywhere that contradict each other. I suppose we've come far since the days of the suffragettes, but not that far considering we are still

making women feel guilty for being raped because of how they were dressed when they were attacked. (Oh, but don't forget to dress sexy to appeal to the opposite sex.) Breastfeed, but not in public. Get your figure back and be back to work in three months. Be a CEO, but don't talk about money because it's tactless. Embrace your curves, but only if the junk is in your trunk. We have even gone so far as to take fat from one place in our bodies and not discard it, but rather move it elsewhere. Or how about paralyzing our faces so our smiles don't reach our full face and cause wrinkles? What in the actual fudgsicle?

The contradictions are mindboggling. No wonder you are constantly chasing an imaginary ideal of what it means to be a woman in modern society.

Ever notice how men don't have the same level of guilt? It's as if they are immune to it. They don't worry about trying to be everything to everyone. I know there are some men out there who would disagree with me, but the Spanish Journal of Psychology, Volume 12, Issue 2 published research suggesting that men are essentially guilt-deficient. "Our initial hypothesis was that feelings of guilt are more intense among females, not only among adolescents but also among young and adult women, and they also show the highest scores for interpersonal sensitivity," says Itziar Etxebarria, lead author of the study and a researcher at the University of the Basque Country (UPV/EHU). We probably could have saved those researchers a whole lot of time and given them the same conclusion without the fancy data. Men do a far better job of not letting guilt eat at them. It's not a criticism. It's just the truth.

The underlying factors of your guilt run deep and wide, and figuring out how to overcome them is even more vast. So many things are outside of your control, but what you can control is

your own reaction. Guilt is a feeling, sure. But guilt is also a decision. You let guilt be your boss when you accept it as fact, as I did the day that being a mother and a lawyer collided head-on. We can't completely terminate guilt from our repertoire of emotions, but recognizing that it is an irrational constraint we place on ourselves is half the battle.

A good girl lets guilt control her because she doesn't ever want to disappoint anyone. A fierce female knows that guilt is a useless feeling and sends it packing.

Let's get that suitcase out.

Pull a Chair Up

You cannot be everywhere and everything to everyone all the time. You are a Wonder Woman, but you don't have the benefit of hyper speed, flight, and semi-immortality. Something has to give, and it starts with dropping the guilt.

Living a balanced life is a bunch of horse manure that someone, somewhere told us needs to be added to our already oozing to-do list. Look at it this way, a whole of anything means you are putting total and complete effort into one thing. For illustration purposes, let's say you are wholly committing to parenting. If you are dedicating all your wholeness into being a supermom, there isn't any room for anything else. But let's say we introduce some self-care into the scenario. While your focus is still predominantly on parenting, you take some of your attention away from the kiddos and give it to exercise and meditation. Let's add in work, time with your spouse, and time for friends, and suddenly your time is really carved up. Rarely are these categories portioned out equally or in a balanced manner.

Sometimes, you need to focus more of your attention on one aspect than another, and when you do that, there is less of you to give to another part. My point is that being balanced is illusive, and when we forget the cupcakes for school or choose to skip a lacrosse game to go to a book club, guilt sets in and screams, "you aren't doing enough!"

You need to make peace with the fact that you can't be everything to everyone. And we all need to remind our friends of the same when we watch them make a valiant effort to try. It's so easy to look at a friend and see that they are spreading themselves too thin, or that fatigue has brought dullness to their face, but why can't we turn that mirror on ourselves?

I was in court many months after the breakdown-lane debacle when daycare called again. I had just sat down with the prosecutor, a woman who was older than me by about twenty years. She was known to be a no-nonsense attorney. I was still a newbie lawyer and was intimidated because she had so much experience. When she saw my look of distress over the caller ID, she encouraged me to take the call. She watched my face fall as I was told that once again, I needed to come get my child. This time he wasn't sick but rather, their air conditioning had stopped working and it was a stifling day so they decided to close early. When I hung up, I hadn't worked out how I was going to handle the situation. I didn't want to seem unprofessional, yet I knew I had at least another hour or longer in court. I didn't say anything about the call, but she must have read my face. She leaned forward and said, "What can I do?"

I didn't know her. It was the first time I had a case with her.

"Do you need to leave?" she asked. "We'll go see the judge right now and push the date." Then she conspiratorially whispered, "We need to stick together." She even offered to send a car service to get him.

All these years later, I don't remember that woman's name, or how the case turned out, but I will always remember how she made me feel. I will always remember how she didn't just tolerate the situation I was in, but actively sought to help me. We were on opposite sides of a case, but we were on the same side of being women navigating that with, the workplace.

You, me, and every other woman out there are all in it together. I've seen us come together to help other women through the most trying of times: the death of a loved one, a lost job, an illness, a loss of marriage. I've seen women rally around and set up meal trains, carpools, and funds to help another woman. It often takes tragedy of the greatest kind for another woman to ask for help. We don't want to be a bother. We don't want to be an inconvenience. We think we can do it all on our own, that is, until we can't.

Asking for help isn't a weakness, nor is it troublesomeness to others. For years, I didn't ask anyone for help with my business even though I had so many questions. I didn't want to be a bother. Now, when something comes up, I send a quick message to one of the people in my vast network because I know someone else will have the answer and will be happy to share their knowledge with me. I won't spend days trying to find a solution when a quick call or email could provide the answer. I love when a friend asks me for help with something I'm uniquely positioned to assist with. I'm happy to help, and I don't know any woman who doesn't feel the same way. We can all win when we support each other.

There are plenty of seats at the right tables. If you find yourself trying to squeeze yourself into a crowded table and being met with resistance, maybe you are trying to jam yourself into the wrong room. Unfortunately, there are still people who believe

that helping someone else is like feeding the competition. It's a scarcity mindset, one that will keep them small. You don't want to hang out with those people. Put yourself in a room with those who are committed to lifting each other up, cheering each other on, and celebrating each other's successes.

Just because another woman has achieved something, doesn't mean you can't also. Her success is not your failure. The room you belong in doesn't have walls or ceilings to contain you. It's a room where all your sisters are ready to help one another, so you don't need to be all to everyone. The room you need is one where guilt is not invited to enter.

So, pull up a chair. You have something to say, and we are listening.

Chapter Sound Bites

- Make peace with the fact that you can't be everything to everyone.
- When you can confidently say something is a "hell yes" or an "absolute no," you start to make decisions based on your truth at a cellular level.
- The next time a guilty thought nags itself into your psyche, recognize it, then turn the dial way down.
- A fierce female knows that guilt is a useless feeling and sends it packing.
- **DROP the guilt,** and send it to the gutter with the rest of your excuses.

Drop Your Need to Please

*When a woman finally learns that pleasing
the world is impossible, she becomes
free to learn how to please herself.*
—GLENNON DOYLE

I never knew that being a *displeaser* would be so delightfully satisfying, but it was a lesson I learned one day when I was in court.

"If you walk back into that courtroom, I will ask the judge to sanction you... and I will make sure your career is short-lived," the opposing counsel said to me. Sanctions could mean a monetary fine or discipline by the state bar association. Let's just say, you don't want it to happen, especially in your first year of practicing law.

I'll never forget that day in court. I was a brand-new lawyer sent to court to represent a woman in a restraining-order hearing after her husband threw a television at her head. The husband happened to be employed by his own lawyer who also happened to be a well-connected political figure in that city. The lawyer was someone who got what he wanted by bullying. They don't

teach you what to do in a situation like this in law school. They don't teach you about short, balding, opposing counsel getting in your face and flinging a threat (or potentially a promise) your way.

My client, a slight woman, was still trembling from having to testify against her husband. She was afraid of him. She fidgeted nervously just so she didn't have to make eye contact with him. I saw the fear in her eyes when she looked at the man she had vowed to spend the rest of her life with; I saw the hope when she looked to me to help her. But who was I to help her? Sure, I was a lawyer, but I was still a kid at twenty-eight years old, the ink barely dried on my diploma. Like most young lawyers, I didn't really know what I was doing. I was scared shitless. I'm not going to pretend I was some badass, young, confident woman sashaying into court with her confidence as tall as her spike heels. No, quite the opposite. I was in an oversized, gold-buttoned blazer that looked like it had been plucked from my grandfather's closet. I carried a black briefcase that was so new, the leather was still stiff and the clasp squeaky. I may have been dressed to play a certain part, but I was uncertain and intimidated, and I wasn't sure I was fooling anyone.

"I guess we will just see what a judge has to say," I replied trying not to break eye contact. I turned away from him and walked back into the courtroom, bag in hand, client trailing behind. My hand was shaking. I had no idea if his threat was empty. I just knew that I couldn't let my client down, and I knew the right thing to do.

Having grown up as a people pleaser, I certainly picked the wrong profession. It was literally my job to piss people off on a daily basis, so trying to please everyone was an impossible feat. (Perhaps, I should have stuck with my teenage job escorting Barney, the

purple dinosaur, to children's parties. Now, that was a happy job except when I had to peel a child off his tail.)

Despite my nervousness, I won that day in court. My client got a restraining order, and she was safe from her husband. That lawyer left court with his tail (not of the purple variety) between his legs. He didn't ask for sanctions or carry out any of his intimidations. He knew his threat was baseless, but it didn't stop him from trying to scare a young lawyer. It almost worked. What was really interesting though, was what happened after that day. I had other cases with him in the following years, but he never tried to intimidate me again. Because I'd stood my ground, he knew I could not be persuaded with menacing words. He knew where he stood with me. Imagine if I had caved. I bet he would have continued to bully me in all our future interactions because he would have known he could get away with it. That day was a lesson.

I knew that I needed to get comfortable being a people *dis*pleaser.

Lose the Ladylike Bit

People pleasing is a distinctly feminine, cultural standard that is thrust at women.

Smile.

Act like a lady.

Keep the peace.

Powder your nose so they don't see you sweat.

Apologize for and then justify your decisions.

When was the last time a man was told to smile when he was walking down the street? When was the last time a man was told

to keep the peace? When was the last time a man was told to explain his choices? To the contrary, men are told to be warriors and to stand their ground. They are revered for not showing weakness. They are praised as leaders when they command and demand. And rarely, do they apologize for saying *no*.

As a result, women's wellbeing suffers because we are always chasing a double standard, and we find ourselves in a land of confusion as we try to keep it all straight. Be strong, but look pretty while you're doing it. Be smart, but don't be a know-it-all. Be educated about financial matters, but don't talk about it because it's tacky.

Think about the bros out there showing off their private jets and Lamborghinis. It's cool for them, but shameless for women. You literally can't win when you stay trapped in your people-pleasing ways. You will always be judged by someone who isn't doing the work, so why even bother trying? Why not give it up and free yourself?

You can't wait around for the world to catch up with you, and your life is too short to live trapped in an unattainable standard. The responsibility to change your people-pleasing ways falls squarely on your shoulders.

Think about all the times you said *yes* when you actually meant *no*. How did it make you feel? Resentful? Angry? You most certainly didn't show up to whatever you said yes to with energy and excitement. Instead, you probably grumbled under your breath, dreaded the drive to where you had to go, and felt depleted and drained when it was done. You put your own needs and desires second, and that likely impacted just about everything that followed. When was the last time you disagreed with someone close to you? Or called someone out for acting or saying something that went against your morals or values? If it's been a

while, this work is going to be a little more challenging. That's OK. It's still worth the efforts, and quite frankly, it's the only way to go from living for everyone else to living for you.

People pleasing is a selfish act. When you try to accommodate everyone all the time, you will be unable to fully show up for what really lights you up, and you are robbing the world of your brilliance, your talents, and your purpose. Now, that's some selfish trappings right there because the world needs what you have to give, but you can't give it if you are saying *yes* to everything all of the time.

Getting comfortable with saying *no* takes practice. It takes implementation and readjustments because what was a *yes* last year, might be is a *no* this week. It also takes a willingness to occasionally upset, frustrate, or disappoint other people, because when you start to establish boundaries and place value on your time, you will ruffle feathers of those who expect you to adhere strictly to their needs. That's OK, too. They will survive. I promise.

Being a "good girl" won't get you financial freedom. It won't help you build a seven-figure business. Being a lady won't get you the raise or even the relationship you want. Being a lady might keep someone else happy, but it won't do much for you at all. And may I remind you, you are no longer in the business of making others happy. You are in the business of being fierce, so raise your pepper spray, and blast your people pleasing ways into oblivion.

DROP the need to please and start living for you.

Don't you feel lighter already?

STOP + **DROP** + **ROLL** = **WIN**
(and assess) (your need to please) (into action) (at life)

Be a Truthteller

Dear Attorney Bauer,
Now that my divorce is complete, I'd like to send you an
email with feedback about all the ways in which I
believe you could have been more effective as my lawyer
and why I'm not happy with your representation.
Signed,
A male client

Dear Attorney Bauer,
I am unhappy with your bill. I don't think I should have
to pay that much for your services.
Signed,
A male client

Dear Attorney Bauer,
I want a phone call today. I did my own research and I
think your legal advice is incorrect.
Signed,
A male client

Being a divorce attorney can be immensely satisfying and just as
intensely demoralizing. The job is to help people go through one

of the most traumatic times of their lives. For the short period of time I practiced criminal law, I never dealt with the level of demands, disrespect, and patronization that was a daily occurrence in family law. It is especially difficult if you are an empath. But what I'm talking about is not exclusive to work as a family attorney. Every woman I know has a story of being told they weren't enough. They didn't do enough. Or if they did, then they were bossy or bitchy. They don't "know their place." Their value was discounted. "Please adjust my bill," translates to, "Please don't charge me what your worth."

Society says have dreams, but keep them smaller than your husband's so as not to make him feel inadequate. Speak up, but only if you don't offend someone else. Have a career, but don't be so successful that you make your boyfriend or husband insecure. You can look up at that glass ceiling, and maybe, if you are lucky, you can use your forehead to bang a crack into it, but let's not give you any tools to break it wide open. Let's not make the glass rain down on society's heads. Some people just aren't ready for that. Some people are fine with you being successful so long as you keep the peace, calm down, and be the "good girl" you were raised to be.

Society has also trained me to be conflict adverse. I've been that way my whole life. It was easier to get along to go along. This bit me in my ass in my first marriage. I went along with everything no matter how I felt about it. I swept every last issue under the rug. You know what happens when you do this? Resentment grows until it's not only an elephant in the room, but a whole damn herd. It was my fault. I didn't give my ex a chance to compromise or argue things out because I didn't want the fight, so I went along with everything. When I asked for a divorce around our five-year anniversary, he was totally blindsided. How

unfair was that? I never gave him a chance to work on our problems because my resentment was too unwieldy by the time I told him I was unhappy. Here is an interesting observation from all my years of being a divorce attorney—it's not uncommon for a divorcing couple to report that they never argued. Constructive conflict is healthy.

During that time in my life, I was too busy being a people pleaser to be a truthteller. You can't be both. Resentment from being a people pleaser will impact work relationships, romantic relationships, friendships, family, and yourself because so long as you put everyone else's needs before your own, you will chip away at your fundamental self-respect. Unequivocally and irrefutably, you cannot be a people pleaser and win at life. It's impossible. And the only way to counter your old people-pleasing ways is to vow to be a truthteller all the time.

You warrant that level of honesty.

You warrant that degree of authenticity.

You warrant that magnitude of self-actualization.

But heed this warning: People won't be used to this updated version of you, so how they respond will vary. Some will respect your new ways. Some will reject them. You may hear statements like this:

You're being so difficult.
You're too sensitive.
You're overreacting.
Why can't you take a joke?
Nothing ever makes you happy.
You are blowing things out of proportion.
You're acting crazy.
You make no sense.

You are being unreasonable.
You are twisting things.
Why are you starting a fight?
I guess I just do everything wrong (said as sarcastically as
possible).
I just won't say anything next time.
You always take things the wrong way.
Why are you getting so worked up?
You're being ridiculous.
I must be a piece of garbage then.
If I'm so unreasonable, why are you with me?
Do you hear yourself?
I was joking.
You have issues that you need help with.
Get over yourself.

These statements are meant to deflect and undermine your feelings. They are also meant to shut you down, and in this moment, when you are on the verge of giving in to avoid the disagreement, it is your responsibility to plant your feet in the ground, steady your resolve, and say, "It is important to me that we discuss this as civil adults."

Those who can't accept your boundaries don't belong in your inner circle. If they respect you, they will understand, even if they don't necessarily like it. Over time, they will get used to the new normal that you've defined.

And that, my friend, is your truthteller squashing your old people-pleasing ways.

Brief, Businesslike, and Blank

As a business owner, I love envisioning creative and innovative ways to deliver services. I love all things marketing and to think outside the bleak box for ways to grow and scale my business. I love leading my team with office retreats and fun challenges. On the other hand, I absolutely hate, despise, and abhor managing people. I hate having hard conversations about performance or unmet goals. I hate it with a passion. Can you feel how much I detest this role? For years, I ignored it. After all, these employees were also my friends, and I was uncomfortable admonishing any of them for their performance. It was easier to avoid those conversations. (Cue up my conflict aversion, which I believe was partially responsible for the demise of my first marriage, and probably stems from my former "good girl" ways.) Sometimes, old habits die hard.

I also knew that by not having the hard talks, I was doing a disservice to my team. How could I possibly expect an employee to jump into my brain and know what I was displeased with or what expectations I had if I wasn't being clear with them. It was a ridiculous prospect, and it caused me internal frustration whenever someone didn't do what I felt they should know to do without me having to tell them. I know how ridiculous that sounds, and it kept my business's growth stifled for a bit.

Having hard conversations are not fun. I don't know anyone who says, *I can't wait to have this uncomfortable conversation today.* Yet, for some reason, women struggle even more with this than men. I know lots of female entrepreneurs, and managing their employees is something they often meet with resistance. This goes to personal relationships, too. It's hard stuff, but that doesn't mean you should avoid it.

When I was in college, I joined a student activist group, and in that role I volunteered to testify in the state legislature about how ATM bank fees and credit cards were targeting students (sexy topic, I know). I delivered my speech with conviction and passion (credit card fees were serious business). After I finished, a state senator addressed me and said, "Now, Miss, that accent isn't from here. Are you from New York or Boston? It has to be one of the two."

My message was forgotten, and my accent became the distraction. I let him redirect the conversation because he was clearly receiving money from the banking industry, and I didn't have the confidence to bring the conversation back to my message. My words were lost. If that happened today, I would have the skills and practice to respond effectively to someone who is demeaning, deflecting, and trying to undervalue my skills or opinions. It took me time to figure out how to do this, and I share what has been a true-and-tested strategy.

Ditching your old ways is going to require some tools in your bedazzled toolbox. Here are the 3 Bs to engaging in an uncomfortable conversation.

- **Brief** – Keep your topic related to the issue at hand. Don't bring up old wounds. Staying on point will help you reach an understanding on that particular issue. Watch your words. Instead of blaming the person at the other end of the conversation for all that you perceive as their fault, change up how you are communicating your concerns. Instead of "You are a slob, and I can't rely on you to help with the kids." Try, "I feel really overwhelmed trying to keep the house clean and getting the kids to activities. Can we talk about how you can help me, so I'm not so stressed all the time?"

- **Businesslike** – Be direct and clear about what you want to say. Don't leave any room for ambiguity. Also, schedule a time to have the conversation. Don't just spring it on them when they are about to head out to golf or are watching their favorite reruns. You want to set the stage so that you both show up ready to give the conversation the undivided attention it deserves.

- **Blank** – High emotion begets high emotion, and when you bring so much charge into a conversation, things are sure to go askew. Show up with your emotion in check so you can focus on a positive outcome. If the conversation gets heated, call a time-out. If either of you is losing your temper and the script is becoming accusatory, you will never get to a compromise, so request that you both take a five-minute break to cool off. Then, you can come back and continue the conversation in a respectful manner. If you are being disrespected or the other person has resorted to name calling or flinging insults, terminate the conversation.

Making the decision to switch from people pleaser to truthteller is arguably the single most important choice you can make to start choosing you. It's not easy, but it is so worth the reward on the other side. It means you respect yourself, and you value what you offer to the world. Whether it's prices on services you provide, your time, or your mind, once you stop trying to be all to everyone, you can be a changemaker. Changemakers can lead the way, transform the rules, and shine their light on the world.

To please everyone is to impact no one. Fierce lady, you are meant for so much more.

Chapter Sound Bites

- The responsibility to change your people-pleasing ways falls squarely on your shoulders.
- When you try to accommodate everyone all the time, you will be unable to fully show up for what really lights you up, and you will rob the world of your brilliance, your talents, and your purpose.
- Making the decision to switch from people pleaser to truth-teller is arguably the single most important choice you can make to start choosing you.
- When engaging in uncomfortable conversations, keep it Brief, Businesslike, and Blank.
- **DROP the need to please**, and shine your light on the world.

CHAPTER 9

Drop the Pity Party

*The difference between successful people
and others is how long they spend time
feeling sorry for themselves.*
—BARBARA CORCORAN

Sometimes a day is just a day, and sometimes a day makes you feel a certain way because of the meaning that's been attached to it. Take New Year's Eve, for example. We think of parties, gatherings, champagne, celebration, annoying party noisemakers, sequined dresses, and fun. Being alone on this holiday is the opposite of what this night stands for. Yet, that is exactly what went down for me on New Year's Eve 2012. I partied like... well, like it was a random Tuesday.

I popped the last piece of cheese in my mouth. It wasn't even a good kind of cheese. It was the prepackaged kind that was already cubed and had a neon-orange hue. That's the level of celebration that was happening that night. I didn't even buy the good Camembert. I was wearing my favorite sweats, the ones that were so worn that the crotch was practically see through. It was New Year's Eve, and I was by myself. My belly was full

of a processed dairy product and my head was full of "poor me."

It was the first time I ever spent a holiday alone. I had my family around me for Christmas, so even though I was single, I wasn't by myself that holiday. I was surrounded by people bustling around, the extra bedrooms were filled, and the house was a beautiful chaos of piled-up gifts and extra shoes in the mudroom. But when the last of the relatives pulled out of the driveway and the family room was tidied of wrapping paper and bows, I was alone.

I exhaled, flipped through the channels, and came back to the broadcast from Times Square. There was an hour and a half left until the ball dropped and people across the world would clink their champagne flutes and have their first kiss of the new year.

I clicked the television off and went to bed. Watching all those people together in party hats, oblivious to the fact that it was freezing out because they were drunk and happy, reminded me of how hollow my house felt. I crawled into bed, willing sleep to come fast so that morning would arrive quickly. I wanted to fill New Year's Day with busyness to distract myself from the fact that New Year's Eve was such a bust. I would not be drowning my hangover in carbs or reliving all the shenanigans of a great night. I just wanted the sun to come up so I could carry on with my life and forget the night before.

You know how the saying goes. "It's my party, and I'll cry if I want to," but I didn't cry. There was no point. Instead, I laid there thinking about how I ended up there. Life wasn't supposed to go that way. I wondered what I could have changed about my past. I grieved what I lost and what I expected to be different. I felt unlovable. I felt unsuccessful. I felt like a big mess. I felt damn sorry for myself.

The party was raging in Times Square, but I was having my own party too—a pity party—and it was hopping.

Burn it up

You get to throw yourself a pity party, but at some point, you need to turn on the lights, kick out the bad guests (your negative thoughts), and clean up the mess. There is no legitimate reason to hold onto self-pity. It serves absolutely no purpose, yet it's a hard one to shake. It feeds on your negativity and multiples like a gremlin when exposed to other people's happiness. The more you scroll and consume other people's perfectly filtered lives, the more potent the pity becomes. Pity is a power sucker. It will literally suck your power right out from within you and leave you parched, resentful, and looking for someone to blame. Pity is really an ugly, little bastard.

Here's the truth bomb that you probably don't want to hear but need to if you are a professional purveyor of pity—if you remain a victim of your history, you cannot win at your life. In other words, it is impossible to hold onto pity and forge fiercely forward.

Think about the restaurant industry when the world shut down because of COVID. Some restaurants closed because indoor dining was halted, while others pivoted, expanded their take-out service, got creative with their offerings, and boasted increased revenues. Some owners complained about how COVID was their demise, while others took the challenge head-on and came up with solutions that were profitable. The same thing happened with brick-and-mortar gyms. Some closed. Others offered virtual classes and virtual personal training. For these businesses

and many others, resilience and the determination not to be a victim of an uncontrollable circumstance, catapulted their profits, while others became victims of the situation. I'll give you one guess which business owner got stuck in a pity cycle and which pummeled their pity so they could act.

You, too, have a choice: to stay stuck in victimhood or to rise to the challenge. It's a decision that you make one thought at a time. If your mind can talk you into feeling bad for yourself, your mind can also talk you out of self-pity. Thinking something does not make the thought fact. Let's give this a whirl.

Instead of thinking, *I lost my job because I'm not good enough.* Tell yourself, *I was released from a job that was holding me back from my potential.*

Instead of thinking, *my partner cheated on me because I'm not loveable.* Tell yourself, *my partner's infidelity reflects their own insecurities, and now I am free to find someone who values and respects me.*

Instead of thinking, *I cannot start the business because I never went to college.* Tell yourself, *I don't need a diploma to have determination and grit, and life experience is far more valuable than a course.*

Your self-pity stems from words and thoughts that are stuck in your brain on repeat. You don't need anything else but the decision to change it up. Think about what pity story you are holding onto. Are you ready to let it go so you can move forward?

Pretend there is an imaginary firepit in front of you. It contains the ashes of the rulebook you previously set ablaze. You are standing at the edge of the fire holding a bag filled with all your pity stories. They are your history. They are the ways in which you may have been wronged. They are circumstances outside of your control. Your pity-filled bag is highly flammable, so on the

count of three, you are going to throw the whole damn bundle into the fire and watch it go up in flames. Once you do, you no longer have those old stories attached to you. You cannot look back except to acknowledge how far you've come. Are you ready to set fire to your pity?

One.

Two.

Three.

Burn, baby, burn.

STOP + **DROP** + **ROLL** = **WIN**
(and assess) (your pityparty) (into action) (at life)

It's Part of Your Story

Chloé Temtchine is an award-winning musician and songwriter. She is beautiful, stylish, and uber talented. She received the Avon Award for "Best Song" and it was presented to her by Fergie. She's rubbed elbows with Oprah, and has played with and for some of the biggest names in the business. Chloé had an enviable life. Her star was rising until the day everything changed.

She was gearing up to go on tour with Greg Camp, the Grammy-nominated songwriter and guitarist of Smash Mouth. She and Camp had collaborated on an album. Then, she suffered congestive heart failure and was diagnosed with Pulmonary Arterial Hypertension (PAH) and Pulmonary Veno Occlusive Disease (PVOD), a rare and fatal lung condition. It was a terminal

diagnosis that would put her on oxygen for the rest of her life. Her battle with this illness left her in a coma for four days and on life support for almost a month. She's received a double lung transplant and has undergone countless surgeries since the diagnosis.

I had the privilege to interview this beautiful soul on my podcast, and it was one of the most incredible interviews I've ever conducted. Her outlook and positivity around her illness is nothing short of extraordinary. The natural response to being dealt this blow should be anger, grief, and the biggest and baddest pity party that ever existed. Yet, Chloé didn't do that. Instead, she carried on with what she loves to do and continued to perform even with a paralyzed vocal cord and an oxygen tank that is as necessary to her performance as a microphone. She quite literally turned her pain into her purpose, pouring her heart and soul into non-profit work to educate and support others struggling with the same illness.

Despite all that happened to her, her perspective on life is mind-blowing. She makes the conscious decision every single day to live with gratitude, grace, and purpose. I highly suggest you listen to that interview on the *She Who Wins* podcast. I don't do her story any justice here. You need to listen to her story in her own voice.

I think of Chloé whenever I'm grumpy about a particular circumstance or find myself rounding up the pity-party planners. If Chloé can find joy in her life even though she faces an incurable disease, I can too. So can you.

What she has gone through... what you've gone through... what your friend has gone through... It's not a competition as to who can suffer most. Chloé's story doesn't mean your pain is any less. I share her story not to say, quit complaining. Rather, I share

her story to challenge you to change your perspective around what you have gone through. What have you learned from your trials? How have you evolved from them? What can you do with them?

What you've survived or endured is very much part of who you are. Don't erase it.

Use it.

Use it to find purpose, help others, or simply be reminded of the gift of each day. Your struggles shouldn't be erased. They're part of your story and shape who you are. First, you need to make the decision to make your story part of who you are, so long as it is not the *only* part of who you are.

I can't pretend that I woke up New Year's Day that year with a new, beautiful perspective on life. I think I went food shopping and cleaned out my closet. Moving on from feeling bad for myself took a minute, but once I dropped the pity, it could no longer control my feelings of worthiness. And when the Superbowl rolled around that year, I refused to have a repeat act, so I accepted an invitation to a party, attended solo, and brought the good cheese.

Forgiveness is For You

Double, double toil and trouble
Fire burn, and cauldron bubble
Double, double toil and trouble
Something wicked this way comes.
—JOHN WILLIAMS

Are you imagining looking into a boiling pot, stirring in a frog leg, a dash of cinnamon, and the tears of a widow? The satisfaction as

you place a hex on those who have wronged you feels so grati-
fying, doesn't it? You close your eyes and imagine your target
suffers the fate of one who has been damned. Cue the witch's
cackle.

It didn't work out so well for Winifred, Mary, and Sarah
Sanderson, sisters in *Hocus Pocus*. And you shouldn't expect
anything different for you if you decide to hold onto your resent-
ment and anger. As the saying goes, holding onto anger is like
drinking poison and expecting the other person to die.

Letting go of anger is not easy. You want karma to come kick
them in their keister. But holding onto that anger only hurts you.
Forgiveness has nothing to do with them and everything to do
with your own internal peace. Releasing resentment is hard, but
you need to let that bitch go in order to win.

Here's the thing: forgiveness is not actually telling the person
you forgive them.

Forgiveness is not doing acts of kindness for that person.

Forgiveness is not becoming new best friends with that
person.

That's a big ask, and quite frankly, I wouldn't have you put
that much energy into someone who still may deserve your evil
spell. Instead, the type of forgiveness I'm talking about is the
forgiveness that happens within you.

When you hold onto anger and resentment, you have a phys-
ical reaction when you speak or think of that person. You might
get a pit in your stomach, or anxiety, or agitation, or your skin
turns five different variations of red. When you talk about them,
you are negative and spew venom to anyone who will listen. You
catch yourself driving and wishing ill on them. This person has
messed with your peace without doing a thing, and so, they've
won.

On the other hand, if you release them from occupying that space in your head, when you think about them, you'll be able to do so with detachment. When you release something, you are setting yourself free. And freeing yourself from their negative grasp is the goal. So, when you talk about them to someone else, you can do so in a factual manner that is emotionless. They no longer cause a physical reaction. You even say that you wish them the best. Maybe you even feel bad for them because of their own unresolved struggles (which were directed towards you). In that dynamic, you have taken the power back. You win.

See, forgiving has nothing to do with them. Forgiveness happens when you realize that the longer you hang onto stuff that makes you want to dust off your cauldron, the longer you stay stuck and allow them to control your wellbeing. Why give them that influence? Why allow them to control your thoughts? Why let them have a deciding factor on how your day is or how you feel? They don't deserve it. You have come too far to let an unworthy serpent hold any power over you.

I know what you are thinking. How in witch's broom do you forgive someone who has done so much damage? I'll show you.

One of my favorite exercises to start you on your forgiveness journey is to write a letter. This letter will be to the person you need to forgive, but don't worry because they won't ever read it. This is a symbolic act only. Write it all down. Don't hold back. Say whatever you want and once you've covered some pages with your feelings and hurt and anger and even some swear words, close the note by saying that you forgive them. Tell them that you release them into the world and send them peace and light. You won't ever mail this (although we won't stop you from sending them a glitter bomb). Now, here is the fun part: when you've said everything you want to say, take a match to the pages. This letter

was meant to free you. It was never meant for them. They don't need your forgiveness; you do.

The value of this ritual is entirely emblematic. The act of releasing is cathartic. Burning it up is, well, just fun. You'd be surprised by how emotional this exercise can be. You may find yourself crying as you write or tearing the pages with your pen as you voice your anger. The emotions that flow from doing this need to come out, so don't fight your reactions. When it's over, I would do something healing, such as light some candles, take a bath, or do some self-care of whatever variety feels good to you. Forgiveness is hard work, so you should reward yourself.

If this is too hard and too much right now, that's OK. Let's start smaller with some affirmations. Affirmations are positive statements that remind you of your power. You can't change your life by saying one statement one time. However, if you repeat them daily, you can change your mindset. Don't believe something so simple can actually work? Research backs this up. In 1988, Claude Steele revealed the theory of self-affirmation, which in its simplest terms said that people are motivated to maintain their integrity even when self-integrity is threatened. In other words, when faced with adversity, if we say affirmations, we can believe them over the challenges we face. You can write your own affirmations, or use this list to kick off your own forgiveness journey.

- I release what held me back and embrace this new chapter in my life.
- Everything is a lesson to grow from.
- I am ready to let go.
- I am brave and confident all on my own.
- I send them peace and light.

- I forgive myself.
- I welcome change.
- My past experiences have no power over me.

Keep a copy of your favorite affirmations by your bed and read through them before you turn off your lights and first thing every morning. By starting your day with speaking and absorbing positivity, you have the power to shape how the rest of your day unfolds. It's hard to be crabby or angry when you've just reminded yourself of how amazing and strong you are. And when you say it enough, you start to believe it. When you believe it, every decision you make is impacted. You don't accept people who don't value you. You choose things that enrich your life rather than take away from your life. You don't just wish for more; you start believing that more is your right as a woman. And then, you go for it.

And if that still doesn't work, I'll start gathering some frogs and we'll get cooking.

Chapter Sound Bites

- You get to throw yourself a pity party, but at some point, you need to turn on the lights, kick out the bad guests (your negative thoughts), and clean up the mess.
- What you've survived or endured is very much part of who you are. Don't erase it. Use it.
- Forgiveness has nothing to do with them and everything to do with your own internal peace.
- Use affirmations because it's really hard to be crabby or angry when you've just reminded yourself of how amazing and strong you are.
- **DROP the pity party,** and throw yourself a whole damn gala.

Part Three:

She Who Wins

Rolls into Action

Roll into Rejection

For there is always light,
if only we're brave enough to see it.
If only we're brave enough to be it."
—AMANDA GORMAN

I'm a stubborn little bugger. I must get that from Mimi. I like a good challenge, and in the past, it's often fueled me to dig deeper, try harder, and find creative ways to reimagine a goal. But even I have my limits, and my publishing journey tested my stamina.

The first ten rejections felt personal as if each email was a direct affront to me. I dismissed and deleted the next dozen or so that came through. I barely read the words by the time I got into the triple digits. You know it's a rejection three words in from the first line. I didn't need to finish the entire email. Rejection after rejection poured in.

Ten.

Fifty.

One Hundred.

One Hundred and Thirteen to be exact.

That's how many rejections I received from literary agents before I found one. I will never forget the morning I woke up to an email that was just a few sentences:

I've just finished reading your manuscript and I'd love to chat with you this week about it, if you have time. If you could let me know what works for you. Also, please confirm your time zone.

–All the best,
Ann

Of course, I responded at 5:30 a.m. because I don't have any chill. The few hours leading up to that call were anxiety-inducing.

What if I say the wrong thing?

What if she changes her mind over the next two hours and fifty-eight minutes before our call?

What if she ghosts me?

Later that morning, she offered representation, and I hung up the phone still convinced she would change her mind at any minute and send a follow-up email that was something like, "Just kidding. I was messing with you." That email never came; instead, she sent a contract. It was a long nine months of obsessively checking my inbox and querying agents, but all that effort was worth it.

That night, I cried, did a shot of whiskey called "Writer's Tears," which was as tasty as gasoline (although whiskey drinkers tell me it's the good stuff), and I celebrated. My career as an author was about to embark. Everything would fall into place. I was already thinking about what I would wear to my first book signing. Let me clarify that while I received an offer of representation from an agent, it was not a book deal. Yet, in my mind,

surely, the deal would come soon. Maybe even days later. Yeah, I was that level of exuberant (and disillusioned).

You do hear stories of authors finding an agent and getting a book deal within weeks. They go on to book tours, sell the movie rights, make it on Reese's Book Club and rise fast to the top of the charts. They quit their jobs, buy a house on a lake, and set off into literary bliss.

That was not my story.

Instead, after I landed this coveted agent, we spent the next three years getting dozens more rejections, but this time from publishers. The emails rolled in at a steady clip. We piqued interests and had some close calls, but there was not an offer in sight. My literary dreams were sinking to the mucky bottom of that aforementioned lake.

I refused to quit. I wanted the traditional book deal. Many people told me to self-publish because it would be the only way my book could make it out into the world. But I held out. I knew eventually it would happen. I imagined the day when Ann would call me and tell me we had an offer. I could feel it. I played out what I would do. I would show up unannounced at the police department where Jay worked. When I did that, he would know I had news. He would leave work, and we would spend the rest of the afternoon celebrating. I imagined that my book would be in the stores and readers' hands within months. None of that happened.

Three years trickled by, and I never got the call. Jay retired from the police force and began working in my business, so my spontaneous announcement plan was laid to rest. There would not be a surprise visit and afternoon of galivanting around town popping champagne. Instead, rejection after rejection trickled in. That is, until my forty-fifth birthday.

I've never particularly liked my birthday. I don't like all the messages on social media. I don't like the attention. But on this particular birthday, Jay and I were in Maine for a long, summer weekend away. I was reading on our small patio, and he stepped out to take the dogs on a quick walk when the text from Ann came through.

Can you talk?

I responded in two seconds: *YES!! Oh my god! YES!!* (I told you that I have absolutely no chill. I'm not kidding). I knew what her text meant. I knew my proposal had made it up the ladder for one publisher, but I hadn't let myself think about it much because we'd been there before, and I didn't want to get my hopes up.

Cool, calm Ann replied: *Calling now.*

My phone didn't ring. I stared at it, hands shaking, head spinning.

Ann again: *It's going to voicemail.*

I looked at my phone. I didn't have any bars. No service. No *flipping* service. I was about to run out the door and sprint down the street with my phone outstretched to the sky when I saw one bar pop up. I was back in business.

I hit call and when she answered, she was ever so cool.

"Hi. How's your birthday?"

"Fine," I said impatiently.

"Are you doing anything fun today?"

I couldn't take the small talk. Not after that text. She wasn't calling to talk about my birthday. "Do you have a gift for me, Ann?" I told you I don't have any chill.

"I do."

The rest is history. This book is in your hands because of that call.

I beat the rejection game.

Rejection is a Sneaky Devil

Before I got the deal, I spoke at an event on a panel and shared my journey of rejection. Someone approached me after and asked how I managed to push through the negativity that comes with each *no*. She was struggling in her business and was losing money month after month. She was ready to throw in the towel. She wanted to know if I thought there would ever come a time when I would give up on a dream.

"I won't quit," I told her. "Because every *no* is one step closer to that *yes*."

When you want something so badly, you won't let anything else get in your way. You won't let challenges disrupt your dreams. You won't let moments of hopelessness linger for too long. You won't let anyone tell you that you can't get what you want. Rejection is just a numbers game. It isn't more or less, and it says absolutely nothing about you, your work, or your talent.

When Jay and I first started dating, my brother once told him "She gets everything she wants." He's not wrong. I do, but not because I stomp my feet and demand compliance. Nor am I a diva who can snap my fingers and have my desires magically appear. I get what I want because I don't give up.

I am unshakably tenacious.

And when you are street-level gritty, you will always find success, because at some point, you will outrun, outwork, and outdream all the rejections.

However, I didn't always have an easy time with rejection. In fact, I was a petulant baby about it a long time ago. I was rejected to every law school I ever applied to except for the one who took me. I applied to about eight different schools. As the thin envelopes trickled in (this was before acceptances were emailed), one

after another was a big fat R. I was heartbroken. I almost didn't go to law school because I told myself that if I couldn't get into at least half of the schools I applied to, I didn't deserve to be a lawyer. Yikes, I was harsh. I most definitely would not have selected my alma mater as my first, second, or even third choice. It was my last choice. It was supposed to be my safety school. It was the one I applied to as an afterthought. It was also my only choice. I almost quit before I even started, until my mother reminded me that my rationalization for throwing away a legal education was a bit extreme.

"In three years, you'll have a law degree. Will it really matter what it says on your diploma? You'll be a lawyer. Isn't that the point?" she asked.

She was right. I hate when that happens.

On the first day of school, I met someone who has become one of my closest friends. I felt at home immediately, and I never looked back. I wouldn't change the experience I had at my school for anything. All those rejections were just a redirection to a place I would never have chosen but ultimately, was the best place for me.

Rejection is a sneaky devil like that.

So, what does rejection have to do with your journey to win?

Everything. I'll explain with some science.

Newton's Second Law of Motion states that force upon an object causes it to accelerate proportional to its mass. Sometimes you just need the push to get the ball rolling. If you've always wanted to get that certification, act fast, sign up, and then allow the rest to roll out. If you've always dreamed of opening a brick-and-mortar store in your town, roll into the first, smallest thing you can do now by setting up an Etsy storefront. If you need to move on from a relationship, schedule a time to have the hard

conversation, and allow momentum of that chat to bring you into your next chapter (either together or apart). If you want to meet someone, set up your online dating account.

Your action is required. Otherwise you are sitting on unrealized dreams and thoughts. However, once you roll into the first, small action, you must allow momentum to take you to the next step, and the next step, and so on. It's hard to roll up a hill, right? It's impossible without momentum, but once you start, you can keep going by continually doing the next best thing to move yourself forward. Once you get going, be careful of self-sabotage syndrome. That is when you think you aren't worthy of love, so you sabotage a relationship. Or you think you aren't worthy of having a successful business, so you sabotage that. You sabotage your happiness because you don't believe you deserve it, even though you so badly want it. It's a phenomenon that impacts the decisions we make, and ultimately, can define our futures. If we don't believe we should have whatever we actually want, then even if it comes to us, we energetically will send it away. Our worthiness compass has us all twisted up and pointed south when we should be heading north.

But you can overcome self-sabotage through action. This stage of the Stop, Drop, and Roll formula requires you to do something. Overthinking or ruminating is no longer an option because dreams and visions of where you want to be will only get you so far. You can't expect the universe to do all the heavy lifting.

Imagine if I stopped trying to find an agent after the hundredth rejection? You wouldn't be reading this book right now. However, my agent was not going to magically find me. I had to be proactive in my search. This book would not magically write itself. I had to sit down at my laptop every single day. Once I had

the agent, I trusted that my book would end up with a publisher who would champion it. Once I got the book deal and wrote the words, I trusted that this book would find its place in the world. And so, it did.

By now, you've STOPPED and assessed everything that's happening inside you. You've DROPPED all the excuses that hold you back. Now, it's time to ROLL into action. Not just any kind of action, but rather, action that will lead to rejection. Because believe it or not, that's the good kind. When you are exposing yourself to the potential of rejection, you are putting yourself on the line, and when you do that, watch out. Because you are on your way.

STOP **DROP** **ROLL** **WIN**
(and assess) (your excuses) (into rejection) (at life)

Wear Rejection Like a Badge of Honor

I like being rejected, says no one ever.

There is an easy, fail-proof way to prevent rejection in your life. Want to know what it is? You simply don't try. If you want to protect yourself from the pain of defeat, then don't put yourself out there. If you want to save yourself from heartache, then don't allow yourself to love. If you don't want to face *no*, then don't ask for *yes*. That sounds like a very safe, very Helen, way to live. It's also very small. Shielding yourself from rejection prevents you from triumph.

You are better than that.

You are more resilient than that.

You have too much to give to allow rejection to hold the reins to your future.

And if you aren't lining up some rejection in your journey, then you are inviting stagnation into your life. If you can't recall the last time you've been rejected by something, you are not dreaming big enough. If you can't remember the last time you got butterflies in your belly at the prospect of doing something, you are stuck in inaction. If you haven't failed at something recently, you are not honoring your fierceness.

Stagnation means you are not taking risks, and you are playing it too small. On the other hand, when you play all out and roll the dice on a dream, you may feel the heartache of rejection. You may have people tell you it's impossible. That's OK. Feeling disappointed or deflated by rejection doesn't mean your efforts were wasted.

Rejection is a gift. If you are paying attention, you will acquire scraps of valuable information with each rebuff. Take the data, analyze it, and use it to get better. You will get stronger. You will get clearer on what you want—and what you'll need to do—to get there. And when you finally get the text, call, or email that validates whatever it is that you've been daring to dream, you will understand that it was all part of your story, and it all had a purpose.

Some of the biggest success stories start off as rejection stories. Anna Wintour, Editor-in-Chief of Vogue, was fired just nine months after being hired as a fashion editor of Harper's Bazaar. Sallie Krawcheck, CEO and co-founder of *Ellevest*, a digital investment platform for women, was terminated from two executive-level positions before she used her terminations as an opportunity to create her own company. Early in her career,

Meryl Streep was told at an audition that she was "ugly." Oprah Winfrey was fired from her first job as an anchor. Imagine if any of these women allowed rejection to stop them. Imagine if they took other people's opinions as a sign to quit. They each had something in common: tenacity. It was their superpower too.

We attach rejection to something bad, but what if rejection is a good thing? Why do we hide rejection instead of sharing it with pride? It's as if we don't want to admit we've been rejected because it means admitting defeat. If we shared our stories of rejection with each other, wouldn't that normalize rejection and make it more palatable? Think about what you can accomplish when you no longer attach negativity to the experience, or even more so, when you no longer attach self-worth to it.

To revel in the elation of victory, you need to get cozy with rejection. Saddle up next to rejection and make her your friend. She isn't there to hurt you. Her purpose is to help you grow, and guide you to the truth and away from unaligned opportunities. Doesn't it sound much nicer when I say it like that? Doesn't it make you want to invite her over for a cup of coffee so you can have a nice chat and understand each other?

How about we take this one step further and even celebrate our rejections? How about you wear your rejections as a badge of honor to be acknowledged instead of hidden and disguised? Let's let our trials and tribulations be known. I propose we all start wearing merit badges like they do in girl scouts. You earn badges for trying, failing, not quitting, and winning. It can be our secret girl code; when we see a sister with a badge commemorating her journey of doing hard things, we can congratulate her for putting herself on the line.

I'm proud of all the rejections I've racked up over the years. I hope you are proud of yours too, because the longer the list, the greater you have dared to live.

Remember, rejection is brave.

Rejection is growth.

Rejection is moving you one step closer to your dreams.

Rejection is redirection to something better.

What inspired action can you take when rejection isn't the nemesis, but rather, is the catalyst to winning at life?

What would you go for right now if you weren't afraid of rejection?

Do that. And wear it proudly.

Chapter Sound Bites

- When you want something so badly, you won't let anything else get in your way.
- Stagnation means that you are not taking risks and it means you are playing it too small.
- Rejection, is a gift because if you are paying attention, you will acquire scraps of valuable information with each rebuff.
- Your action is required otherwise you are sitting on unrealized dreams and thoughts.
- **ROLL into rejection** like a badge of honor.

CHAPTER 11

Roll into Adventure

*The biggest adventure you can ever
take is to live the life of your dreams.*
—OPRAH WINFREY

I'm obsessed with dogs. It's really hard for me to walk past one
without stopping, crouching down, telling my new furry friend
how much I love them in a high-pitched squeal, and petting them
until their owner pulls them away. So, of course one of the first
things I suggested to Jay when we got engaged is that we rescue
another dog. It would seal the deal, and be a bonding ritual for
him and me. I told him the dog could be his. (I lied, but please
don't judge me. I can't help it if the dog picks me as their favorite
human.) He agreed, and we embarked on finding the perfect pup
to complete our new, blended family.

The day had come when we would be meeting our new addi-
tion. It was February 14, 2015, and Jay and I found ourselves
standing in an empty parking lot with a handful of other people
who would also be meeting their newly adopted dogs. Everyone
was bundled up and moving to stay warm. I was jumping up and
down. The chill was the kind that was even freezing my eyelashes.

We watched the dog-transport van roll in. A man stepped out and asked us to give them a few minutes as it would take them some time to get organized. It was too cold for disorganization, but no one complained. We all had nervous energy. We were all excited, too. It's not every day that you meet your new dog for the first time.

The van transported six dogs up from Georgia. None of the owners had yet met them. We didn't know anything about ours apart from what his foster mom had told us over one phone call. He was a stray that she pulled from a kill shelter. She didn't know his history, but she said she couldn't leave him there because of his "soulful eyes." His name was Tig.

"He's my favorite rescue I've ever had," she told me in her southern accent. "He's so sweet. I've had him over a year because, you see... we don't know much about him. He was found on the streets. He has some scars. People are scared of not knowing his history, so I've had him longer than any others."

"Does he have food aggression?" I asked. "Does he get along with other dogs? Does he eat his own poop?" Seriously, I asked this. If you've ever owned a dog that does this, you know exactly what I'm talking about.

"No, on all fronts," his foster mom assured me.

"He's just the sweetest, despite whatever happened to him."

She sent me a couple videos of his tail thumping to her voice and his sideways prance. It was a done deal. This little guy would be making the trek up to the Northeast.

One by one, the driver of the van walked dogs off the vehicle and over to their new owners. The dogs jumped and wagged, greeting their humans. The homecoming was joyful. We waited for our turn. When there didn't appear to be any dogs left, I said, "What about ours?"

"Tig, right?" The driver checked his clip board, "I'll get him now."

It seemed like an eternity as we waited for our pup to come bounding out of the van. I imagined he would run over, jump on us, and lick our faces, and that we would ride off into the sunset, as one big, happy family. That's not what happened. Instead, the driver emerged carrying our argyle sweater-adorned, forty-five-pound Pitbull in his arms.

"He's a nervous one. I'd get him in the car quick. It's cold out here." He put the shaking, brown pup into Jay's arms. I looked into this sweet dog's face and knew immediately that he was ours. I sat in the back seat for the ride home to comfort this shy boy. He didn't bark, move around, or lick my face. He sat on the floor despite my urging that he could join me on the seat. He watched me. I watched him. He let me gently pet his head. I knew it would take time for him to trust us. Whatever happened to him could not have been good.

It took hours before we saw his tail wag for the first time, and it was a quiet, reserved wiggle. On the first night, I called him up on our couch and I tucked him under a blanket and just sat with him. That spot was his for the next seven years, and my spot was right next to him to his right. I moved slowly because I didn't want to scare him. I ran my hands down his back and my heart broke a little more with each scab I found on his body. His tail thumped.

Over the years, Tig would never play fetch. He wouldn't bark at people coming into the house. He wouldn't even play with toys. But he would cuddle up next to me on the couch in our respective assigned places. He would sit under my desk while I worked. And he would run like he was a puppy whenever we went to the beach. It was the only time we saw his youthful exuberance. He loved the

wide-open space of the beach. But most of all, he loved his people. His head could always be found on someone's lap, mine, as I typed on my laptop from the couch; or my son's in the backseat of the car. When he looked at you from his sweet, brown eyes, you just knew he was a kind pup. That day in the parking lot, our family grew by one. We didn't get a happy, bouncy, ball-fetching dog.

We got Tig, and he was perfect just the way he was.

Anytime we embark on something new, we are welcoming adventure into our world. It could look like falling in love, having or adopting a child, or bringing a pet into your home. Maybe, it's saying *yes* to an opportunity that is uncertain and exhilarating. Living an adventurous life doesn't require you to travel the world and bounce from hostel to hostel. It only requires you to open your heart even when it sometimes breaks. Then open it again because every high, every low, every heartbreak, and every moment of celebration, is part of the adventure... even when we don't know what the ending looks like.

The not knowing is part of the adventure, too.

Your Adventure Awaits

Risk is a funny little word. So few letters and so much impact. We think of risk as something that's negative and something we want to avoid at all costs. We think of risk as putting your life on the line and your safety in jeopardy. Adversely, living a life that is *riskless* is accepting a life that is unchallenged, and dare I say, unfulfilled. Every adventure requires some level of risk. Adventure forces you to put yourself out there, push yourself, and see what you're made of. It's called an adventure because it's meant to be exciting and adrenaline pumping.

When you set off to explore, you don't know what you'll get, where you'll land, or how lost you'll be along the way. You may look back and ponder how hard it was, how trying it was, and how rewarding it was too.

Anything new comes with some level of risk. But no matter how it ends, the lessons along the way are growth opportunities. With risk comes the danger of failing, falling, or losing, but on the other side of risk comes incredible adventure.

An adventurous life doesn't require climbing to the summit of one of the tallest mountains or scuba-diving with great whites. That's not the adventure I'm talking about here. The adventure I speak of is one where you challenge yourself to get uncomfortable. An adventurous life is one where you do things that terrify and excite you. It's about saying *yes* to your dreams even when that makes your heart thump like Tig's tail.

I was recently asked to give a keynote at a women's conference. As I accepted the offer, I also had an "oh shit" moment because I needed to actually write a keynote, and the conference was only eight weeks away. I knew one of the other speakers; she is a well-rehearsed rockstar on stage, and I'd be following her. Panic set in. I wanted to turn down the offer, but I also knew this was an opportunity to practice the craft of speaking. It would have been safer to turn it down, but that wasn't the adventurous thing to do. I also knew that if I said, *no thanks*, I would be disappointed in myself for not accepting the challenge. How could I possibly write a book about winning if I was playing it safe?

Whenever I'm faced with a decision like this, I always ask myself how I would feel after I did the thing. Would I be proud? Would it be a teaching moment? If I turned it down, would I be upset that I didn't accept the challenge? It's how I evaluate each adventure. If there is an opportunity to fall on my face, then I

know it's my next escapade. I know it's big enough. Some of the most worthwhile decisions I have ever made have been risky. But those wild adventures have shaped who I am today and the decisions I'll make tomorrow.

Starting a business dared me to keep moving the needle as I scaled. It challenged me to learn how to be a leader. It also highlighted my weaknesses of being a manager. There was a lesson in all of it.

Getting divorced, once, and then twice, forced me to hold up a mirror to my self-worth. It made me get comfortable with spending time alone. It required me to own my financial independence. There was a lesson in all of that, too.

Vacationing alone with my son when he was young mandated that I learn how to navigate maps, airports, and being lost. The lesson was that I'd figure it out, no matter what.

Believing in love and trying it again despite many failures, showed me that love can be so rich when you are vulnerable. It allowed me to trust someone like I had never trusted before. There was a beautiful lesson there too.

Stepping on stage showed me I wouldn't die from doing something I found terrifying. It also reinforced that I had something to say. It showed me that being imperfect is all part of the process. It's a lesson.

Sometimes, you need to hit rock bottom before you pay attention. Sometimes, you need to be sitting on a heap on the floor, crying and begging for an answer or for some relief before you can stand up again. A life lived without struggle, adversity, or pain is one that is also without joy, happiness, and fulfillment. How can we possibly know the heights of elation without also knowing the depths of darkness?

It's only human to let thoughts swirl around in our head and to weigh and judge them. But problems occur if you stay stuck in

the status quo. It's in this place of purgatory where a little tiny part of your soul dies, too. Because that is when you start to tell yourself you don't deserve anything more. You start to tell yourself that you can't. You shouldn't. You aren't strong enough. Or even that you deserve what you got.

I'm here to tell you:

You can.

You should.

You are capable.

You deserve whatever you can dream.

Rock bottom is just a season; it is not a final destination. It's all an adventure, even the bad stuff.

Leaving the practice of law reminded me that being one thing didn't mean I couldn't also be something else. It would have been far safer to stay doing what I'd been doing for twenty years. It was far riskier to try something new. But it's all an adventure, and isn't that the goal?

Laying my vulnerability out in these pages is a lesson I'm learning in the moment. What will happen? How will it be received? That's for you to decide and for me to absorb. I'm sure there is a lesson somewhere in here that I will find out soon enough.

I've never regretted a risky decision. Sometimes they've brought me to my knees. Sometimes they've emboldened and empowered me. Sometimes, they made me celebrate. I've had more moments than I can count when I wanted to give up. I was tired and overwhelmed. I questioned why I even bothered. Then something happened to remind me of my *why*. And it always taught me something.

You are a fierce fire and adventure is your right, but rarely does it force itself upon you. More often, you need to make the

decision to let adventure in. You need to decide that you can't shine without seeing what you are capable of (and what you are capable of is more than you will ever know). You need to want adventure. Most people opt out. You're reading this book, so I know you don't want to sit this life out. If you're always choosing the *riskless* wager, you aren't betting on yourself.

I know you want more.

I know you have big dreams.

I know you have an even bigger heart capable of conquering every challenge thrown at you.

I know you are fierce, brave, and bold.

So, lets pack your symbolic suitcase and **ROLL** into some adventure.

STOP (and assess) **DROP** (your excuses) **ROLL** (into adventure) **WIN** (at life)

Adventure is Not a Platitude

When I was writing this chapter, Tig had a seizure. It was not the first time, but that didn't make it any easier to watch helplessly. It's an awful experience because you can't do anything to help or to make it stop. The seizures started months earlier and he was on a steady dose of medication that kept them at bay, that is, until the medications didn't. Jay and I rushed him to the emergency hospital and waited four hours to be seen.

He had gone through so much in his past. He had a long scar down his back, the cause of which we will never know. He was

missing a piece of his ear, missing teeth, and had other scars on his body. But Tig loved unconditionally. He trusted people, and there wasn't another dog or person he didn't like. He gave his belly to every child he came across. As he looked up at me, waiting patiently at the emergency clinic, I knew the adventure of bringing him into our house was worth all the heartache of watching his health fail. With joy comes pain. It's unavoidable and inevitable.

He had another seizure when we were waiting to be seen. The vet tech scooped him up and rushed him behind swinging doors. We paced, waiting for news. Then we agreed to leave him overnight for tests, even though I knew there was not going to be a positive outcome. I knew the joy of our previous seven years had come to completion. I sobbed the entire drive home. I vowed that I would never own another pet because I couldn't take the pain of losing them. If you've ever lost a pet, you understand the magnitude of heartache. The same goes for your life. The challenges that come with your adventure are uniquely yours alone. The pain that comes from decisions you sometimes must make can't be shared or passed around. It's yours.

Pain is hard.

Heartache can be debilitating.

Loss feels insurmountable.

Loneliness has the capacity to be crippling.

It doesn't mean you don't roll forward anyway. Sometimes the hardest decisions are the best ones you'll ever make. Sometimes adventure is a lonely trek down an unpaved road. But it doesn't mean you should veer back to the well-traveled path just because it's an easier journey.

Platitudes about adventure are phony. While it's nice to think your adventure will be accompanied by a well-packed, Louis

Vuitton suitcase, in reality, your suitcase will look more like a banged-up, scratched canvas bag with a broken clasp. You still need to drag that sucker behind you, and if it gets too heavy, just let it go.

The next day, I received a call from the neurologist that our beloved Tig had a brain tumor, and while we could have put him through surgery and radiation, the recovery would have been hard. That didn't feel right. He had such a difficult early life; I refused to let the end of his life be that way too. It broke my heart to think of putting him through procedures just to extend his life a little longer. He wouldn't understand what was happening to him, and as much as I wanted to hang on to every minute with him, I thought it was cruel.

I arranged for a vet to come to our house so Tig could cross the rainbow bridge while sitting in his favorite spot on the couch. The emotions of writing this are hard and as raw as anything I'll ever write. I sobbed as I tried to release the guilt of making the right decision. I knew in a short while, I'd go to retrieve him from the emergency hospital, and we would have our final night. He'd eat a few Big Macs, sleep in our bed, and get so much love. The space under my desk feels so empty when I think about this now. The spot on the couch is so lonely.

In the words of Winnie the Pooh, "How lucky am I to have something that makes saying goodbye so hard." Had I not had those years of his wagging, thumping tail and little kisses to my nose, I also wouldn't feel so much loss and emptiness now. When Jay and I declared in our moments of grief that we could never allow ourselves to love a pet like that again, we both knew it was a lie. To protect ourselves from heartache, we would also be depriving ourselves of so much joy.

Getting a pet is a risk. You don't often know the history or the temperament of the animal. You don't really know how they

will fit into your household. Yet, we do it anyways, giving our heart to these creatures who start as strangers. It's so worth it because of the immense joy they bring to our lives (even when they chew our remote controls and piddle on our rugs). Bringing an animal into your life is also an adventure. There is joy, and there are moments when you find yourself swearing that you'll never get another pet again because they destroyed your favorite pair of jeans or because the pain of losing one is too hard.

Loving fiercely can be hard. At times, going for everything you dare to dream can be excruciating. When you choose to protect yourself because you don't want to experience the hard stuff, you are also robbing yourself of the immense joy and love that comes from feeling deeply and trying wholeheartedly. Our lives are not meant to be kept small just to keep us insulated from experiencing intense emotions. If we aren't feeling the tough times, we won't ever experience the amazing moments either.

So, ROLL into adventure even when you don't think you'll make it.

ROLL into adventure even when you think you'll pass out from fear.

ROLL into adventure even when you know your heart may break.

ROLL into adventure, and watch your world expand.

At some point, you will look back and see how far you've come. You'll appreciate the obstacles you've pushed through. You'll know your adventure is part of your complete human experience. Adventure isn't about a perfectly curated trip. It's not about staying neat and tidy. It's not about keeping your heart sealed off and safe from heartbreak. Adventure is about getting messy and gritty. It's about making decisions to follow your heart. It's about experiencing sorrow and joy. Adventure is about choosing you.

I know you can do anything and everything you'll ever dream of. You don't need more than exactly what you have now. There will never be a perfect time, so start today.

Do it messy. Do it imperfectly. Do it fiercely.

The world is waiting for you.

The morning we waited for the vet to show up at our house was the longest morning of my life. The minutes ticked by, and I wanted time to stop. Yet I also wanted it over with because it was so hard to sit next to my boy in our favorite place on the couch and look into his eyes, knowing that it was time for him to move on. He gave me a few final licks on my nose before the vet arrived. I believe it was his way of letting me know that it was OK to let him go. Jay held his head in his hand, and I stroked his belly while we watched him slip away from us. I believe we gave him the gift of releasing him from his pain. A week later, I was at the beach missing him terribly. My walk just wasn't the same without him frolicking in the sand with me. I looked up at the sky and asked that he let me know he made it up there. A few minutes later, I glanced up again, and there in the clouds was a distinct shape of an angel. Under the angel, was a cloud shaped like a dog bone.

I know where he is, there is a beach for him to run on, and a spot on the couch that is all his own.

Tig, this chapter is for you. I love you. Good boy.

Chapter Sound Bites

- With risk comes the danger of failing, falling, or losing, but on the other side of risk comes incredible reward.
- To protect yourself from heartache, you would also be depriving yourself of so much joy.
- If you're always choosing the *riskless* wager, you aren't betting on yourself.
- Sometimes the hardest decisions are the best ones you'll ever make.
- **ROLL into adventure**, and do it messy, imperfectly, and fiercely.

CHAPTER 12

Roll into Shame

*Shame is the intensely painful feeling
that we are unworthy of love and belonging.*
—BRENÉ BROWN

At the red light, I gave myself a final glance in the mirror. I was seventeen years old and on my way to meet my friends on a Friday night.

"What took you so long?" they asked when I finally arrived at Lori's house. Hers was the usual place where we kicked off our night and decided what to do next. Driving around aimlessly always topped our list. Sometimes, we hung out at our high school parking lot while the boys played wiffle ball and the girls gathered in clusters.

"I had to visit my grandparents first." It was a lie.

I couldn't tell them the real reason why I was late. I was embarrassed.

A few hours before, my brother and I piled into my parent's car and we set off to a large, brown, square building that had a sign outside which read "Medical Offices." We weren't there for a doctor's appointment. There was no one there at that hour.

There never was. It was just us, the multi-floor commercial building, and silence.

My father unlocked the door and punched in the alarm code while my mother flicked on the lights.

"I've got the barrels," I told my brother. I hated cleaning the bathrooms.

"Can one of you vacuum?" my mother set the vacuum down by our feet. "And don't forget to get all of the rooms." My brother hoisted it up and started the climb to the second floor.

I went to the closet that contained all the supplies and grabbed some clear bags. This was by far the easiest job. I glanced at my watch. If we moved fast, we could be done in an hour, and I would still be able to meet up with my friends.

This was a typical Friday night. My family cleaned a medical building. During the days, my father was trying to build a construction business and his luck had run short. This side gig helped pay the bills. During the day, my mother cleaned houses to help pay for all the activities my brother and I were in. Dancing—the costumes, competitions, lessons, and workshops—were expensive. We lived in a nice, suburban, yellow, colonial house in a middle-class town. We vacationed in Florida. There was always food on our table, so our struggles were tiny compared to what others endure. We presented as a nice, middle-class family. Except we had a secret. Well, I had a secret; one that I would do anything to keep hidden from my friends. When you're in high school, perception is everything.

I hated those nights. I never told my friends that I did this because I was ashamed. They didn't have to clean doctor's offices or tag along with their mother to clean houses on days when there wasn't school. I did it because I felt bad. She was working so hard to pay for us to be able to do activities which we loved,

but that could have been cut from their expenses. I accepted a Dunkin' Donuts coffee Coolatta as my payment for those work days. Some of the houses were worse than others. The ones that were filled with clutter were my least favorite because no matter how much I dusted, it never looked clean.

I never told my friends that this was where I was on those days. I was embarrassed.

Sometimes, the thing that brings us the most shame is also the bridge to the most freedom. Back then, I would have done anything to avoid those Friday nights. Now, I can look back and say that my parents gifted me work ethic and grit. I learned how to get my hands dirty, literally and figuratively. I learned how to go after whatever I wanted, no matter the grind and hustle it sometimes took. I also learned that I could change a barrel liner like nobody's business. I still hate cleaning bathrooms.

While this was my first lesson in shame, it certainly was not my last.

Be Unapologetically Shameless

Have you ever looked up the definition of the word *shamelessness?* Well, I have, and it's not positive. Merriam-Webster defines it as: insensible to disgrace. The Cambridge Dictionary takes it a step further and defines it as: a lack of shame, especially about something generally considered unacceptable. And if that definition isn't satisfying enough, they give us a second: behavior that is intended to attract sexual interest, and that shows no feeling of shame. The example they use in a sentence is a real zinger. *He blushed at her shamelessness.* Oh, that poor man (whose name is likely Adam) was subjected to that woman's Eve-like ways.

People find shame hidden in all kinds of life events. They are ashamed that their marriage ended. They are ashamed that they gained weight. They are ashamed that they were fired. People are ashamed when their house is dirty and someone stops by unexpectedly. I even know someone who tried living in another state, and felt ashamed when she didn't like it and moved back to Connecticut. Shame is why 20 percent of college-aged victims do not report sexual violence on their campus according to a study done by the non-profit RAINN. When I found myself in a bad situation during my freshman year of college, I never said anything. I was lucky, because I was able to get myself out of the room before things got worse, but one of my sorority sisters was raped by this same person, and she never said anything either. Why? We blamed ourselves. We blamed it on alcohol. We were embarrassed. We had shame.

You and I know that there is nothing shameful about any of these life occurrences. They are things that sometimes happen. That's all. Yet, somewhere along our journey, we decided that if something didn't work out flawlessly, then we need to attach shame to it.

On the other hand, when you don't feel shame and society tells you that you should, you are shameless. And it's bad to be shameless, right? At least the dictionary says it's worthy of condemnation.

I, however, call bullshit.

When you have shame, you hold it in, let it fester, and even lie to keep it from getting out (as I did with my friends back in my teenage days). However, shame has not one ounce of usefulness. It doesn't inspire you, motivate you, or make you strive for something more. Shame doesn't teach you; it torments you.

For years, I never talked about my two divorces because I had so much shame around them. I didn't want people to think that my divorce history reflected who I was. In fact, I went out of my way to keep it buttoned up and tucked away from my work life. I went to great lengths to keep my truth hidden. One day, that all changed. I dipped my toe into the shamelessness pool by accident and once it was submerged, I found I liked it and jumped all the way in.

Let me share the story that all started with sushi. My friend Nicole is a podcaster, and she asked to interview me. At the time, I didn't listen to podcasts or even know where to find one to listen to. I was skeptical.

"I'll bring over sushi. It will be fine," she said when she saw me hesitate.

I agreed immediately. I'd talk for some good sushi. She showed up with not just a few rolls, but a whole enormous platter. We had a Bee's Knees cocktail, and then when I was really relaxed and a bit loose in the lips, she clipped the microphone onto my shirt. "We're just going to have a conversation. No big deal," she said.

I popped another piece of sushi in my mouth. I was ready to go. That is, until she started asking me questions about my divorce. I had never spoken about my divorce before, at least not in a public forum. I kept that part of my life shrink-wrapped away from the rest of my life. It was easier that way, or so I thought. When she started asking me questions, something really wild happened. I answered. And I didn't just give her some platitude-filled vagueness; I spilled the beans on all that I had felt during and after the divorce. Oddly, with every question, I felt a weight lift. I said things I had never spoken out loud. It was liberating because I started to feel my shame lift. I was amazed that

something as simple as talking about my divorce could alleviate my shame around it.

When the episode dropped, two things happened.

1. I had to warn my mother that she may have come up in the interview.
2. I was inundated with messages from women who said they too, felt what I had, and they thanked me for sharing my story because they didn't feel so alone anymore.

From that point on, I knew that holding onto my shame held no purpose. I knew that I could serve so many more women by sharing my pain rather than hiding it. Once I took a sledgehammer to my shame, my entire life changed. I showed up to the world in a different way and I slowly started to become more and more vulnerable. And that vulnerability led to increased revenue, speaking gigs, and this book. But more importantly, that vulnerability led to personal freedom.

Your shame has no purpose. Shame doesn't heal; it hinders. Shame doesn't serve you; it silences you. Shame doesn't free you; it imprisons you.

Share your story.

Speak your truth.

Squash your shame story once and for all.

Want to send your shame into the wind? Try this exercise: Write down the shame you've been holding onto. A few sentences will do. Then take a match to that paper and all the old shame stories that you've been holding onto. Feel the power when you watch your shame go up in flames.

Use your shame as a catalyst for your purpose. Let's flip the definition of shamelessness. Let's free your shame. Let's celebrate

being shameless because on the other side of shame is humanity. You, me, and everyone else who breathes air has made mistakes and hard decisions and has stories that color their past and present. It's part of who we are, and we shouldn't feel any shame around that.

ROLL into your shame, and free yourself.

STOP + **DROP** + **ROLL** = **WIN**
(and assess) (your excuses) (into shamelessness) (at life)

Say it Loud, Say it Proud

"You are really good at self-promotion," he said. He was a lawyer I respected. He was always deferential and civil, so his words landed a bit heavy.

"What do you mean?" I was truly perplexed. I loved marketing my business. Isn't that what you are supposed to do when you own a business? You want people to know what you do, so those who need you can find you.

"I mean, you don't hesitate to put yourself out there," he explained. "It's not a bad thing. I mean, I wish I could be so... shameless." My eyebrows shot up. "I don't mean shameless, I mean bold." He truly looked apologetic. I wasn't upset, but I was curious.

There it was again. This idea that women need to be quiet, refined, and humble—in other words, good girls. I really don't think that lawyer meant anything by his comment, but I do think he was a victim of societal conditioning which told him that a

woman who speaks out is boastful. How many men do you know who brag about everything from their golf game to their bonus to the size of their boat (I said boat, so get your mind out of the gutter). Men can boast, and there is nothing wrong with it. In fact, it's expected. But, when a woman even remotely suggests she is good at something, well, she is something else. She's conceited. She's a diva (not the good kind). She's brazen. I know so many women who are the best at what they do, better even than the men. Imagine that.

It's time for you and me to change this script. It's time for you to get loud and proud about all that you have done. It's time to celebrate your victories with pride. It's time to let everyone know why you are so damn special. You absolutely should be promoting yourself. You should be sharing wins. You should be brazenly cheering other women on as they achieve great things. You should be taking a megaphone to your achievements, and you should do this unequivocally. You should also be willing to stare down anyone who has the audacity to call your modus operandi into question.

If someone tells you that you are "too much," thank them. I'd take "too much" over "not enough" all day long. If someone tells you that you are weird, eccentric, or odd, thank them too. I'd take those over "ordinary" in a heartbeat. If someone tells you that you are "too opinionated," thank them. Passion is something to be celebrated, not quieted.

Think about the ridiculous idiom, "They bit off more than they can chew." That sounds like a person who went for it. It sounds like someone who didn't let fear of failure obstruct their path. That's a good thing, yet we all know that saying is never used in a positive context. How about we congratulate that person for playing bigger instead?

If someone laughs at your dreams or belittles your ambition, cut their energy from your reality. You may not be able to physically remove them from your life, but you can imagine there is a cord connecting the two of you, and you can take a giant pair of scissors and cut that cord so their energy is no longer attached to yours. Anyone who thinks your goals are unrealistic needs to be ejected from your inner circle. Surround yourself with those who are daring you to go bigger, louder, and bolder. Those are your people. That's the energy you want near you.

I recently had a Reiki session. I went in not knowing much about it, other than that it's a healing technique where practitioners use their hands to balance and move energy in your body. I was skeptically curious, thinking Reiki's been around for thousands of years, so maybe there was something to it. I am very much a spiritual person, but the idea of someone waving their arms over my body and magically taking away all my negative energy seemed a bit much, even for me. However, I walked into the small studio with an open mind because I knew something felt off in my life. I felt like my energy was stagnant. This woman walked me through a guided meditation while also doing some trickery with her hands. What happened after was nothing short of a miracle. A few hours later, I felt so light. I was able to concentrate with a renewed focus that I hadn't had in months. My mood was lifted, and that night, I even had a phone conversation wherein I removed someone from a project because the person was no longer the right fit.

I told myself it was probably just because I was well rested, but I knew it was more than that. She changed my energy. I share this story not to tell you to run out and get a Reiki session, but because energy is not a figment of your imagination. It's alive and can move or stay stuck, and it's up to you to be sure you cut the

energetic cords of those who are holding you back from success or keeping you stuck in shame.

You've come this far not to only come this far. You've worked, hustled, grinded, studied, and showed up even when it was hard. You've climbed obstacles and overcome challenges, so why shouldn't you be proud? Why shouldn't you boast about how much you've achieved?

Raise your megaphone, shout it loud, and shout it proud.

Money is Not a Dirty Word

I grew up believing that it's tactless to talk about money. It's rude. Ladies don't do that. I'm not even sure if someone told me this, but somewhere along the way, I adopted this belief. When I found myself working with women who were going through divorces, I noticed that so many others had the same money story. I noticed how uncomfortable some women were. Often, they wanted someone else to figure out their finances for them. I also noticed that a lot of my friends don't talk about money. They don't share how much they make, how they invest, or how they eliminated debt. Money just doesn't come up often. That is, until I started putting myself in rooms with other female entrepreneurs who were celebrating their financial wins.

Money was no longer taboo. Money was a tool to create a life of freedom, which meant something different to everyone.

This section won't solve all your money woes. I can't wave a wand and make the money tree grow some extra branches. I can't tell you how your bills will get paid if they are larger than your income. I can't forecast your financial landscape if you quit your job, get divorced, or go back to school for that MBA you've

always wanted (although the most successful entrepreneurs I know don't even have degrees, so save your money and just start the business if that's your path). I do hope this section inspires you to take control of your money story, and get really good at knowing how it's working for, or against, you. Once you get really clear on your relationship with your finances, you can start to mold that relationship to help you get everything you want out of your life.

Let's get something straight right now: money, wealth, and financial security are not reserved just for the lucky ones. They are there for you too. Regardless of whether you are single, a stay-at-home mom, earning less than your spouse, or are the breadwinner in your house, you need to take control of your financial knowledge. In fact, it is your responsibility to be well-versed in money talk. If you outsource to your spouse the financial responsibilities in your home, it's time to reevaluate your relationship with money. If you ever crossed your fingers and hoped a check would clear because you hadn't balanced your account, it's time to get a grasp on your finances. If you don't pay attention to how much money you spend on discretionary things such as meals and entertainment, it's time to spend some effort calculating a budget. Is it annoying and not at all fun? Yes, but you should do it anyway.

This is why: women tend to have blocks around money. We've been taught not to boast or brag about money. We've even been taught not to talk about it because it's tacky. We've been taught to keep our finances close to our chest and when at all possible, to let someone else handle them for us. When you understand what is happening in your wallet, you are better positioned to increase your savings and decrease your debt. And when you have a handle on your money situation, you won't feel powerless to change it.

I don't ever want you to be stuck at a job you hate, in a marriage that is toxic, or in any other circumstance because of money. In the context of a divorce, it is still common for women to tell me their spouse handled the finances. It's still normal for women to say they had their income deposited into a joint account and aren't aware of where the money went and how it was being spent. It is also not uncommon for fear around money to hold women back from leaving their marriages. Regardless of whether they are employed or are the CEO of the home, money woes paralyze them. I don't want that to be you.

If you are considering marriage, are married, or think that one day you will be part of a coupledom, make sure you are actively engaged in the household finances. And to take it one step further, make sure you, fierce female, have your own separate credit card and bank accounts. Make sure you have access to your own money exclusive of any joint funds. Sometimes life unfolds in unintended ways, and having a good handle on your money situation can help alleviate anxiety and stress from life-altering events. If nothing else, you shouldn't have to get permission to access your own money to go shopping or plan a girl's weekend, or even to hire a divorce lawyer. A healthy relationship needs to have healthy communication around money, even when it's uncomfortable.

When you know, understand, and have some control around your financial situation, you will never be trapped into a decision because of money. When you have some level of financial independence, you are empowered to use money to your advantage. Don't wait for something to fall apart before you ask the questions. Single or attached, don't punt your financial acumen down the road for a later time. If you can't answer these questions, you

need to dig into your finances and take ownership of your financial power:

- What is your gross income (how much you make before taxes) versus net income (what you take home)?
- What tax deductions are coming out of your paycheck? (Make sure you are taking the appropriate deductions. Speak to an accountant if you are unsure).
- If you are a stay-at-home parent, you can still gather the above info about what income your partner brings into the home. And let me be clear here: it's not "his money." Your family made a decision for you to be in the Executive C-Suite of your home, and that job is so damn hard. So, we will call it household income, and you have a right to this information too.
- How much money do you need to cover your basic living expenses (rent/mortgage, utilities, food)?
- How much money do you have left over to spend on discretionary things after basic expenses are paid (these things include shopping, self-care, travel, etc.)?
- How much money are you actually spending on discretionary things (pay attention to eating out, because that one tends to be higher than we think).
- How much credit card debt do you have? How much are you paying on interest each month?
- How much good debt do you have? (Good debt is money owed on things that can build wealth such as a mortgage)?
- What does your retirement plan look like? (If you don't have one, schedule an appointment with a financial advisor to start the conversation. It is never too early, or too late).

- What is your credit rating, and how can you improve it if it's low?
- Do you have a "rainy day" fund for emergencies?

Your relationship with money starts with you having a clear understanding of how it flows in and out of your wallet. If you haven't considered retirement, now is a good time to, no matter your age or income. If you haven't ever looked at how much money you are spending each month on discretionary things, this is a good time too. You'll probably be surprised. Those manicures add up fast. I'm not saying you should cut anything out, but I am saying you should know where your money is going. If something happens and you had to eliminate some of your expenses, you should know what can be cut. Or maybe you want to start a business; you may want to figure out how many months you can get by without any income if you shave your expenses down to the minimum. You can start to plan accordingly and balance out your short-term consumables and long-term wealth planning once you have a grasp of your money reality.

Knowing your numbers is part of your financial freedom. Your money mindset is the other side of this coin. (See what I did there?) Most people have a fear-based relationship with money. They hold on tight because they fear there will never be enough. For years, I was telling myself a money story based on my childhood of watching my parent's struggle for so long. The story was, I had to work harder because money could run out at any time. I was trapped in a negative relationship with money that had formed during all those years of emptying barrels and feeling ashamed. When I launched my law firm, I had this same story on repeat, and for years, I struggled. I worried about what was in the pipeline, and there were many times when I wasn't sure I

could make payroll. For years, I cleaned my office myself because I couldn't imagine spending money on having someone else do that. Think about all those lost hours when I wasn't generating business because I was too busy changing trashcan liners.

Eventually, I changed my money story. Instead of having a scarcity mindset of there never being enough, I changed my script to one of abundance. That changed everything. I stopped stressing about money, and I watched it flow in. I stopped losing sleep over money, and I watched it multiply. In fact, once I understood my money mindset, my revenue skyrocketed. Coincidence? I think not. What did I do differently? Well, instead of focusing on all the ways in which the business was struggling, I started focusing on all of the things I could do proactively to acquire new customers.

It was mindset *plus* action.

Instead of focusing on how much debt you have, focus on what action you can take to eliminate it. Instead of stressing about how you will pay your bills if you lose your job, focus on what opportunities are in front of you that could be additional revenue sources. Your action is a necessary part of the process. To merely wish for it is not enough.

There is a statement I speak every time a money situation arises in my personal life. I share it with clients when they panic about not having enough money.

Money rejuvenates itself.

There is a caveat to that statement. Money rejuvenates itself so long as you release the fear around money and take action. And, to all my manifesters out there (I'm one too), you still need to act to help the Universe along. I've watched so many women launch themselves into new chapters as single women who are afraid they won't have enough to pay their bills. Money always

works itself out, so long as your relationship with it is healthy, and you don't leave it to whim. Now, that does not mean go max out your credit cards because money will magically appear. But it does mean, sometimes we need to trust that it will all work out. Trust that if you walk away from the relationship that is sucking your soul, you will be financially fine. Trust that if you take the job that excites you over the one that pays more but drains you, you will be able to make ends' meet.

I'm not delusional. I understand that you have bills that need to be paid and basic needs that must be met. But the minute you let money control you, that's the minute you are being guided by fear rather than abundance. It's a lack-money mindset that will hold you back rather than propel you into financial success. Let's get to the bottom of your money story. The following questions will help you uncover how your unique money story is holding you back. Be brutally honest with your answers, because under the fluff is the key to spinning your new money story into something useful—one in which your relationship with money is not one of fear, but rather one of curiosity and decisiveness.

- How was money discussed at home in your childhood?
- What were you taught about spending money?
- What were you taught about saving money?
- Do you recall your parents ever fighting about money?
- Did you feel like you had more or less than your friends growing up?
- Do you feel guilty when you spend money?
- Are you afraid you won't have enough money?

Getting to the bottom of your money story can help you create a new, healthy relationship with money. When you take control

over what happens to the money in your life, you become money savvy and empowered to use money in ways that work for you. There is absolutely nothing stopping you from buying your own house, scaling a business to seven figures, buying a vacation home, investing in other opportunities, and having enough money in the bank to feel financially secure. Well, there is one thing stopping you—that is, *you*. You are the only one getting in your own way.

So, spend it. Invest it. Save it. Earn it. Talk about it.

Now, let's go bury that old story and dig up that pot of gold. I'll bring the shovel.

Chapter Sound Bites

- Shame doesn't heal; it hinders. Shame doesn't serve you; it silences you. Shame doesn't free you; it imprisons you.
- It's time for you to get loud and proud about all you have done.
- When you know, understand, and have some control over your financial situation, you can stop feeling trapped in a situation because of money.
- Money rejuvenates itself.
- **ROLL into your shame**, and free yourself.

Roll and Release

Everything is working out for my highest good.
—Louise Hay

When I was planning a vacation out west with my son, no one told me to bring a wetsuit. Yet there I was, wishing I had one. Ethan and I traveled to Colorado and spent a week at a dude ranch. We signed up for every excursion offered, and that was how I found myself in a chilly predicament.

The guide called out to all the boats in our rafting group a few minutes prior, "Who wants to jump off the cliff?"

My hand shot up immediately without really thinking. From my raft, I watched a few people walk to the edge and jump, and others look over the side and turn back.

"Going down the rocks is far more dangerous than going up so be sure if you climb up you are going down that way." He pointed to the water. "I've seen too many people hurt themselves because they chickened out and needed to get back down. Let's not do that today, OK? It will make the rest of our day bad for everyone." He laughed, as if he'd told a joke.

On cue, a woman at the top did a little dance of indecision. She looked over the ledge, shook her head, and took a few steps back. Someone else jumped. She walked up to the side again, peered over, and then shook her head again. She made her way back to the narrow path that led to ground level. We all watched her, holding our breath. She started her descent when her foot slipped, and she slid down a stretch of rock.

"That's going to hurt later," the guide said to us. "Don't do that."

How bad could it be, I thought when I jumped out of the raft. The water was frigid. I focused on one stroke in front of another to get to the side of the river where I would climb the narrow, rocky path to the top. When I reached the water's edge, I put one hand over the other as I climbed up, up, up. My water shoes were too big, and my heel kept slipping out. There was no turning back though, and I scrambled over the rocks behind a few others who were making the ascent too. When we made it to the top, we lined up breathlessly. The guy in front of me took a few baby steps to the edge, looked over, and then turned back to the rest of us.

"Shit, it looks much higher from up here," he chuckled nervously.

Someone said something encouraging to him, but at that point, I wasn't listening because all I could hear was my heart pounding. I bungy jumped when I was eighteen years old and jumped from a plane before I was twenty-one. I always loved a good adrenaline rush, but something had changed. I was a grown woman with an eight-year-old child waiting in the boat below. What if something happened to me? It was just the two of us on this trip. So many things could go wrong. I chastised myself for acting before thinking. The man in front of me looked back one

final time and stepped off the cliff. The splash seemed so distant.

It was my turn. I stepped forward and looked down into the Colorado River below. It appeared so far away. I was shivering from the cold water, or it could have been from fear. It was all the same.

"You've got this," someone behind me said. My son's face looked so small from up there. I took a deep breath and jumped.

I hit the water so hard that it felt like I hit a cement floor. My backside stung. I went under but didn't hit the bottom. Instead, I had to swim hard to get up to the surface. It felt like I would never emerge. My head finally popped up out of the water, and then both water shoes shot up after. I lost them in the impact. I tugged at my suit to make sure it was covering everything it was supposed to, and then I saw my guide laughing from his boat.

"That was quite a landing." He turned his attention to those in the water who were making their way over to the side to start their climb and yelled to them, "Make sure when you jump, you try to keep your body straight. Like a pencil. Otherwise, you'll land like she did." He laughed again. "That was quite a smack."

Sometimes, when we go for something, it feels like jumping into a cold river from fifty feet. The journey to the top will be rough. The launch will be scary as hell. You won't know how you'll land. The adrenaline will invigorate you.

And sometimes, you'll end up losing your shoes and getting a wedgie.

Embrace the Plot Twist

I wouldn't consider myself a control freak, but rather a control enthusiast. I like to make plans, execute them, and have the end

result unfold exactly as I envisioned. That day on the Colorado River, I imagined a smooth swan-like descent into the river. What I got instead was an ungraceful flop that walloped my behind. Life is kind of like that. We can lay out the most well-thought-out plans and still get thwacked with twists and turns.

White knuckling expectations and trying to bend them to your will like a glass blower molding the outcome, has only one guarantee: disappointment. When someone is going through a divorce, one of the most important aspects of what I do is manage their expectations. If I fail to succeed, they will never review any decisions with a clear mind. They will never be happy with the outcome, and they will never be able to move on peacefully because they'll be too busy looking back at their unfulfilled expectations. They'll be disappointed.

It's the same with someone who starts a new business and expects immediately to start producing seven figures because that's what people are doing on social media. Guess what happens when they barely break the six-figure mark in their first year? They are disappointed. They question their ability to be a business owner. They wonder if starting the business was a bad idea. They expected too much, too soon.

Think about one of those quick-fix diets that promises you unrealistic results. What happens when you don't lose the promised ten pounds in five days? You are disappointed. Your expectations were out of whack with what your body can actually do. Let's be real. Did we really expect to get the six-pack in thirty days?

Perhaps the most important element of ROLLING into action doesn't have anything to do with action, at all. If you're anything like me, you are a planner and doer, and slowing down feels forced because rocking and rolling is your default function. Yet,

holding onto an expectation that everything will happen exactly how you planned it when you planned it, is a guaranteed trip to disappointment land.

Let's just get this out of the way: nothing will go exactly as planned. If you expect the unexpected, at least you won't be disappointed when there is a plot twist. The secret is to embrace the plot twist and trust that it was supposed to happen this way. Trust that the twist is all part of the journey, and that you'll come out wiser for it on the other side.

When Jay and I were getting ready to take a trip down the aisle, there was a major power grid outage, and all the lights went out when we were separately getting dressed. He panicked, thinking I was panicking, but at that point in my life, I could not have cared less about a perfect wedding. I knew one day was the least important part of the relationship, so I was actually chill (for once in my life). I knew why this day was happening, and I didn't attach much to how it would happen. So what if there wasn't electricity to cook the dinner? We'd order some pizza. So what if we couldn't actually see the interior of the quaint bed and breakfast that was hosting our day? We'd light some candles and have a cozy hang with our closest family and friends. Because I released all expectations of what that day looked like, I was not disappointed. I didn't freak out. And I actually enjoyed the disruption for making that day even more memorable. The lights came on again mid-ceremony, and they stayed on long enough for dinner to be prepared. Then we were submerged into darkness once again. None of that mattered.

Releasing your expectations of what your journey looks like, and how long it will take to get there, is the final act of this phase of the Stop, Drop, and Roll formula. It's where you ROLL into action, and let momentum take over.

Most people I know like to be in control. I'm sure you do too. We have a desire to know exactly what outcome will follow our efforts. It's the desire to prohibit things that could throw us off course.

Yet, when control renders us incapable of movement, it is also a prison. Holding onto the idea that you can maintain control over all things all the time serves only one purpose—to prevent you from taking the risks we spoke about in a previous chapter. The fear of losing control over your life can stop you in your tracks and keep you stuck.

Let's shake up how you think about control. What if control was steel bars that held you back from living out your dreams? What if control was shackles on your goals? What if you released the need to be clairvoyant with your life, and instead of trying to control the roll, once you set your action into motion, you released it? What if you trust that your path will roll out for you exactly as it is meant to? What if you had faith that the Universe would provide you with exactly what you need? Would that help you loosen your grip?

Rather than be distressed when something happens differently than you imagined, what if you were curious? What if you approached a deviation in your well mapped-out plans as a redirection to something even better? What if the re-routing was happening for you rather than to you?

If someone asked you what your life would look in five years if all your dreams came true, you might say that you are doing what you love, living in the house of your dreams, and taking two exotic vacations a year. However, there are so many other details in the folds of those dreams. There are so many experiences that you can't imagine but are also part of the plan.

It's easy for us to create a place marker for goals. It looks like a job, house, or location. The place marker often doesn't contain a feeling, a moment in your day, or a thought before you turn off the lights. Yet, it's not always the big picture where we find ourselves. Sometimes, we uncover the beauty of the unknown in the intricacies of a morning routine or comfortable silence.

There is so much beauty to be seen, heard, and felt if we release our grip. Jay and I explored Paris years ago. We had a well-planned itinerary that included a ballet at the Opera house, a burlesque show, and lots of museums. However, the most memorable day was the one in which we set out on foot one morning, back-pack on, without a destination in mind. We explored and wandered, and what treasures we found that day: the best espresso martini I've ever had; a falafel with flavors that exploded in my mouth; the cutest, quaintest boutiques where I found some of my favorite, most unique pieces of clothing, items I still cherish to this day. There was so much beauty in not knowing what the day would bring.

Opening yourself up to experiences, people, and opportunities can change your life. Going off script can lead you to the next part of your story. There is so much freedom in not knowing. There is so much potential to bring you what you never knew you needed.

Sometimes, we just need to let go, in order to bring in.

ROLL and release, and watch how far you can go.

STOP + **DROP** + **ROLL** = **WIN**
(and assess) (your excuses) (and release) (at life)

Faith – the other "F" Word

Faith is a funny word. Everyone has a different interpretation of what it means to be faithful. For some, faith is attached to religion. For others, the idea of institutionalized religion may cause an adverse reaction. And for many, faith is a spiritual practice. It doesn't matter what you believe in, but having faith matters. Without faith, you will have a difficult time releasing control. Without faith, you believe that you alone are responsible for an outcome. Without faith, you will hustle so hard because you think that if you aren't doing something, you are losing precious time.

Believing that something bigger than you is at play is a common thread among leaders. Some will speak of Law of Attraction. Others speak of God. Some speak about their Reticular Activating System. These are all different ways of saying something very similar. That is, something incredible happens when we have faith, even though we cannot see it in a physical state.

For example, your brain can't tell the difference between reality and imagination. In other words, if you visualize something and feel all the sensations that go along with that visualization, your brain thinks it's happening. When you say you hope for something, there is a lot of fuzziness around what hope means. It's not definitive. There is too much room for not getting it. However, when you set detailed and distinct intentions to achieve something, your brain doesn't understand you don't have it yet, and your subconscious mind and conscious mind conspire to bring your intention into your present reality. That's the science of faith.

For my woo-woo peeps, the Law of Attraction serves the same function. Law of Attraction says what you think, you create—both

positively and negatively (so be careful about what thoughts you let in). Law of attraction says you have the power to create your reality through manifestation. There is an element of faith here too. At the risk of some criticism here, I don't believe that thoughts without any other action will get the job done.

Thoughts all on their own are never enough. Thoughts plus action plus faith is where the magic lies. Enter the Stop, Drop, and Roll formula. For example, no matter how hard I want to manifest a completed book, it would never happen unless I believed first that I could do it. Then, I stopped coming up with excuses as to why I couldn't. Lastly, I needed to sit down at my laptop and type some words. But what happens once that book is into the world is out of my hands and outside of my control. I can't make you feel a certain way about it. So I must release how it lands, who finds it, and where it goes. I must release my expectation of how well it does and have faith that it will find the people who need it most. No matter how hard I could have wanted, yearned for, and visualized a completed book, it would not have written itself.

Let's look at it another way: imagine if you found an ad for your dream job. You applied, interviewed for it, and are now waiting for a call back. You've done everything in your power to bring the job into existence, but now, you must release the outcome. If you don't get the job, maybe it wasn't the right one for you and next week, you'll find, apply, and be offered a position for a much better company. When you have faith that everything will fall into place exactly the way it is intended to, the outcome of your action is easier to accept.

A good friend called me recently. She was heartbreakingly unhappy with a situation in her life. She was desperate for advice. I couldn't give her the type of advice she was seeking. I

couldn't tell her what to do, but I could tell her what she shouldn't do. She shouldn't let this fester. She shouldn't wait for it to fix itself. She shouldn't wait for someone to fix the problem for her. No one had that power... except her. She already knew what she needed to do, but she was frozen in confusion and overwhelmed with feelings. She didn't have faith that it would all work out, because she didn't believe in her decisions. So, her faithlessness about her circumstance had her stuck in quicksand.

If we look at situations, life decisions, and game changers on a grand scale, we will get overwhelmed. But once we break things down into actionable, bite-sized tasks, they become manageable. I told her to give herself benchmarks to take action. Within three weeks, she should make peace with what her heart was telling her. In three months, she should have a plan in place so she wouldn't stay stuck. In six months, she should take action so the second half of the year would be filled with change either way. Either she changed the current situation and fixed it, or she removed this stressor from her life. Her soul was begging her for change. Her spirit was wilting under her circumstances. But she was lacking the faith that it would all work out once she rolled into action.

When you have faith that everything will happen as it should, you set things in motion, and your perspective shifts. You aren't married to only one option as an outcome, but rather, you are open to receive the absolute best outcome for you, and it could be something better than anything you imagined.

Having faith requires letting go of the idea that you know best.

It's time to loosen your grip. The universe will be there to catch you.

Now close your eyes, count to three, and fall.

Being Human is Hard

I've always hated the saying; *it is what it is.* Sometimes we don't want what fate is dishing out. It feels unfair. It's painful. It can't be justified or reasoned into something that makes us feel better. Sometimes it just sucks. A motivational book without real talk is as fake as the filters on snapchat. Winning isn't always adrenaline spikes and high fives. Sometimes, releasing requires a moment of just being. Sometimes, releasing calls for feeling the heaviness of it all.

I wouldn't dare tell you to try and see the positive in everything all the time. Sometimes, you just need to sit in the awfulness, cry it out, hide away under the covers, and feel every damn emotion. In these situations, trying to control your feelings is pointless. They only thing you can do to move through is to allow the feelings to come and pass. Get angry when you are upset. Scream when you need to let it out. Ugly cry when you are anguished. This isn't the time to box it up, put on a happy face, and pretend all is well.

Fortunately, I can count on two hands the times in my life when I truly endured grief and thought I would never emerge from it. I thought I would feel this way for the rest of my life. I thought this is just the way it would be from then on. At one point, I told my doctor what I was experiencing. Do you know what she said? She asked if I wanted a prescription.

I wasn't depressed. I was grieving. There is a difference. I didn't need to medicate my feelings. I needed to feel them and work through them. I was hoping she would offer holistic advice, but instead, I got chemical advice to fix me right up in no time. I didn't take the prescription. Instead, I found a new doctor and let myself sit in the suck.

Part of releasing is sitting in the suck when it's called for. It's accepting that sometimes, it doesn't work. Sometimes it's not meant to be. Sometimes, something just hurts. And that's OK. That time in your life is temporary. You don't have to show up with a smile when you don't want to. You get to rest and take time to heal. You get to have a season of taking care of your mental health. You get to hide from the world and sob. There is a release in that too.

You can release the need to always be on.

You can release the expectations of how you think you are supposed to feel.

You can release your positivity and just feel the terribleness of whatever it is you are experiencing.

But while allowing yourself to go through your feelings is part of healing, it's also important to know when it's time to pull yourself up so you don't stay trapped. Know when it's time to ask for help. Get proactive in your own healing. Sometimes, you need more than time, so know when you should seek professional guidance. I know some people who still attach shame to the idea of counseling There are times when we can't fix something ourselves, and the only way out is by sitting across from someone who can help you work through whatever is going on in your life. If we don't ask for help because of shame, we are stunting our healing and personal development. A note about therapy: not all therapists are made the same. Be sure to find the right one for you, and don't be afraid to leave one that isn't working out so you can find one you feel comfortable with.

Jay and I found ourselves having a deep conversation a few weeks after we lost Tig. I was in a good place with his loss (that is, I had finally stopped sobbing). Yet, there was still something heavy lingering in the air. I couldn't figure out what it was. Jay

asked if I was happy, and I am. I was unquestionably in love with our life and happy, so that wasn't it. He admitted he was having some feelings too, but didn't know what to make of them. Then, it dawned on me. Tig triggered something—it was the idea that nothing was permanent, and in fact, everything was changing in our lives. Our lives had been steady and constant since we'd been married. But at that moment, his three kids were making their way into the world as adults, and they were no longer a presence in our house. My son had two years left of high school and then he would be heading to college too. Our lives were going to change. When we got married, our house was chaotic. We had four kids there on any given night. There were empty chip bags in the snack drawer, candy wrappers shoved in between the cushions, and constant noise. We were entering a phase of quiet, and it was uncomfortably eerie. The heaviness we both felt was a sense of loss as our family shapeshifted.

We brainstormed some things we could do to deal with the feelings. Having fun was on top of the list because we both agreed we had been working more than having fun. But ultimately, we just needed to move through the waves of emotions that we were feeling. We just needed to be. I couldn't control that I felt this way. I couldn't change it. All I could do was let it be. So when I found myself spiraling into empty-nest doldrums, I acknowledged where the feelings were coming from so I could allow them to pass through me. And it was refreshing to name it.

The next time you find yourself in a funk, try to figure out its root so you can name it and let it wash over you, moving out like the tide. Most importantly, give yourself permission to have feelings.

Consider this permission to be grumpy when life calls for it. Consider it authorization to hide away from the world when you

can't fathom the prospect of engaging with people. Consider it approval to spend an entire weekend indoors, even when it's beautiful out, just because you are sad. Consider it a license to snap back when someone is trying to rush you out of your hard spell. Sometimes, people don't know what to do with someone else's grief, so they get avoidant and weird about it. You can enlighten them or not. It's not your job to make someone else understand what you are going through.

Life can be joyful and momentous. It can be exciting and celebratory. It can be exhilarating and stimulating.

And sometimes, being human is just plain hard.

Chapter Sound Bites

- We can lay out the most well-thought-out plans and still get thwacked with twists and turns.
- Everything will work out exactly as it should as soon as you set things in motion.
- There is so much freedom in not knowing. There is so much potential to bring you what you never knew you needed.
- Sometimes, you just need to sit in the awfulness, cry it out, hide away under the covers, and feel every damn emotion.
- **ROLL and release**, and watch how far you can go.

She Who Wins
at Life

Win at Gratitude

The more grateful I am, the more beauty I see.
—MARY DAVIS

I closed my eyes and inhaled. The day was out of a glossy magazine. The water right off the deck of our bungalow was the clearest, most turquoise water I'd ever seen. A skate glided by in the shallow sea. I took a moment to be present and to take it all in. Jay was snorkeling in the reef, and I had a few minutes of quiet introspection.

I was happy, content, and at peace in this moment. I appreciated my journey because it all led me there. I realized how different things could have turned out had I weaved right when I decided to go left. I smiled to myself. Life is really good.

I noticed Jay was swimming far away from our bungalow. In fact, he was swimming toward the bungalow next to ours. I watched perplexed. When he grabbed onto our neighbor's ladder, I thought about calling out to him. I should have waved my arms and tried to get his attention because clearly, he was lost, but I stopped myself. This was going to be good. I sat up to watch the scene unfold.

One clumsy, flippered step after another he climbed each rung. The mask still covered his face, and the snorkel was still between his lips. He finally pulled himself onto our neighbor's deck. With the mask still obstructing his full vision, he glanced around. It seemed like he realized that something was not right. Perhaps it was the fact that his wife wasn't where he left her fifteen minutes ago. He waddled over to the slider in his fins, lifted his mask, and peered into the window. All of a sudden, he quickly backed away from the door. His flippers slapped the deck as he tried to run across the beams. He realized that he was not on our deck. The rest happened so fast, and yet I felt like I was watching it in slow motion. He shuffled to the edge and jumped without checking for any sea life below him. Small, harmless sharks shared these waters, but what was happening above the surface was far scarier to him than what was happening below. He propelled himself off the side. He frantically kicked his fins and flailed his arms until he found his way back to our bungalow. He put one rubber-enclosed foot in front of the other up the ladder again until he was back on our deck. He flung his mask off his face breathlessly.

I was laughing so hard that I was gasping for air. I'm so grateful that my husband can still make me laugh.

Gratitude (Even When You Are Not Feeling It)

It's easy to be grateful when everything is going well. It's easy to be grateful when you are at peace on a beautiful vacation. It doesn't take much effort. However, the challenge is to also be grateful when things aren't working out. Gratitude, just when it's convenient or obvious, is effortless.

But being grateful when you lose your job. That's hard.

Being grateful for the end of a relationship is even harder.

Being grateful for the heartbreak of losing your best pup friend feels unbearable, right?

Three days after we sent Tig to the other side, I was undone. My heart was broken, and I felt like there was a void in my days. He was part of my life for seven years, so this loss took me out at my knees. Jay and I went to dinner even though I hadn't eaten a decent meal in days. We needed to feel normal. We needed to get dressed, go out, and do something that didn't involve sobbing. I had reserved the cutest Airbnb in the quaintest village in Chester, Connecticut weeks prior. I was going to spend some time surrounded by a babbling brook, as I quietly finished up this book. When it was time for me to go, I almost cancelled. I just wasn't in the right headspace. But Jay insisted we head to the town, check out the rental, and grab some dinner. We sat outside overlooking the stream, reminiscing, shedding some tears, but also celebrating Tig's life. We laughed at some memories and then cried more. We said how lucky we were to have loved him so deeply and that he had such a special place in our life. We still had pain, but we also committed to tapping into something far more powerful—gratitude.

I see this phenomenon with people going through divorce too. Some have gratitude for their relationship even though it has come to completion and the end was rocky. They have children to be grateful for. They have fond memories if they can allow themselves to go there. Some become grateful after they have had time and distance on the other side. When there is a little separation, they can look back and be grateful for the pain for how it brought them to a happier, more peaceful time in their life, and perhaps even to a new love.

Chloé Temtchine from chapter nine had so much gratitude despite her debilitating illness. This is a hard one to master especially when you have endured so much suffering, but she has somehow managed to find the value in what she has gone through. I can't even begin to comprehend what gratitude despite illness feels like. It seems like an impossible feat. Yet, what is the alternative? To wallow and get caught up in anger and victimhood? I can't say I'd be able to approach this lot with the same level of gratitude that Chloé exhibited. I'd like to think I would, but I also think I'd probably have temper tantrums the size of the Taj Mahal. Perhaps time carries some grace with it. Fortunately, most of us don't need to conjure up superhero-levels of gratitude for a circumstance of this magnitude.

When I was fired from my first job out of law school, I was not grateful. I blamed my boss, the job, and the legal world. In hindsight, I realized it was a gift to be released from the hellish existence of that work so I could find something that wouldn't suck my soul dry. Now, I know the universe was sending me a message: my purpose was not to hide behind insurance claims and reports, but rather to help others who were going through one of the worst times in their lives. Gratitude rushed in when I was able to change the vantage point from which I viewed the situation.

Think about what has happened in your life that has knocked you down. Were you able to find any nuggets of gratitude in the undoing? Can you look at the situation today and understand that, perhaps, it was a gift? Has it led you to something better? Has it helped you get stronger and wiser? What is the purpose of that experience? It's there if you dig deep enough. It's always there. Now the question is, *what do you do with it?* Flexing your gratitude muscle daily can help when things get rough. For

example, until my son got his license, every morning as I drove him to school, I'd ask him for three things he was grateful for. His gratitude ranged from his parents, to it being French toast day at school. It didn't matter what he was grateful for. What mattered was that he had gratitude. I hope it's something he remembers as he embarks on his journey into adulthood and experiences all the highs and lows he'll find there.

Gratitude is something you choose. It rarely just happens. You can be grateful and still detest what you went through. You can be angry and still grateful. You can be heartbroken and grateful too. When you find yourself in a woe-is-me mood, try expressing your gratitude. I like to do this in the car where I can speak it out loud. I also try to start every day with some simple gratitude statements. I write them down in a journal to lock them in. It looks as simple as this:

I am grateful for _____.
I am grateful for _____.
I am grateful for _____.

Each day, my statements change based on what the day ahead of me looks like, or how I'm feeling. Sometimes, I direct my gratitude to the obvious things (kids, health, my long eyelashes). Sometimes, I have to dig deeper (rejection, a person who is niggling me, a hardship). It's hard to stay in a bad mood when you are focusing on the blessings and lessons in your life. A gratitude practice can set you up to have a great day, every day. It's hard to stay angry and bitter when you are acknowledging all that is right in your world.

WIN at gratitude, and call in your inner peace.

STOP + **DROP** + **ROLL** = **WIN**

(and assess) (your excuses) (into action) (at gratitude)

Regret is a Dirty Word

My best friend and I would climb up to the loft at her grandfather's cottage in Wolfeboro, New Hampshire when we were kids. We would hunker down in our sleeping bags with an open bag of Doritos next to us and play a game. We opened the page of a bridal magazine and picked which dress we would want from those two pages. When we decided, we would flip the page and choose again. We were twelve years old. When she got engaged, I gave her a stack of bridal magazines so she could find her dress for real. And she grew up to be happily married with three kids. I got engaged too. Then divorced. And engaged again. And divorced again. And just for good measure, I got engaged one more time. So, I got to wear three wedding dresses. Don't judge me. I'm living happily ever after too. It just took me a hot minute to get here. But there was so much regret weaved into those years.

I jumped fast and furiously from my first divorce into a relationship. I was so sure that if I distracted myself, I couldn't feel the pain of a lost a marriage. As I should have known, but didn't want to see, that rebound relationship was destined for a slippery slide down the couples drain. I couldn't make clear decisions when I was putting lipstick on a pig. The relationship was the pig, if you're wondering. When it crashed and burned, I had so much regret.

I regretted that I didn't give myself the space to just be. I regretted that I thought someone could fix my pain. I regretted how I handled everything in that relationship. I regretted that I opened my home to this person for a year. I regretted it all. I tortured myself with regret. It took me years to understand, that storyline was also part of my journey. It took me years to acknowledge that perhaps that person came into my life to help me make peace with having walked away from a marriage that was not good enough for me nor my husband. Regret will keep you down, stuck, and harping on your past decisions. Regret is quite literally the anthesis to healing because you can't have regret and heal, grow, and evolve.

Regret is a dirty word, and no amount of bleach can whiten it up.

When you find yourself walking down the narrow path to regret-land, flip your thoughts around. Instead of saying, *I should never have...* or, *I should have known...*or, *I should have done it differently*, say, *from this experience I learned something about myself.*

I learned I am stronger than I ever thought possible.

I learned sometimes my decisions can be clouded by my self-limiting beliefs.

I learned this thing needed to happen so that I could take action and change something in my life.

I learned it's worth it to walk away from something that has served its purpose and needs to be ejected from my life. I learned I'm worth it.

I learned I can be more, earn more, and achieve more than what I settled for.

When we believe that every circumstance and challenge has a greater purpose—that is to teach—we should never have regret.

If something is supposed to happen the way it does, there is nothing to regret. Listen, this is not permission to treat others poorly, lie, cheat, or indulge in any of the other vices that we like to justify when we are lost. But I am saying, when you make a human decision that later reveals itself not to be what it initially presented as, it wasn't a mistake; it was a lesson.

I've made so many mistakes in my life.

Relationship mistakes. Business mistakes. Personal mistakes. Life mistakes.

Each one provided a lesson along with it. I cringe when I think of some of those lessons, and I paid close enough attention to be sure I would never repeat them.

And for that, I'm grateful.

As I sit here today in my personal development journey, I can finally say I do not have any regret. But that mindset switch did not happen without some work on myself. It required me to stop being a mean girl to myself, and to start appreciating that my journey—the good and bad—is all part of my human experience. Likewise, your human experience requires you to make mistakes too. If you are not making mistakes, you are not stepping into the fullest, most expansive version of yourself.

Why look back and say you should have, could have, or would have done something differently? There is literally no point in doing this unless you are committed to driving yourself mad, beating yourself up for being human, and living in the past. Ruminating on regret has no purpose other than to personally torment you. Why would you be so mean to you? You wouldn't make your friend feel bad about their struggles, so why are you so unkind to yourself? Because when you have regret, it is impossible to also have gratitude. They cannot coexist, so one needs to be given the heave-ho.

You can choose to live in the past, or you can choose to live in your present with an eye on your future. You can choose to live in self-criticism, or you can choose to live in self-acceptance. You can choose to live in regret, or you can choose to live in gratitude. Gratitude is a far better place to dwell.

Give gratitude a try, and watch your mindset get an upgrade.

Chapter Sound Bites

- A gratitude practice can set you up to have a great day, every day
- Regret is the anthesis to healing. You can't have regret and heal, grow, and evolve.
- When we believe that every circumstance and challenge has a greater purpose—to teach—we should never have regret.
- You can choose to live in regret, or you can choose to live in gratitude.
- **WIN at gratitude**, and call in your inner peace.

Win at Unfolding

*The great thing about getting older is that
you don't lose all the other ages you've been.*
—MADELEINE L'ENGLE

Midlife is an interesting stage. If you're there, you know what I mean. The reflection that stared back at me was a stranger, but also someone I knew so well. The slight wrinkles around my eyes signify years of laughter and smiles, and also a reminder of all the years gone by.

I'm not old.

I'm not young.

I'm right in the middle.

My exterior is a bit more worn, and I continue to slather on creams, dye my hair, and wear Spanx. That's the easy part. I can dress up, smooth things out, and add filters from my phone to take away my lines. That's all outside stuff.

"So, this is it." I wrinkled my forehead and wondered if a little Botox wasn't such a bad idea after all.

I took inventory of my life, how far I'd been and how much further I still had to go. If you are still figuring out who you are

and how you want to show up, enjoy every phase. There is beauty in all of it.

In my twenties, I was trying to find my place in the world. I was trying to fit in while also stand out. What a paradox! I was still very much committed to living a good-girl life.

In my thirties, I knew who I was, but I didn't know what to do about it. I was starting to bend some rules and push back against the norm, while still trying to be it all to everyone. This was the decade when the curtain was pulled back about being a good girl. I saw it for what it was —a great, big sham.

In my forties, my current decade, I found freedom. Sure, I have some whacky things that I need to get a handle on, such as irate periods and a metamorphosing body, but there is a freedom that comes with this decade. I don't care what anyone thinks of me. I don't care if someone doesn't like me or judges me. I understand that their opinion doesn't impact my life, and more often, it reflects their own insecurities or self-limiting beliefs. I also finally dropped the good-girl act once and for all. I could breathe again.

I've heard your fifties are even better. Isn't it interesting that this sacred time when women start to feel comfortable in their skins and their own power, is also the same time when society tells them to fight for their youth? Society wants us to do everything within our power to stay young (they also just happen to have the perfect product to sell us to do just that). The women I know in their fifties are magnificently fierce.

Every day we age. Regardless of which decade you are in, each day is a gift and an opportunity. You aren't just racking up miles and wrinkles.

You are learning and evolving.

You are experiencing joy and heartache.

With each season that passes, you are acquiring lessons, truths, grit, and stories.

You are collecting memories, heartaches, and triumphs.

With each year, you absorb more knowledge and wisdom.

Your life is a book, and you get to decide whether you'll write an abridged version that is short on everything—love, loss, success, failures, dreams; or, whether you'll fill pages and pages with stories, memories, lessons, and tributes. I hope your book is well-worn and loved. I hope the binding breaks, pages float out, and the cover is worn thin. I hope you allow yourself to write a sloppy, messy tome, filled with adventure and love.

When you think about the weeks, they can seem endless. We are always waiting for something—vacation, summer, a holiday, retirement. We tend to spend significant time looking back at our pain or looking forward in anticipation of something yet to come. The present is where we belong. We shouldn't forget or bury our past. That is where our roots are planted and how we've become the person we are today. We also shouldn't spend all our days waiting for something else to happen. We should be right here, right now. We should be in this moment.

I read that people clone their pets with the expectation that the new cloned animal will be a replica of a beloved pet they lost. But it never ends up that way. Sure, the new pet may look exactly like the past one, but they can't possibly have the same personality because their life experience has not been the same. The lenses from which they show up in this world are unique.

It's the same with people. My life experience is very different from yours. It shapes who I am, and your story shapes who you are. With each year and experience, we further etch out who we are meant to be in this lifetime. If I didn't experience those Friday nights of cleaning offices, I probably would not have the same

work ethic that I do today. If I didn't go through two divorces, I would not have the same appreciation for the marriage I'm in now. Those are my experiences and my lessons. You have your own. Think about how your past has woven into the fabric of your present. It's the lens from which you view the world and your life. As the years go by and the wrinkles gather at the corners of your eyes, you evolve. You grow and change with the seasons. You learn, fail, remember, and forgive. You move, rise, fall, and expand.

You unfold.

Unfolding Authentically

What does it mean to be authentic?

We hear people talk about living an authentic life, but what does that mean in practice? How do you even figure out who your authentic self is? After so many years of conforming and squeezing into society's ideal of who you should be, how do you know your most authentic self? If you bumped into her walking down the street, would you recognize her?

For me, this book was an exercise in authenticity. It forced me to strip away the façade of who I've been for so much of my life. When I started writing this book, the stories I initially used were very different than the ones you've read. I kept it safe. Yet, each time I read one of those chapters, I knew something was missing. I knew the real me was missing from the book. The stories I needed to tell were the ones I hadn't shared before.

The story of my body humiliation.

The story of what I didn't tell my friends about cleaning office buildings because I was embarrassed.

The story of falling in and out of love like a fickle teenager. Those were the stories wrought with shame. They were also the stories that comprised the most authentic parts of me. They shaped the version of me that is here today. This book wouldn't resonate with you or move you if it was filled with a filtered montage of who I'd wanted other people to see for so many years. I needed to show you the imperfect, messy, mistake-ridden, version of me. I needed to share with you the most human side of me because we are all the same. We are all on a journey to live a life of meaning, and that starts by embracing our faults along with our triumphs. It starts by celebrating our challenges along with our truths. It starts by laying our defenses at our feet and declaring, "Here I am."

This quote by Ernest Hemingway sits on my bookshelf:

There is nothing to writing. All you do is sit down at a typewriter and bleed.

When I write fiction, through the protagonist I can open my veins all over the pages. It's a made-up world, and in that paradigm, I feel safe using my experiences to craft the main character's struggle. However, writing a personal development book is entirely different. Sure, I could have written a book that didn't include any personal stories. I've read plenty of self-help books like that, but I also knew those were not the books that touched me most. The books that moved me were the ones where the author cracked their soul open and dripped it on the pages. That was the book I wanted to write. But with that knowledge came a stark realization; I was going to have to become incredibly vulnerable and honest with myself so that I could be truthful with you.

So, that's what I did. I unfolded in these pages.

Your unfolding happens when you don't just speak about authenticity, but you inhale and exhale it too. Unfolding authentically means you've cracked yourself open so you can share your talents and gifts with those who you can serve. It means you show up and opt in, even when you are scared. It means you stand grounded in the certainty that you are a fierce force. It means you declare, *Here I am.*

There is always a risk when you become your authentic self. The risk is that you will be judged, criticized, and disparaged. There will be people who think you are too much, too outspoken, or too brazen. They will talk about you and will condemn your passion. Those are not your people. For every critic, there is also a champion of your work. For every cynic, there is a believer. Surround yourself with those who root for you rather than those who tear you down. Your authenticity will attract your tribe. Those are your people.

If you find yourself withholding your opinions or values, you are rejecting your authenticity. If you find yourself shrinking to fit in, you are rejecting your authenticity. If you find yourself placating to keep the peace, you are rejecting your authenticity. You can't WIN at life if you are not allowing your true self—your words, your actions, and even your thoughts—to shine. The people in your life deserve your authentic self. You deserve to be the most authentic version of you. And when you accept her, you'll be able to recognize her on the street because she looks exactly like you.

WIN at unfolding, and let your real *you* shine.

STOP + **DROP** + **ROLL** = **WIN**
(and assess) (your excuses) (into action) (at unfolding)

Learn from Our Angels

There is no better teacher than someone who has lived a full, colorful life before you. You met Mimi's spunk earlier as she debated the accuracy of my French text. She passed away when I was in college. She had a certain aroma to her. It was distinctly hers. She smelled like cigarettes, roses, and a hint of sass. She drove her green Oldsmobile so slowly that cars piled up behind her on the road. She was one of the most authentic women I've ever known. No one was bossing her around (except, maybe, her mean cats). I learned lessons from her.

My other grandparents, Nana and Papa, shared their love through food. A holiday was not complete without all of us assembled at their dining-room table, squeaking on the plastic chair covers for multiple courses. Their house was small. Their table was large, and their love was expansive. My Papa loved boxing. In fact, it was the only thing I ever saw him watch. When I visited, he'd come into the family room, plop down on his recliner, turn the channel to boxing, and try to explain to his granddaughter why it was the best sport that ever existed. I learned lessons from both my Nana and Papa.

Our ancestors have unfolded. They've gone through their own journeys, and there is something to learn from their lives. I learned lessons from so many others who have passed in my

life—relatives, a boss, acquaintances, and family friends. Some of these teachings did not happen until years after they left this earth. Some of their wisdom came directly from their mouths each time I saw them. Some of their insights have been left behind in cards I've saved. We have so much to absorb from those who have lived before us. I like to believe they are my guides today. They leave behind lessons and memories. Sometimes, they leave behind dimes or pennies for me to find at the exact moment I think of them.

Think about those who passed on in your life. How did they live their lives? Did they touch your life, or can you look upon their choices and wish they chose differently? You can learn from someone even if your relationship with them was difficult. What unhealed trauma did they live with? What self-limiting beliefs held them back? Or perhaps, they were the type of person who was loved by everyone they met, and there is a lesson in their joy. The relationship you have with someone who has passed away does not have to end with their last breath. You can continue to learn from their choices and their history. You can draw inspiration from their past. You can welcome them into your life every single day.

I've learned so many lessons from people in my life who are no longer here. Some of them are grandparents; and some are people who I only saw a few times a year, but who touched my life in some way. I believe my relationship with each was special in its own way, and this book would not be complete without paying homage to the people who shaped who I am. Here are the lessons that I have absorbed because of their presence in my life.

Ten Cents from my Angels

1. Happiness is a choice, not a circumstance.

2. Creativity is a connection to the soul.
3. Everything can be made better with a good meal.
4. Fighting the good fight is worth a go-around in the ring.
5. Don't judge someone else's journey.
6. Raise some hell.
7. Love fiercely and without regret. Then, love again.
8. If you ask for a sign, you will receive it... if you are paying attention.
9. Too good is no good.
10. Sometimes letting go is the greatest gift you can give.

Soon after Mimi passed, I was in my college dorm, and I was sad. Life felt heavy. It was rare for me to have a moment when my roommate wasn't around, but she was in class, so I had some time to sit with my feelings. The smell came on so fast and strong that I immediately jumped to my feet. I couldn't believe it. It was her smell. It wasn't something that could be replicated, and it certainly had no business in my dorm room. I moved to the opposite side of the room and sniffed the air. The smell wasn't there. I moved again towards the door and sniffed. There was nothing there either. I eyeballed my worn couch and decided to sit back down. That was where the smell originated, and maybe, it would still be there. I sat cautiously, skeptical of my senses. The smell lingered in the air. That was when I knew. I felt a sense of calm and comfort. I didn't feel alone.

"Hey, Mimi," I said. And just like that, the smell vanished. I knew she was there that day to tell me everything would be OK.

And I'm here to tell you the same. Whatever season you are in, it is temporary. If it's a season of growth, learn from it and take the teachings with you. If it's a season of stillness, sit in it so you can hear your heart or guides speak. If it's a season of acceleration,

trust your intuition and act swiftly and unquestionably. If it's a season of passion, enjoy the heightened emotions. If it's a season of mourning, let yourself feel. No matter your season, no matter your age, no matter your history...

...everything will be OK.

Chapter Sound Bites

- Your life is a book, and you get to decide to write an abridged version that is short on everything—love, loss, success, failures, dreams. Or, you can fill your book with pages and pages of stories, memories, lessons, and tributes.
- Unfolding authentically means you've cracked yourself open so that you can share your talents and gifts with those who you can serve.
- Your authenticity will attract your tribe.
- There is no better teacher than someone who has lived a full, colorful life before you.
- **WIN at unfolding,** and let your real *you* shine.

Win at Ease

A mind lively and at ease can do with seeing nothing,
and can see nothing that does not answer.
—Jane Austen

Summer in New England is magical. It's made up of long stretches of white sand in Gloucester, Massachusetts, clam bakes, outdoor showers, fishing and only catching sand sharks (because I always let my bait go down too low), and boat rides. That is summer on the east coast. And the day I want to tell you about was like any other. The sun was bright, the water was salty, and nothing else mattered. We were going to take a quick ride around the harbor. We piled into the small, motorized boat. There was only room for four people, and there were four of us. My aunt sat at the very front. My mother and I were in the middle, and my father was in the back, directing the boat through the waves. Off we went for a fun, little zip around the Annisquam. That is, until it all went wrong.

I'm not sure if we hit something, a rock, or the bottom, but the water started to trickle into the boat. Then it started coming in faster. We all watched my father as he worked furiously

to scoop it out, but man never wins the war with the ocean. When the water started sloshing around our ankles at an increasing rate, we all knew this boat was going down. We were panicked.

My father threw life jackets to us. We moved quickly and wordlessly as we clicked the latches into place. We futilely used our hands to get the water out as we tried to buy ourselves more time on the boat. I surveyed our situation. We were far out, but a beach was in sight, so we would need to swim. When the edge of the boat was almost submerged, I knew it was hopeless. The boat was going down, and I had to get off it, so I jumped. I steeled myself for the swim. It was far, but I could make it. We would make it. This would not be a summer day that ended in tragedy.

Right. Left. Right. Left.

I repeated the mantra as I performed each smooth stroke. I lifted my head from the water and gasped for air. The shore looked so far away. I could see people on the beach, but they were tiny specks. I had a long way to go. Just keep moving, I reminded myself. One stroke at a time. One kick at a time. You will not die. You will survive this.

Right. Left. Right. Left.

This day was not going the way we intended.

Right. Left. Right. Left.

My mind was singularly focused on survival. I couldn't feel the cold water. I was in fight-or-flight mode, and I was determined to fight.

Right. Left. Right. Left.

"Just stand up," a voice called out. The voice sounded so distant. Maybe it was God sending me a message. Calling me to him, to the light, to the other side. Maybe I was imagining it.

I didn't feel like I was moving at all despite how furiously I paddled my arms and legs. I banged my knee on something hard. Panic set in. What was under me?

"Just stand up," the voice called out again. It sounded suspiciously like my father. I heard my name.

"Renée, just stand up." Wait, it was definitely my father's voice. Not *the* father, but *my* father.

I lifted my head out of the water and realized I was looking at someone's calf. How was that even possible?

"Renée, just stand up."

My father was standing over me. But we were so far from shore. How was he standing? And then I realized I didn't die in the chaos. I was not having a near-death experience. I was still very much here, fighting my way to the beach, stroke after stroke. I didn't hit my knee on some exotic underwater sea monster. I hit my knee on the bottom of the ocean. It was low tide, and while we seemed to be so far away from shore, we were quite shallow.

"Stand up," my father repeated.

I pushed myself off the ocean floor, which happened to also be skimming my belly with each desperate stroke. I stood up. The ferocious, wild, unruly sea was, well... at my calves. I always did have quite an imagination.

We lost the boat that day, and I lost some skin on my knee from dragging my legs along the floor of the ocean trying to swim. We didn't need to be rescued. We didn't need to fight our way to the shore with endurance and grit. We didn't need to send out a flare.

Sometimes, we make things much harder than they need to be. We think we need to muscle our way through a situation, a job, or a relationship. We think we need to drag our bodies through a grind and fight the tides.

And, sometimes, all you need to do is stand up.

Ride with Ease

I have a confession.

I'm a grinder, a hustler, and even at times, a bulldozer. If my husband wants to really rile my feathers, he just needs to tell me to "chill out."

I don't chill well. I'm more of a heat 'em up, cook 'em up, fry 'em up, serve 'em up, kind of doer. Sitting still is a challenge. Relaxing can sometimes be a chore. I'm a work in progress. But aren't we all? If tenacity is my superpower, impatience is my major character flaw. When I say I want something done, I wanted it done two weeks ago. This is a standard I have for myself, not other people. I'm cool if someone needs time to percolate an idea or complete a project, but I'm far less forgiving of my own escapades with immediate gratification.

So, what a surprise I had when I learned everything I needed to know about slowing down, easing up, and riding the waves, from a horse. My horse for the week was a massive, black stallion named Hawk. He was so tall that I needed a booster step to climb on top of him. It was my first time at a dude ranch, and I had never ridden a horse before, so I was intimidated. On that first day, I had on red cowboy boots, a hat, jeans, and a red-plaid shirt. I certainly looked the part, but I didn't have a clue what I was doing. The ranch cowboys taught all of us city slickers how to walk, trot, canter, and gallop. The lesson lasted ten minutes, and then we set out to conquer the valleys of Colorado.

Have you ever ridden a horse? If you have, you quickly learn that riding on a horse as it flings you up and down in the saddle can be quite painful. You get jostled and banged around in that medieval, leather, torture contraption. You keep a death grip on the reins, dig into the stirrups, and if you are brave enough, you

let go with one hand just in time to grab your cowboy hat before it flies off, knocking into the person on the horse behind you. But once you learn to work with your horse (and not against him), everything changes. Once you master flowing with the horse's gait, riding gets a lot easier, and dare I say, enjoyable. While I climbed up on my horse that first day and whispered sweet nothings into his ear and promised him extra treats if he kept me upright, it was my own conduct that mattered. I had the power to turn the ride from a wild west show to a blissful prance with nature. The horse had nothing to do with it.

Think about your life the same way. The circumstances and situations you run up against have little to do with how easy your ride will be. Rather, how you handle the jolts and bumps thrown at you is the sole predictor of what kind of journey you'll have. You can tense up, clench your thighs, white knuckle the reins, and end up with a sore bottom and disposition. That's the opposite of ease. Or you can release the tension, breathe deeply with each movement, drive forward fluidly, and find yourself on the best ride of your life.

Resistance is a human reaction to losing control. We think if we can only grab the reins, redirect the carriage, and avoid the potholes, then we can also eliminate the chance of hitting every bump. But it's a lot of work to steer over and through the bumps to a smoother path. It's not supposed to be that hard. Winning at life should be easy. It shouldn't be forced and manipulated into compliance. When your life is in alignment, it is joyful, full, and uncomplicated. That doesn't mean there aren't challenges. It just means that life shouldn't take massive efforts. It should ebb and flow. It should be unfussy, breezy, and fluent.

Think about the people you know whose relationships are wrought with constant struggle and conflict. Whether it's a skirmish

with a boss, a spouse, or a relative, their interactions with everyone clash and clang, sucking the air out of the room and away from anyone who is in close proximity. We all know someone who finds drama no matter where they go. They like to spout that drama finds them, but it isn't so. They are just a person who allows situations and conversations to turn into theatrics.

Instead of pushing against your life, what would happen if you flowed with it? What would happen if you rode the waves, enjoyed the scenery, and loosened your grip on control? If you can master flow, you will be a master of ease.

Hawk and I ended the week as good friends. Eventually, I was able to climb him without a stool. He didn't dump me into the bushes. And I learned to direct him with little flicks of my wrist and with the slightest pressure in my feet. Riding him became effortless. Most importantly, we spent long rides through fields and valleys together, and I was able to enjoy the journey, because I stopped trying to control it.

WIN at ease, and ride through your life with joy.

STOP	DROP	ROLL	WIN
(and assess)	(your excuses)	(into action)	(at ease)

Swim With the Current

Ever notice how much worse any situation becomes when you resist? I was recently speaking at an event in North Carolina, and I had connecting flights to get there just in time for the welcome party. The first leg of the trip was delightful. I was seated near a

Boston restaurateur who taught me all about importing meats and cheeses. However, trouble began outside the gate of our arriving flight. Even though we were on the ground, there wasn't a gate for our plane, so we were stuck on the tarmac. The connecting flight time was short, and I knew I'd probably miss it. I took a few deep breaths and started to explore some alternative arrangements, none of which were great. I could get the next flight, but that was the following day; I would miss most of the conference and potentially my speaker timeslot should be time slot. Or I could turn around and head home. I could even rent a car and drive home. Driving to the conference, however, was not an option. It was just too far. As I turned over the different possibilities, something was happening amongst other passengers.

Some were aggressively pushing the flight attendant button and demanding to know what was happening. Many were complaining about missing their connecting flights and a few even got up and, despite the seat belt sign, rushed to the front of the plane so they could be first off when we finally made it to a gate. The flight attendants were forced to order them back to their seats and were met with resistance because of the passengers' insistence that they'd miss their connection. Most of us would miss connections, but how each passenger handled the disruption directly related to their perspective on all other things in life.

Those who WIN with ease can easily adapt with deviations along the way. Those who resist ease allow themselves to get flustered, rattled, and agitated with the slightest interruption. There were flight delays across the entire airport. The airlines adjusted all departure times to reduce passengers' missing flights. I landed a couple of hours behind schedule, but I made my connecting flight and got there. The passengers who were angry also got to their final destinations, but when they arrived, they were

grumpy and disheveled because they allowed something outside of their control to dictate their disposition.

Think about how you handle inconveniences. It could be traffic that is making you late. It could be a long line at the coffee shop, getting to the counter, and being told they've run out of your favorite brew. It could be a lost piece of luggage. How do you respond to the disruption? Do you have a three-year-old sized tantrum? Do you yell at someone? Do you let it impact the rest of your day?

You don't have control over everything or (really over anything), but you do have control over how you respond. Your perspective will determine how you show up in this world, in every interaction and everything you do. Do you want to walk around perpetually irritated, or do you want to be at peace no matter what curveballs are pitched to you?

No one is innately positive. There isn't a person out there with a secret elixir to being perpetually optimistic. Your reaction to situations is a choice. You get to decide whether to be exasperated or open. You get to decide whether you want to let some hiccup in your plans set your mood, or to use it as an opportunity for adventure.

Have you ever been so annoyed with something that for the next fifteen minutes, you feel yourself getting even more worked up? You might cut someone off while driving. Or maybe you'll snap at your kids or spouse. You are short-fused towards co-workers. If you allow the annoyance to fester, the rest of your day will continue to unravel at the same, irksome velocity, and when you settle down into the couch at the end of the day, you will tell yourself that it was the worst day ever.

Imagine how differently that could go down. Imagine if, as soon as you found your blood pressure rising, you took some

deep breaths and acknowledged that the person who was rude to you might have been going through something. Maybe they are caring for a sick parent or are going through a divorce. Maybe they are just a jerk. Imagine if you redirected your attention to something positive, something you are grateful for. Each moment starts and ends with your decision on how it will impact you. You are in control of your days, your mood, and your reaction to experiences. And that, my fierce friend, is powerful stuff.

But let me be clear, I didn't always go with the flow. In fact, I have been a complete jerk over something I couldn't control, and my attitude had a direct consequence. I'll explain further, but please don't judge me. I was changing the name of my business, and if you've ever changed your name, you know it is a royal pain in the behind. It's more than just ordering a new sign and new letterhead. In my case, it involved bank accounts, a marriage certificate, a divorce decree, and all kinds of other legal documents that were meant to annoy and frustrate me. I had been back and forth to the bank multiple times with documents only to learn I needed something else. So, on this day, I walked up to the counter confident I finally had everything necessary to complete this painstaking task, only to learn I was wrong.

I don't recall what was missing, but when the teller told me she couldn't do it, I snapped. I huffed and puffed like a child, told her I was taking my business elsewhere, and stormed out of the bank. (I told you not to judge. We all have moments, and this is one I'm not proud of.) Still in my rage, I got into my car, threw it in reverse and backed up quickly. So quickly, in fact, that I backed into a car parked behind me.

I had to get out of my car, walk back into the bank, and announce to everyone that I was looking for the owner of the car I hit.

Karma 1. Renée 0.

That was not my most-winning moment. The following week, I went back to the bank and apologized to the teller. I was a jerk, and I needed to own it. The universe gave me a smack across the face. And I paid attention. Had I approached that situation with ease, I would have spoken like an adult to the teller, asked her for everything that was required for me to complete the name change, and left peacefully with my bumper intact. That story forever lives in my repertoire of dumb things I've done, but I will also always use it as a reminder that when I run up against an annoyance, I can flow with ease into the situation, or I can crash into another bumper.

When you try to swim against the current, you get sore arms and a mouthful of water. When you go with the flow, you can glide into shore effortlessly. I don't know about you, but I'll take effortless over arduous any day of the week.

Chapter Sound Bites

- Sometimes, when you walk away from something, you make room for the answer you were looking for.
- When your life is in alignment, it is joyful, full, and uncomplicated.
- Release tension, breathe deeply, drive forward fluidly, and find yourself on the best ride of your life.
- You don't have control over everything (or really over anything), but you do have control over your perspective.
- **WIN at ease,** and flow into life.

A Final Word On *Winning*

In a world that wants women to whisper, I choose to yell.
—LUVVIE AJAYI JONES

I've always believed the book I need finds me when I need it most. Over the years, I've had many books that sit endlessly in "to be read" piles, only for me to pick them up exactly when I needed the message in their pages. I hope this book found you when you needed it too.

I pray that this book has awoken something asleep in you. I hope I made you laugh, and if I made you cry, perhaps that is also exactly what you needed. Whether you need to let go of something that has come to completion, or embrace something you wish to bring into your life, I hope you have clarity around your next best step.

It is up to you, now, to relinquish the good girl who has kept you small. Pay attention to what your heart wants, and know that you are capable of so much more than any of your best excuses. Take messy, imperfect, scary action so that you can shine your gifts outward. The world is ready for all you can offer.

She Who Wins has the courage to take bold steps, to love deeply, to rise when she has fallen, and to live unapologetically.

She Who Wins is on a journey of self-discovery, adventure, and amplification.

She Who Wins celebrates the success of other women, and gives women a lift when they have fallen and a voice when they have gone silent.

She Who Wins is not a singular woman. She Who Wins is a collective voice of all who have been victimized, silenced, and shut down from speaking up and speaking out.

She Who Wins **Stops (and assesses).**

She Who Wins **Drops (her excuses).**

She Who Wins **Rolls (into action).**

That is how she wins at life.

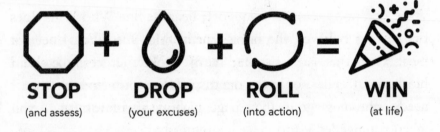

STOP **DROP** **ROLL** **WIN**
(and assess) (your excuses) (into action) (at life)

It's Your Time

Over a hundred years ago, a group of women led the way in a movement that has changed the lives of generations to follow. In doing so, some were imprisoned, beaten, and tortured. Yet, they carried on because they believed in a cause. They believed they should have a voice in society and the laws that were being made for them. The suffragettes believed that all women should have a voice in what happens in their communities, in their homes, and in their lives. They won the battle, even though so many lost so much in their fight. Let's celebrate their courage to do what is right, even when it's met with resistance. Let's not

forget that sometimes, doing that which lives in your heart requires sacrifice.

Rising up as a collective is about changing the climate of impossible standards that we've endured for too long. It's about rejecting the notion that our lives can be dictated and prescribed, and we should live with less because *it's just the way it is*. In a time when divisiveness and discord permeate the headlines, I implore you to rise with your sisters and show the world that together, we can change the conversation and set things right.

And for those who continue to tear down women who put themselves out there bravely, I have a message for you too: We will be your voice, even when you criticize; we will love you, even when you can't accept it; we will champion your victories, even when you don't want our support; because She Who Wins does not place conditions on who is worthy; She Who Wins does not need to earn your acceptance; She Who Wins is every woman. I hope somewhere within the depths of your disharmony, there is a deep knowing that you, too, are part of this movement.

You, me, and every other woman out there has a voice and an impact. It starts in our homes and with our children, not just by telling them, but also by showing them what it looks like to be a woman who stands unapologetically in her power. It starts in our workplaces when we speak out against harassment and gender pay deficits. It starts as soon as we stop judging other women who are making difficult choices in sometimes-impossible circumstances.

Winning doesn't involve medals or accolades. It is about waking up every day and realizing you have absolute power over your life—what you do, where you live, how you spend your money, and when you change course. Winning is about rejecting mediocrity because you know your light is meant to shine. Winning is

about being able to look in a mirror with pride because you are someone who has lived and loved fully.

The journey is not always easy, which is why I believe community is the path to self-actualization. Sometimes, we need to witness our reflection in other people's eyes to truly understand what we are capable of. Community is a support system when you need a cheering squad, and it is a source of shared resources and education when you need help. It is a place to be safe, seen, and heard. So, find your community, your tribe, or your posse. They will be there for you when you need the nudge or inspiration to keep going. They will be there to offer a soft landing when you start to fall. You are invited to join my community too. You can learn more at my website: https://msreneebauer.com/

Lastly, from the depths of my soul, thank you for reading this book. I hope this book makes it around the world and into the hands of every woman who needs it. Please share it with a friend who needs to be reminded of how amazing she is. If it moves you, I would so appreciate if you could write a review or post a photo on social media. Tag me so I can celebrate your wins with you. Make it a book-club pick so covens of women can gather, tell stories, and raise each other up. Invite me to attend. I want to be part of these conversations too.

I have a final story to share before our time together comes to completion. This story is about a woman who has gone through so much and has experienced so many moments that have brought her to her knees. This woman has doubted herself over the years and questioned whether she was worthy of receiving love, success, money, and anything else she dreamed of. This woman looks in the mirror and sees weariness and faults. This woman almost gave up, but there was something tugging at her heart. There was a flutter in her belly, and a tingle in her

toes every time she dared to imagine a different way, a different story.

I look at this woman and see her strength. It was written in the wrinkles around her eyes and the tiger stripes that years of living had placed upon her skin. I see her beauty, even when she doesn't feel beautiful. I see her resilience, even when she's disappointed. I see her resolve when she's been told she shouldn't do something. I see her determination when she has a dream. I never doubted her path, her vision, or her ability to impact the lives of those she loves.

I stand beside her, not to lead, but to remind her of how amazing she is, even if she doesn't always believe that herself. And we do not stand alone. There are hundreds and thousands of women standing with her, with us. Her ancestors, as well as those who are here now, stand with her, walk with her, cry with her, and celebrate with her. You know this woman too.

She is your friend. She is your neighbor. She is your coworker. She is your daughter. She is every woman who has ever questioned why she is here, and what purpose she possesses.

She is you.

Remember, there has always been a fierceness within you.

It's time to let her out.

Reader's Guide

I was once in a book club, and while we all read the book, we usually didn't have any insightful questions to guide a discussion. So instead of deep conversations, we filled our plates, caught up about what was happening in each other's worlds, then, when the night was wrapping up, spent a few minutes selecting the book for next month. So I hope by providing some questions here, you can spend a few minutes talking, sharing, and supporting each other. I'll bring the dip.

1. Have you ever done something disruptive? What was it? How did others respond? What is something you would love to do now but fear the condemnation of your friends and family?
2. Have you ever had someone comment on your body? How did it make you feel? Are you at peace with your body as it is right now?
3. Have you ever been in a relationship in which there were red flags that you ignored? What were they? Are you able to clearly communicate what you need in a relationship?

Have you ever been afraid to communicate your needs to a partner?

4. Think about the last difficult decision you had to make. Did you allow your head or heart to dictate your decision?

5. Who do you want to be in five years? Ten years? Twenty years? When you retire?

6. If nothing changed from how your life is right now, how would that make you feel? What would you change?

7. What breaks your heart?

8. What brings you joy?

9. If you had your dream job, what would you be doing?

10. How do you want to be remembered?

11. What is your superpower?

12. What's on your "No" List; what will you say *no* to from now on because it's not lighting you up?

13. What decisions would you make in your life if you had unlimited resources?

14. What does winning at life mean to you?

15. When was the last time an excuse held you back from something? What was it? Is there one excuse that you use all the time (i.e.: not enough time, not enough money, too afraid of uncertainty).

16. When was the last time you had guilt? Was it something created in your own imagination? Do you ever do things you don't want to do because of guilt?

17. Are you a people pleaser? Where do you think the root of this comes from? What is one thing you can commit to right now to resist your people-pleasing ways?

18. Let's celebrate your rejections. Share what rejections you have received. What did it teach you? Did you give up or keep trying?

19. When was the last time you went on an adventure? Share the story. If you can't think of anything, what is one adventure you'd like to embark on before the year is over? Can you put a plan into place to make it happen?

20. Have you ever felt shame over something? Speak it to release it.

21. What is one plot twist that has happened in your life? Was there good that came from it?

22. Fill in the blanks:
 o I am grateful for _____.
 o I am grateful for _____.
 o I am grateful for _____.

23. Who are the angels in your life? They can be alive or passed. What lessons have these angels taught you?

24. How do you handle challenges or obstacles? What is one situation in which you handled something well? What is one situation you did not handle well? Which was a better experience?

25. What are you most proud of? Share it, so it can be celebrated.

26. If you would like a free pdf of the Stop, Drop, and Roll formula to keep handy by your bed or tacked to your wall, go to https://msreneebauer.com/ and enter your email address to immediately receive it.

Works Cited

Etxebarria, I., Ortiz, M. J., Conejero, S. y Pascual, A. Intensity of habitual guilt in men and women: Differences in interpersonal sensitivity and the tendency towards anxious-aggressive guilt. *Spanish Journal of Psychology*, 2009; 12 (2): 540-554

Acknowledgments

To a writer, the acknowledgment page is like an acceptance speech for an Oscar. We get to thank everyone who helped make our book a reality without the music telling us to wrap it up. So, I'll take my time and mention the many people in my world that I am grateful for who played some part in this project.

None of this would have happened without my agent, Ann Rose, of the Tobias Literary Agency. You believed in my work even when I sometimes doubted it, and you always respond to my random texts at inconvenient hours. I begrudgingly admit that your edits are always on point. I am forever grateful that you took me on and never gave up.

The team at Urano Publishing has been a dream to work with. Thank you for believing my book was meant to exist. A special thank you to my editor, Lydia Stevens, who championed my words, who helped make them sing, and who trusted my vision.

I owe so much of who I am to my parents. They were my number one supporters from the very beginning. Mom and Dad, I love you.

Hey, Kevin, thanks for being a cool *older* brother. I dig being related to you.

Mimi, Nana, and Papa, I know you're still cheering me on and nudging the Universe on my behalf. I'm listening.

I'm lucky to have a tribe of incredible women in my life:

Lori Manzo, Kim Matarazzo, and Kristen Tortora, our group texts give me life and laughs. Krista Gorman, we may not live across the street from each other anymore, but you'll always be my go-to for a trip down memory lane that may or may not involve a squirrel. Jill Hallihan and Nadine Pare, I'm grateful that our friendship outlasted that dreadful job. Erin Hatzikostas and Nicole Licata, I dare say this whole journey started with your podcast. Denise Petry, you told me it would happen—you were right, but then again, you always are. Jackie Brubaker, while our friendship may have started later on, our souls have been acquainted for lifetimes.

Kristen Hartnagel, what a ride it has been. You are a gift. Candy Valentino, your capacity to give and help others is relentless. You've inspired and motivated me to dream even bigger and take action even quicker.

To my team at Happy Even After Family Law who carried the torch while my head was down tapping on my keyboard, I'm ever so grateful. A special shoutout to Megan McGrath, Shannon Jakubowski, Kathryn MacDonald, and Joe DiSilvestro who are more like family than they are co-workers.

The little town of Chester, Connecticut played an unwitting supportive role in the production of my book. The village fueled me with everything I needed when I was trying to finish writing it—incredibly, delicious restaurants, kind and chatty shopkeepers, the cutest apartment, and a babbling brook. And also, the River Witch, Jenn Calabro, who has no idea how much she

helped me get to the end when I was sad and grieving a loss. You gave me renewed energy.

To that English teacher from chapter three, you didn't make me a better writer. You almost dimmed my passion. This acknowledgment page is *not* for you.

And finally, to my children and husband:

Ethan, your sense of humor keeps me grounded and your determination to excel inspires me every day. I love you bigger than the whole sky.

Kendall, Emerson, and Aiden, thank you for letting me be your bonus mom. My life has been enriched because you are in it.

Jay, you are my rock and my best friend. You picked up the million pieces of our life that needed attention so that I could write. You fed me. You listened to me. You were unwavering in your support. I love what we've built together, and I won't ever take a moment of our life for granted. Thank you for loving me unconditionally and wholly. Every path led me to you.

And finally, to all of the fierce women out there. You are my muse.